Dan Heller

PROFITABLE PHOTOGRAPHY IN THE DIGITAL AGE

Strategies for Success

ALLWORTH PRESS
NEW YORK

08 07 06 05 04 5 4 3 2 1

Published by Allworth Press
An imprint of Allworth Communications, Inc.
10 East 23rd Street, New York, NY 10010

Cover design by Derek Bacchus
Cover and interior photos by Dan Heller
Interior design by Mary Belibasakis
Page composition/typography by Integra Software Services, Pvt. Ltd., Pondicherry, India

ISBN: 1-58115-412-7 (pbk.)

LIBRARY OF CONGRESS CATALOGING-IN-PUBLICATION DATA

Heller, Dan.
 Profitable photography in the digital age: strategies for success/Dan Heller.
 p. cm
 Includes index.
1. Commercial photography. 2. Photography—Business methods. 3. Photography—Marketing. 4. Internet marketing. 5. Electronic commerce—Management. I. Title.

 TR690.H43 2005
 770'.68—dc22

 2005008202

Printed in Canada

DEDICATION

"If we can't do it, we can't teach it. And if we can't teach it, we're out of business."

—*Strictly Ballroom*

Contents

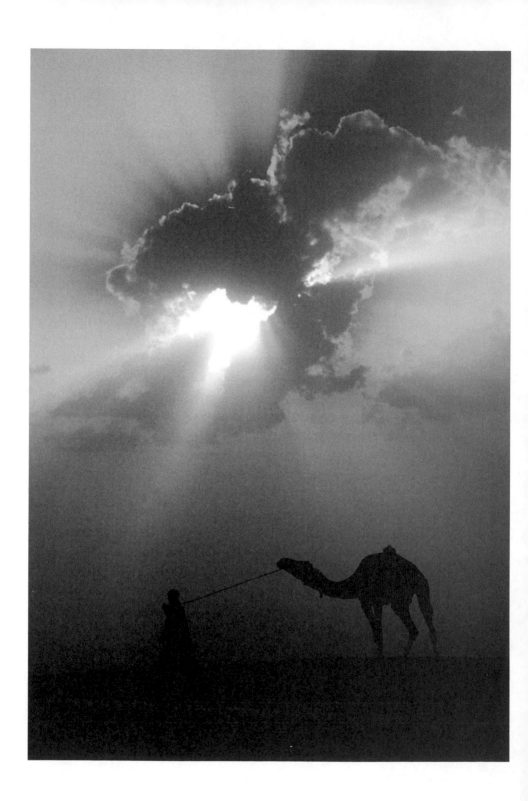

Read Me First 1

I want to talk to you about a subject that many people find difficult to bring up, but which they think about all the time. I mean, *all* the time. You don't just think about it, you do it. And you're not alone. I do it, too. So do your friends. Your neighbors. Yes, even your *parents*. We all do it. In our homes, in private; some do it in parks and other public places. Others do it at school or at work. But when you want to talk about it, not many people know what to say. To some, it's too private to discuss. Many will even lie about it, while others are just ill-informed. The good news is, I'm not your parents, so I can talk about it freely, openly, and honestly. And because I don't know you, I can tell you the ugly truth about it that no one else will tell you.

Yes, that's right. I'm talking about the photography business. While photography is something that everyone is familiar with, the *business of photography* is a mystery. You probably can't talk to your parents about it, and people on the Internet may just tell you rumors that aren't true. Talking to other photographers often doesn't help; most will try to talk you out of it, warning that it's a saturated market and there's no way to make a living at it anymore. You may have already learned that pros are reluctant to share their "secrets," or provide much useful advice on what to do and how. Of the photographers I e-mailed when I was learning, few replied, and of those that did, none gave any useful advice (one even tried to sabotage my efforts, since my goal of pursuing travel photography encroached on his turf).

Paths to the Photo Business
There are many paths that lead to the photography business, but they tend to fall into three basic categories:

1. Hobby/enthusiast.
2. Student/traditional paths.
3. Migration from another career.

Because people's objectives in life vary, there is no "correct" path into the photo business. One person may want to just have fun and pull

1

in a few dollars to pay for his hobby, while someone else might want to put his kids through college. Many drift from one goal to another as conditions in their lives change. (For example, I started out as a hobbyist and ended up making a substantial career out of my photography.) Your goals will vary depending on the strength of your photography ambitions and the lifestyle you are (or aren't) willing to endure. Also, your own past experiences in life and career will greatly affect your business potential and financial needs.

But take note: While there are often tradeoffs between goals, don't fall into the trap of believing there is only one path to success, or that there are strict rules for succession. No matter who you are, eventually you will learn the first rule in making money, which applies to any and all business models:

"If it were easy, everyone would do it."

This is my number-one mantra, one which I've typed until I was blue in the fingers, and I will continue to do so. You "can" make money, but it's simplistic to think that it's just a matter of doing tasks that someone else tells you to do, or that it's a matter of having the right forms, or looking to a chart to tell you how to price your pictures, or getting the right portfolio in the hands of art directors. No business can be broken down into "painting by numbers," especially in the world of photography. There are no secrets, whether it's becoming the celebrity star photographer for the cover of *Vanity Fair* magazine or entering the less-ambitious greeting card market. Any task can be fraught with little gotchas that no book can prepare you for in "simple terms." At the end of the day, *if it were that easy*, then . . . well, you know.

It's natural to think that if someone else can do it, so can you, especially when you see the kinds of pictures that are used in magazines, postcards, and art galleries. This reminds me of a joke:

Q. How many photographers does it take to screw in a light bulb?
A. Fifty. One to screw it in, and 49 to say, "I could have done that!"

As a skill, photography is not hard to do technically. Creativity takes time to develop, but while truly unique artists are less common, making images good enough to *sell* is relatively easy. That's why the joke above applies: most photographers with reasonable competency can

look at "commercially successful" pictures and say, "I could have done that." But this isn't what makes you successful. It's having business sense. It's knowing what to bother shooting, and how to sell it to someone. You could probably make a good living shooting shoes for catalog companies, but is that what you really *want* to do? Because of the nature of the business and your lifestyle goals, the first thing you need to do is envision what you want out of photography, *then* what you want out of a photography business. Here is my last quote on the subject:

"Trying to make a career out of photography is a sure way to ruin a perfectly lovely hobby."

Photography is more a lifestyle than it is labor that one does to earn an income. (One rarely goes into photography because he can't find any other way of making money.)

MONEY AND PHOTOGRAPHY

A costly mistake that people make about the photography business is, unlike other capital-intensive businesses (that require cash to start), you can't buy your way to success. There is usually one reason for this: your value to photo buyers is not something you can purchase. They don't care that you bought your own ticket to that African safari and got pictures of cute little leopard cubs. Nor does it matter that you are willing to shoot an assignment "for free" if you don't have the credentials to show your knowledge about the subject or to demonstrate your skills. And it wouldn't even cross someone's mind to consider you ahead of someone else because you have more expensive equipment.

The misperception that money buys access or success is one of the more senseless ideas to permeate the industry—on both ends of the spectrum. Rich people who retire and go into photography believe that, because money isn't a barrier for them, they will rise above others without much effort. Likewise, professionals erroneously feel that rich people are hurting the photo business because they don't charge much (if anything), since all they want to do is get their images published. (The percentage of rich people who do this is tiny compared to that of the general public who do it as well.)

Both sides are wrong, and this misconception of money's role in photography is responsible for the failure of both groups. The rich people will find they spent a lot of money on an elaborate hobby, and the few chance

occurrences where their images were published don't really amount to a career. (Sure, it's a hobby, and there's nothing wrong with that; but it's not a career, which is the topic under discussion.) As for the pros whose careers are stagnating, they've got other problems that go way beyond whatever those rich people are doing.

There are a few photo-business models that do require more significant capital, such as that of a studio photographer doing high-end product shots involving substantial lighting equipment and big, roomy space. *That* can be quite prohibitive, especially if you live in an expensive city like San Francisco or New York. But, just because one can afford it doesn't mean he's ahead of the competition. He still needs to compete in terms of experience, portfolio, and credibility within his target market segment. More resourceful amateurs who have a lot less money are forced, out of need, to network within the community and establish relationships with existing studios. As a consequence, they learn more and gain more credible experience than their richer counterparts who try to go it alone.

The Serious Photographer
Okay, let's put this into context. Regardless of which path you choose to enter this business, when it comes to making money with photography there are two kinds of people: the *serious* photographer, and the *insanely serious* photographer. The primary difference (of many) is that of lifestyle. You may think that you're just a casual hobbyist who wants to pick up a few dollars for some pictures, but by the time you actually get those dollars, you'll have invested considerable time and effort. You're the *serious* photographer.

Many drop out by that time, so if you do get that far, you've achieved that level of "a few dollars," you'll believe that "just a little more effort" can yield considerably better returns. It's sort of like buying a soft drink in a movie theater: the smallest cup you can buy is ridiculously expensive, but for just a couple of quarters more, you can get twice as much. That's what the photography business feels like. And by the time you learn that "a little more work" is really *a lot*, you've graduated to the *insanely serious* photographer.

Where you see yourself along this spectrum really what will determine where you end up. Are you "the hobbyist that wants to make money," or do you want to build a real, bona fide career? There is no

right or wrong to either choice, because the *type* of work (not just the amount of it) is what will greatly alter your lifestyle.

In fact, the two tracks are so completely opposite one another, you can actually do yourself more harm than good by trying to make a career using the strategies of a hobbyist. Similarly, the hobbyist would quickly lose interest by trying tactics that only the professionally minded photographer should use. Put another way, making short-term income often involves tasks that have no long-term benefit. There is a limit to how much you can make as a hobbyist, simply because the tasks and methodologies are so brute-force and simplistic that they can't be automated cost-effectively to yield any appreciable income.

An example of this is the postcard business: you can make some money, but just getting to the point of generating revenue requires work and time that, if invested in other areas, would yield more profit. Is that payoff worthwhile? For the amateur looking to tool around in a car visiting gift shops in town or in a vacation spot, the experience alone is often appealing enough. But, don't expect to raise a family on this strategy without having expanded into something that's no longer considered a "photography business." That is, people who make a living in postcards alone are usually in the distribution business and happen to spend little time doing photography.

Q. What's the difference between a photographer and a large pizza?
A. A large pizza can feed a family of four.

The above joke not withstanding, given a choice as to how to invest time and resources, pro photographers differ from hobbyists in this way: Hobbyists put lifestyle ahead of business; they photograph for fun, then figure out how to make a living at it. Professionals also love photography, and although it's fun, they choose options where there is opportunity for *long-term growth* and *name recognition,* which contribute to higher pay and recurring business over the long haul.

Note that these are two ends of a wide spectrum, and not everyone is at one end or the other. Many photographers find themselves somewhere in the middle, and finding your place is your first objective. As you do your soul-searching, remember this quip:

"What you do to make money as a hobbyist is *not* what you do to develop a career."

This may help clarify why and how some people go about their photo businesses. Their intentions may appear very different than what you see at first blush if you only look at it from one perspective.

"VANITY BUSINESS" VERSUS CAREER PATH

One of these middle areas that hobbyists and professionals both share (where it's often hard to differentiate between the two) is the *vanity business*. In this area, your main goal is to express yourself and your ideas using a business model in which earning income is secondary. One example is a "vanity gallery," where the artist owns the retail space and exhibits and sells only his own work. Other examples include selling prints at art festivals, cafés, or the county fair. Any of these are fun, rewarding, and even profitable. I've known many people (including myself) who have made some money at these venues. But the path to financial success here is more ambiguous. Among certain demographics and in some geographical regions, the vanity business can be profitable enough to support a family, but these are exceptions to the rule. For this to work, the photographer is usually very well known, or he has a large, rotating client base in tourist-laden cities, such as San Francisco, New York, Los Angeles, and "art Meccas" like Santa Fe, New Mexico. Or, it could be that the business is an adjunct to a much more active photo business behind the scenes, and the gallery itself is just selling its by-products.

Not all vanity businesses are as elaborate or involved. In fact, many don't necessarily have to be profitable. Examples include photo books or postcards, where the primary focus is to bring attention to the artist. (Normally, photo books are regarded more as marketing tools for artists than as income generators.) Pros who've migrated away from their more established photography careers into vanity businesses often do so as a form of pseudo-retirement; they can leverage their existing stock of successful images as annuities that bring in residual income without having to remain as active as they used to be.

In summary, the vanity business is best accomplished when you're either laid back about your longer term ambitions, or when you use it as an avenue for picking up additional revenue from images already created through other business means. Either way, this is rarely the end objective for the career-minded photographer (although it may certainly be an *exit strategy* after loftier goals have already been accomplished). This brings us to the next section.

The *Insanely Serious* Photographer

There are those who are so set on becoming a photographer they've even considered animal sacrifice. For some, this happens at a very early age, where they have visions of shooting supermodels in bathing suits, or car ads for magazines, or war zones and other news-breaking events for newspapers. (The family cat looks upon these young people with caution.) Others get the itch at an older age, when they decide that they've had it with their current careers and need to change to something entirely within their control, so they can attack it with all their (remaining) vigor.

For the younger members of this group, there is the option of going to photography school, whereas older adults usually consider a direct migration path, often involving minutes of dedicated research and seconds of getting out the credit card at the camera store. Let's address each of these approaches.

PHOTOGRAPHY SCHOOL

I have two extremely strong points of view on photography school. (Okay, three.) It's either the perfect (if not only) option, or it's such an incredibly bad personal decision, you might as well spend your money on a good therapist, because that's where you're going to send your parents when they see what's become of you. (While they're on the couch, you'll be in coffee shops reading the want ads and whining to friends about how unfair the world is to artists.)

My third perspective? Well, let's get to that after I clarify my first two.

The Strong Advocate of Photography School

For the emerging art photographer or photojournalist who wishes to follow a more serious path in either of these markets, to make "statements," or to have influence (or at least an effect) on the art community or in world events, I am a strong advocate of going to art school. In fact, you should get a master's degree from a reputable university first, or, failing acceptance there, a specialized photography school. If that doesn't work out, get a regular degree at a normal college and take a lot of art classes. (If this option is undesirable, get one of those fake diplomas online through one of the many spams that are sent out.)

Most successful artists and photojournalists emerge from academic circles. Of course, there are myriads of exceptions, but statistically they

come from fine art schools. Educational programs provide avenues to resources and networks of people who can lead students through the labyrinth of this quirky and often unforgiving realm. You come out with credibility that is respected by people and venues where you can establish your career. It's such a tight-knit world that, if you're not in school, you may find it hard to compete against those who have access to the movers and shakers in the industry.

While I do believe that photography school is imperative for certain people, I also have some reservations about this avenue. Hence my second view of art school.

The Moderate Supporter of Photography School

When it comes to younger people considering college for a commercial photography track, I'm sort of "in the middle." You definitely get a good education and hands-on knowledge of how to do things like configure studio lighting, put together a portfolio, send out marketing postcards, and various and sundry tasks associated with running a business, but these are things you can learn on your own. Photography is a formidable and honorable career, and the networking on the inside can be useful for the top students in the class (thus the benefit of school). Yet, competing in the outside world, where you also have to compete against nonacademic types who compete tooth and nail in ways that school doesn't teach you—that's another thing.

The photo world is difficult, competitive, and it doesn't pay well. And that's the good news. The bad news is that it's also terribly unfair and unforgiving. To succeed, you need to learn *business* skills and ideas, which will be more responsible for your success than whether you know how to configure studio lights to yield a 2:1 lighting ratio. Most photo schools teach nothing about the real world of the business, and what they do teach has been made mostly obsolete by how business (not just technology) has changed. I'm not talking about digital photography, Photoshop, or anything like that. I'm talking about the fact that photographers can no longer build businesses on the same foundations that they used to.

If it sounds like I'm talking you out of photo school, I'm not. I'm just concerned that you will put all your eggs in one basket in terms of your *education*. Well, unless you're really, really sure—you know, "insane." (I realize you've probably already heard all this from your parents. But

remember, I'm not your parent.) And I'm no longer inside parentheses, so you can't pretend you don't hear me. Which leads me to my third perspective on photography schools.

WhatEVER!

As long as you're going to college, I'm happy. A well-rounded education and a rich set of life experiences makes for a better artist overall, because you learn to see multiple perspectives on broader world issues. Remember: you can always do photography along with something else. Just about *any* other career can also involve photography in your spare time (and if you're that wild about photography, I guarantee you'll find that time is copious). You're also fortunate: photography isn't expensive, and it doesn't require anyone else's participation (unlike that rock band you had back in high school). If you develop your photography to the point where you're making money, great! You can always quit your other job then.

Migrating to Photography

If you're past college age, chances are that a career in photography is a migration path from another job. The majority of the population (and probably most readers of this book) have taken pictures, and a huge percentage of them are very good at it, despite having had no formal training in photography. This is partially why many people feel that a migration to the photo business is an arm's length away. For these people, it's an alluring prospect to give up the day job, or enter into retirement, and pick up photography as a full-time job. What isn't expected, however, is that 90 percent of this business is *not* taking pictures and living a romantic life—it's *managing your business*. Because of reasons like this, the majority who try drop right back out.

I leverage my skills and interests in ways that are not only successful for me, but that make it easier to beat my competition. (This point is critical.) Photographers who try to emulate what I do, simply because I've been successful, may be making a big mistake unless they understand the broader concepts of how companies use imagery to market their products or services. Someone with a strong marketing background might do well in this regard.

Alternatively, someone migrating to freelance photography from having worked as a photojournalist would be well suited to selling stock

photography to the very market segment from which he came. Having contacts is one thing, but also knowing how the business works—price points, negotiating points, and other inside business information—provides a great springboard for upward mobility.

If someone is adept at managing teams of employees, is good at setting up assembly line processes, and can manage distribution channels, that person would be better suited to selling in the commodity sector, such as gift manufacturers, and so on. The point is, we all came from *somewhere*. Use that place to your advantage.

Remember, all of this applies if photography is your *career*. If it's just a small money-generating hobby, the "business management" aspect needn't be so time-consuming or troublesome. This is why the migration path can be a more attainable and fun activity. If you are realistic about what an "arm's length" is, and have reasonable financial expectations, you're set.

What I Don't Cover

There are various things that I don't cover. First and foremost, I do not discuss "what images sell" because the sad truth is *any* image can sell. I'm not going to have you spread your photos out on the floor and compare them with those you see in magazines, because all you need to do is look around and see the pictures that *are* out there to understand what I'm talking about. For example, the photo shown on page 10 is a billboard-size image advertising a shopping mall. Someone seemed to snap a camera at a group of people and plastered the photo on a wall. I see examples of this all the time, even in extremely high-profile business environments. One such example that I've seen is a completely out-of-focus picture of trees with a caption reading "Seeing the forest for its trees." It's a fine marketing piece, because it demonstrates the idea it is trying to communicate. But one doesn't have to have a good picture—or be a good photographer—to use these kinds of images. In the art world they are euphemistically called *high-concept imagery*, because the message isn't the photo, it's the concept.

Don't get me wrong. I don't mean to suggest that you don't need to achieve a degree of proficiency with your talent in order to build a long-term business. You do. It's just that trying to discuss what is "good" or "salable" imagery is irrelevant. The photo business is less about quality images than it is about knowing how to get people to buy them—and that's what this book is about. If you can do this, your natural ability to create the kinds of images that people buy will evolve.

In a similar vein, this book is not a "how-to" book on taking pictures, printing, using a camera, or other instructional matters. I do not give advice on what cameras are best or recommend business services or Web sites that can suit a specific need, I present issues that are important to the decision-making process. (There are other resources for teaching hands-on tutorials on photography tasks.) I assume you know how to take the kinds of photographs that suit your fancy; my goal here is to merely present the business issues for leveraging what you produce.

If I give specific examples of products, brands, or Web sites, they are to illustrate points only. For example, I may say, "A search on google.com reveals several hosting companies that serve your Web pages," but it doesn't mean that I recommend any of them (nor am I specifically advocating Google as a search engine). I'm just showing you how to do your own research.

The reasons I don't spoon-feed you answers are two-fold: First, you need to be resourceful and learn how to evaluate your research results and how to think critically in business terms. Second, the world is changing far too rapidly for any single piece of advice to remain valid long enough to warrant recommendation. Any product that I might recommend as I write this may be obsolete by the time you read it.

Lastly, every subject I discuss here can have several volumes of books written about it, so it's impossible to cover everything in the depth it deserves. There are many caveats to every issue, and it's infeasible to cover them all, so I focus on the most typical and common cases that may affect you. If you have additional questions, I have written considerably more on all of these subjects in related articles on my Web site, *www.danheller.com*), and I encourage you to read them and send me e-mail. That said, reading this book will certainly get you on the right foot for starting a fundamentally sound business model (or extending your existing one).

The Reader's Responsibilities

All of the discussions in this book are based solely on business strategies that thrive in a heavily competitive environment where your peers aren't necessarily looking out for your best interests. The assumption here is that you are ultimately responsible for your own career.

So, now that you know what I'm going to cover, it's time to do your part. First, look at the big picture. The greatest mistakes just about everyone makes when reading business books are:

1. **Looking for the quickest or biggest gains.**
 You don't make money in the photo business quickly. Short-term strategies that may pay quicker dollars rarely turn into longer-term strategies that earn the greater returns.

2. **Looking for specific information to address an immediate question.**
 There are no hard rules about what a "fair price" is for a photo, and even if you have a pricing guide, it won't help you understand how to negotiate. Similarly, deciding whether a particular image requires a model release isn't black and white; you have to understand the process of weighing many factors. Most questions I get, as well as

those asked in discussion groups on and off the Internet, attempt to get quick answers to complicated situations.

3. Looking for the easy way.

Photography is not a simple industry to play around with if you're planning your future or making a livable income. Play all you like, and rake in those pennies for fun and profit, but when it comes to your security, you can get in a lot trouble if you don't first understand the bigger picture of how it all fits together.

In the grand scheme of things, it's better to learn how to think for yourself, be analytical, resourceful, efficient, and effective. These are timeless business attributes that will garner success in any endeavor.

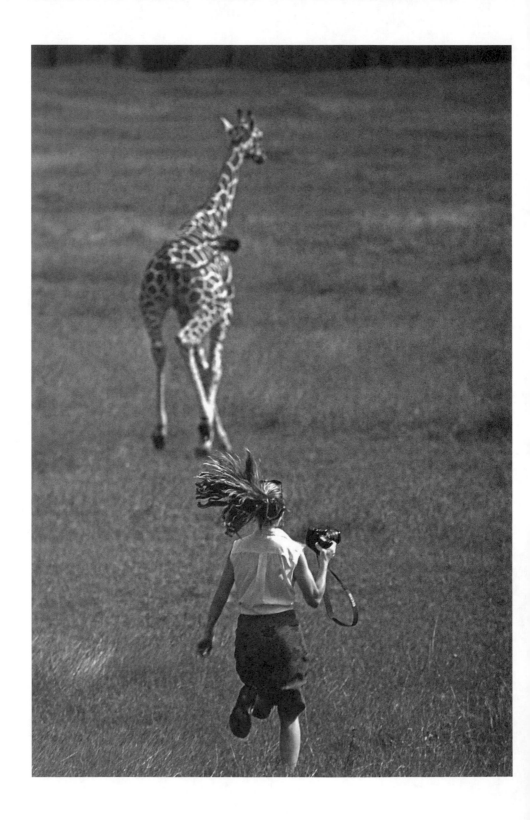

The Five Truisms of the Photography Business 2

Above all else, the main purpose of this book is to get you to think critically and analytically about business. Critical thinking is a discipline that challenges you to examine all sides of any issue or postulate. Business changes so rapidly that what was true yesterday may not be true today, and today's lessons may not apply tomorrow. As conditions change (the marketplace, pricing, technology, economics), different decisions should be made, based on current circumstances. Anyone who says, "This is the way the photo business has always worked and always will," is viewing the world too simplistically. All too often people merely react to a given business condition by applying preprogrammed mantras, or by blindly following others. To make sound, intelligent decisions about how and where to spend capital, to predict what people will buy and when, to effectively price products or services, and, most of all, to know what to do when things go wrong, one needs to see how all of it fits in the bigger picture without prejudice to how things used to be.

Differing Business Models

Anyone wishing to enter the photography business as a serious endeavor must recognize that there are two polarized views about this industry's business climate, each offering an opposing philosophy on how to approach your business. We will examine both views closely and ascertain from those strategies which may be more pertinent to today's environment. The two paradigms under consideration are the historical model that has traditionally been part of the photography culture, and the free-market model, where most businesses operate in a capitalist economic system. We'll discuss each in depth, but let's start by defining them in terms of how they apply to the photography industry.

- **The Solidarity Model**
 The solidarity model is based on the presumption that a photographer's best chance at succeeding in business is to join with other photographers as a cohesive industrial force, similar to a union, where pay and contract terms are enforced implicitly through a voluntary

15

agreement among all photographers. In this model, photographers won't enter into business agreements with clients that don't adhere to those terms, which would be "standardized" by various entities within the photo industry. This may include pricing structures, contract forms, terms and conditions for employment, and so on. The theory is that such cooperation will force photo buyers and contractors to agree to those terms. Since only real unions can force buyers to comply with such terms, and since photographers are not permitted to unionize, the solidarity among photographers would have to be voluntary. Companies that do not comply with such terms are deemed to be "bad for the industry," and are be subject to boycott by those cooperating photographers.

Policing the solidarity is also part of the model; uncooperative photographers are often "excommunicated" and, on occasion, outed by the press. The terms—also called "codes of ethics"—are currently written by industry trade groups, which include subgroups within market segments. Current language for such codes includes, "never underbid other photographers," "never bid an assignment below cost," "*never* work for free," and "never consider your own needs at the expense of the industry."

The goal of the codes to is to enforce behaviors that are intended to keep market rates higher and to preserve the jobs and livelihoods of its members. The assumption is that if enough higher end professional photographers participate in the solidarity, buyers will have no choice but to adhere to the terms, or suffer with lower quality shooters and their images.

In the end, the theory goes, photographers only need to compete with one another on one aspect: their craft. All other business terms would have been negotiated in good faith in advance by "the industry" and the majority of the photo-buying clientele. This would reduce incidences of workers being unfairly exploited by the bigger and richer employers or licensees.

• **The Free-Market Model**
The free-market paradigm presumes that photographers compete head to head on everything from price to contract terms to all other aspects of business at every level. As individuals focus on promoting their careers as best they can, their combined successes strengthen

the industry as a whole. As weaker and less successful workers drop off, the de facto leaders become the trendsetters for how contracts are written, where market rates end up, and so on. This model needs no oversight or policing, because the free-market system is self-sustaining. Buyers who desire valuable photographers and their assets have no choice but to comply with the terms that *they* set, which trickles down to the rest. This puts an upward pressure on terms, counteracting the downward pressures from competition. As better and more qualified photographers rise through merit and strong business acumen, a more stable foundation is established to secure industry terms. Best of all, the system is flexible due to changing technological or economic conditions: when such changes occur, emerging photographers who succeed in the new environment naturally set the stage for those who follow.

THE DECISIVE QUESTION

In reality, neither theory can be fully realized due to the simple law of chaos theory (that is, there are too many variables to fully predict an outcome within a certain degree of accuracy). Furthermore, neither model is new or unique: the solidarity model is used by unions all over the country today, as well as many European countries with strong socialist governments. The free-market model is used throughout most industries in the United States, ranging from technology to medical care. The predicate question is how to determine which model is more appropriate for *photographers* in today's market. Hence, the following:

"Is the number of pro photographers large enough, and is their unification centralized enough, so that mass cooperation affects the entire industry positively?"

This begs the corollary question:

"How many uncooperative members are required before solidarity has eroded to the point where those who 'cooperate' are worse off than those who don't?"

An example of this risk analysis is found today among oil producers. Because there are only a few countries that produce and supply oil to the world, they can control pricing by simply cooperating with one another and agreeing not to sell below a certain price. While this form of organized price control is largely effective, it is also brittle, as evidenced by this example. In 1999, the "agreed" price among OPEC members was $28 per barrel, but

Venezuela was having several economic troubles internally, and the only way they could get out of it was by secretly and quietly dropping its prices to $20 per barrel, thereby cornering the market. The lower price was offset by the disproportionate amount of oil they sold (relative to their competitors) hence, yielding a net profit. By the time the news got out, they had already realized the revenue boost they were seeking, whereby they returned to "compliance prices" before getting penalized by the consortium.

The point: Venezuela's undercutting of the market for their own financial gain caused the other members to suffer. This practice is the basis for one of the "codes of ethics" described earlier.

If one were to believe that sufficient cooperation can be obtained from the photo industry, then it not only makes sense to participate in this solidarity, but you also should be able to build a business strategy that confidently *relies* on such cooperation. If one does not believe that solidarity is sustainable, one has no choice but to default to a free-market model of competitive strategies against competition because, well, everyone else is.

What makes this question so important—*and why so much attention is given to it in this chapter*—is that virtually all professional photo organizations (commercial and educational) base their entire business foundations on the solidarity model. Their influence on the photo community is strong, and dissenting views are not widely heard (you're not going to see *this* material in their curricula), so most people who go through traditional educational programs are going to hear that model and no other. This is what is called a "captive audience," where the members usually don't have other business experiences from which to base their analysis. That is, emerging photographers look to professionals for guidance, and there is no other source of information they can rely on. Moreover, most professionals today evolved from an era when the solidarity model was not only the prevailing one but it also *worked*. However, just because people learn this doesn't ensure that they will be compliant. In order to study the topic objectively, one has to do independent analysis, which is the spirit of this book. We'll start that here by looking first at the historical context.

HISTORICAL CONTEXT

In photography, the historical business model was such that individuals couldn't easily represent themselves directly to buyers because of two major barriers: *cost* and *time*. First, the cost of production, marketing, sales, and delivery of images were such that individuals couldn't make enough money

by manually dealing with each and every client. This was especially true in the days when film was the only medium available to photographers. The infrastructure alone can be daunting: duping and sending film, making prints, producing portfolios, tracking images, billing clients, providing customer service—, not to mention the other costs of maintaining a business. This all required considerable capital investment. To be profitable, one had to move enough product to offset those expenses, and do so expeditiously; the speed of business in days before there was such a thing as "overnight delivery service" (let alone e-mail and faxes) meant profits were subject to the capacity of resources and time—all that while meeting price points established by industry rates.

At the same time, photo agencies, media companies, and other conglomerates were able to build a scalable infrastructure, where they could streamline processes, keep costs down, and increase volume, all of which boosts profitability. This profit margin was enhanced by the time factor, since they could deal with hundreds or thousands of clients at a time, making the aggregate turnaround time considerably better for all involved. There were enough agencies to enable competition, but not enough to lose control of the distribution channel. For this reason alone, most photographers either had to work for a full-time employer or have full-time representation by one or more agencies.

In their course of business, photographers really didn't compete directly with each other for clients; they mostly just tried to get accepted into newspapers, magazines, and photo and ad agencies (which cumulatively accounted for just about the entire photo industry). Getting a job with one of these organizations had never been considered something that fostered a sense of competition among photographers. Once in an agency, they just "worked." In fact, the spirit of competition never really took hold in the industry. The problem facing photographers most was not other photographers or even buyers, it was their own employers.

Because magazines and agencies controlled what images to use and where to use them, photographers really had few creative outlets, much less flexibility in their own futures. This caused a backlash among a select group of now-famous luminaries, led by Henri Cartier-Bresson and Robert Capa. Together with two other photographers, they founded *Magnum* in 1947, as the first photographer-owned and operated "co-operative" (or agency). The founding principle of this organization was that photographers had their own vision of what they could shoot, and, given the latest

technology (small cameras), they could go out into the world and capture it in photos. Their assumption—and they were right—was that every magazine would clamor over them. Magnum's success attracted top photographers from all major magazines, which put the agency in control of business terms and other negotiations. This is the critical point here, and the foundation for how the photo industry views itself today. Magnum became the main go-to repository for news and other life images that were used by newspapers and magazines worldwide for years to come, and it trail-blazed the model where the collective had more power than the individual. They proved that by working together as a whole, all photographers could rise higher than they could if they all worked independently.

This model persisted for many years. As long as the distribution channel was in the hands of the few, and as long as the photographers remained cohesive in their business dealings, there was never a need to change from this model.

DIGITAL PHOTOGRAPHY AND THE INTERNET

But change did occur when two fundamental technologies came to the fore: *digital imaging* and the *Internet*. Digital photography finally had its impact when it surpassed that threshold where high-quality pictures could be obtained affordably by enough people to affect the supply chain. This removed the first barrier for photographers: they were now able to produce a lot of good, quality images to meet demand. But supply isn't enough—one needs a distribution channel to get that supply to buyers. This is where the Internet came in.

Today, the Internet allows high-quality pictures to be distributed directly, instantly, and inexpensively between buyers and sellers all over the world. As the floodgates opened, the supply of images skyrocketed, causing swift downward pressure on prices. This immediately increased the supply of photographers by several orders of magnitude. The entire market ballooned, but it was the individual photographer who was quicker and nimbler than his agency counterparts to meet and conform to the demands of buyers. Furthermore, individuals could do so at lower prices because of lower overhead. Photographers found it more profitable to sell directly to buyers at lower prices than what their agencies were charging. That is, if a magazine used to buy an image from an agency for $100, the photographer got $40 after "expenses and commissions." However, on his own, the photographer could charge $50 for the same image. The rate for

the image in the open market dropped from $100 to $50. This proves an interesting data point: In 1990, 90 percent of images were obtained from photo agencies, compared with 35 percent in 2000. And the trend is continuing. (Keep this point in mind; it'll come up again later.)

TODAY'S CLIMATE

It would follow that today's economic model is simple enough: the supply and demand are high. But what does that tell us about which business model is more appropriate for the photographer? One could say that the photographer could still have sold direct to the magazine for the $100 rate—because *that* was the market rate—and still bypass the agency. True, but to do so would have required an implicit agreement among all the photographers to do so. Then there are the market pressures from the buyers who also put downward pressure on prices. If the photographer wants to make the sale ahead of the agencies or other photographers, or if the buyer wants to negotiate for a lower price, he drops his price. How far? As low as he needs to in order to compete not just with the agency, but with all the other photographers who are also willing to drop their prices. If none drop their price (in solidarity), the prices remain high. So, the predicate question arises again: Is the number of photographers sufficient to sustain this level of cooperation? And, how many non-cooperatives does it take to erode prices? (Remember Venezuela?)

To answer those questions, we must look at economic data to examine how many people are selling images, to whom, for how much, and what those trends are. If the only people selling images are pros who are in complete agreement on pricing structures, this may work. However, if the pool of photo sellers includes non-pros who do not cooperate, this can erode the pricing structure. The more non-pros there are, the less stability the structure has.

Collecting data isn't hard—it's knowing what data to collect, and then analyzing it properly. The first question is, "What data is relevant to our question?" Historically, the data *only* included surveys of photo agencies, photographers, studios, schools, and any other source that had some established business connection to traditional photo buyers. At one time, these were the only ones taking part in the supply chain *and* the distribution channel, so no other data was relevant. But, do those surveys reflect *current* economic activity? If they are based on older models, one

21

might suspect that the validity of the data may no longer apply. So, one must examine two factors: Who's doing the survey? And, does that data meet with statistically viable sampling sizes and methods that reflect today's conditions?

If stock photo agencies are doing this research, they likely are not going to survey people who are buying and selling from non-agency sources. Why should they, if the results might suggest that their own business models may not be sustainable? Sure, they may have accurate data within some segments of the industry, but it may not be complete data that represents the entire industry. Surveys are deemed reliable if the people being surveyed are representative of what the data claims they represent. For example, if you ask what percentage of women voted for a particular candidate, you can't just ask "white women," you have to get your sampling from a reliable source that represents the entire population of women. For our purposes, photo industry data must come from an independent source (i.e., one doesn't look to cigarette companies for reliable data that show the number of people who get lung cancer).

If the photo market has grown to include enough people that the survey methods currently don't recognize as viable members of the study group, then statisticians would say the data tells us nothing. The problem at hand is determining what that "population size" is (of buyers and sellers) in the photo industry today. The hypothesis is that the majority of buyers and sellers are not associated with the industry as it has traditionally been defined.

We can test whether this hypothesis has legs by looking at other industry data. For example, a report on the sales of digital cameras from *Digital Photography Review*, (*www.dpreview.com/news/0407/04073002camerasales.asp*) indicates that 22.8 million digital cameras will be sold between 2005 and 2006, a 42 percent jump from 2003. If one of those nonprofessional amateurs (who isn't currently part of "industry survey data") sells an image to someone, he may not be counted in the survey. But if a million of these people do it only once a year, that could account for hundreds of millions of dollars of economic activity that traditional surveys don't take into account. Taken a step further, a report on CNBC states that over the course of five years, over 100 million digital cameras of at least eight megapixels or higher will be sold. If only one percent of those buyers sells $1,000 worth of photography per year, that's *$1 BILLION* of

sales that isn't accounted for in current survey data, because "the industry" doesn't recognize amateurs in their surveying methodologies.

So, the market may be considerably larger than what survey data currently claim, but we don't know by how much. It's sort of like how physicists know that there is more matter in the universe than what we can see by traditional means: measuring light. They can look at how much light galaxies produce and estimate the number of stars they have. This gives one measurement for the size of the galaxy, but there's a problem. If you look at the rate at which a galaxy spins, it should be flying apart. But it doesn't. Why? The only possible explanation is that there must be some *additional* source of gravity that accounts for the gravitational pull that isn't being accounted for. In other words, dust, gas, and planets, to name a few, account for a lot more gravity because there is more of them than people thought. Even though these objects do not produce light (i.e., "dark matter"), they have a far more profound effect on the universe than once thought. What percent of the universe is full of this material? Estimates are that over 70 percent of the universe is full of this stuff.

Could this be what's going on in the photo industry that current data doesn't account for? We see economic activity that current market surveys can't explain. Could it mean that "non-pros" are having a much larger effect than previously thought? Only if the industry acknowledges this possibility and revises their survey methods will we ever know more accurately what the reality is. Sadly, no one but the trade associations have any financial incentive to do these studies, so industry data is all we have.

TRADITIONAL PHOTO BUSINESS MODEL

The industry does not believe their data to be inaccurate or incomplete. Furthermore, their research concludes that the current economic downturn in the industry is attributed not to nonprofessional photography sales, but to these two factors:

- **Agencies Selling Out**
 Photo agencies have consolidated and, in an effort to gain market share, cut prices on licensed images and introduced "royalty free" images to flush older images that would soon be obsolete and worthless. They have also replaced their "career photographer"

base with cheap, young photo-school grads who are willing to work for pennies on the dollar, allowing for profitability, even from heavily discounted prices.

- **Uncooperative Professionals**
 Photographers who are either too afraid or too naïve to hold firm in pricing and contract negotiations are the second-strongest contributors to falling market prices. This emboldens buyers to force down prices, causing all photographers to suffer.

The industry associations claim that photographers could have more negotiating power and other benefits if only more people were willing to cooperate, forcing buyers to have no other resources for images and to pay the higher rates. They also contend that photo agencies and media companies would also have to stop undermining their efforts. The willingness of a photographer to lower prices in order to make a sale is, according to industry trade groups, making things worse for the industry. A document on the Web site of one of the largest industry trade groups, the American Society of Media Photographers (ASMP), states in their "code of ethics" (*www.asmp.org/culture/code.php*):

"Never advance one's own interests at the expense of the profession."

This statement is perhaps the cornerstone of ASMP's attitude toward the profession, the spirit of which is shared by all other trade organizations.

This again raises the question posed earlier: Is the solidarity sustainable to a point where one can base a business strategy on that stability? The industry feels it *can* be if more people cooperated, and professional organizations still emphasize its importance in their educational programs and literature. Whether they can send this message through the spectrum of industry segments is yet to be seen.

THE MARKET-BASED MODEL

The market-based model for business strategies in the photo industry is based on the premise that the number of photographers is too large to organize and to act in unison to achieve common objectives. Instead, the alternative is to strategize independently based on one's own needs and objectives. Advancing one's own interests yields a stronger base of successful photographers, who do not need to be centrally organized and who are not dependent on compliance from their contemporaries.

Since anyone can and will compete on any set of terms, whether on price, fees, rights, or other conditions, the most successful will not only have established a viable precedent, but also one that can be adopted by others. As technology and other market conditions change, those terms that define a "successful photographer" will evolve naturally.

The Analysis

Industry trade associations claim that the traditional model still applies today. If that is the case, then there are two questions that need to be analyzed. Can solidarity be achieved? And, Does it matter? If solidarity doesn't matter, there's no point in asking whether it can be achieved.

For example, if a tiny airline drops its price between two cities, the major airlines must follow suit because of the perception of the general public. This has been proven time and again, which is why the airline industry acts as it does. And this same economic phenomenon applies to many industries, including photography. Hypothetically, even if we were able to sustain 100 percent compliance among all pros in the industry, a very small number of non-pros that engage in *any* sort of contribution to the supply chain will have an aggregate effect on perception of value among buyers. The higher the number of those non-pros to the total market, the greater the effect on market prices.

The reader is strongly encouraged to look up "The Prisoner's Dilemma" (one example can be found at *http://plato.stanford.edu/entries/prisoner-dilemma/*) to illustrate the point. Take special note of the pitfalls associated with members who *try* to cooperate as a group: they are generally worse off than those who pursue their own self-interests. What's more, the likelihood of someone *not* cooperating grows exponentially as the number of people in the group gets larger.

We now have two pieces of data to take into account: (1) the total size of the photo market is considerably larger than is currently recognized by the photo industry and (2) the number of people it takes to profoundly affect prices does not need to be as high as what has previously been thought. If this is the case, one can question the reliability of a business strategy that depends on cooperation and solidarity among its members that is not legally enforced by government mandate. It's not a far stretch to see the trickle-down effect that goes beyond photo pricing—terms and conditions, contract negotiations, royalty splits, and so on, are all affected by this model. This implies that a more competitive strategy must be employed.

This book takes the position that the traditional model is obsolete, and that to compete competitively in today's market, *especially* as an emerging photographer, you must operate on the assumption that most of your competition *is not* going to cooperate with you or anyone else. The chain is only as strong as its weakest link, which means you need to concern yourself with only one market player: yourself.

AN EXAMPLE

Let's apply this model to a hotly debated subject in the industry and view how each strategy approaches the subject. The issue is a type of contract called a *work-for-hire*. A photographer shoots an assignment as an agent for the client, which means that, in exchange for his fixed shooting fee, he retains no ownership of the images he shoots and is entitled to no royalty commissions. Unstated are the potential advantages and disadvantages of such a relationship. We have two scenarios that illustrate each.

- **Scenario 1**
 A stock photographer usually derives a large percentage of his income from sales of pictures he has already shot throughout his career. Therefore, he depends on retaining ownership and copyright to the photos he shoots for his future income. If he enters into a work-for-hire agreement, he has no future for these photos.

- **Scenario 2**
 A photographer has no interest in getting into the stock photo business, but wants to use the assignment fee from a work-for-hire contract to finance his own studio that he'll use for his portraiture business.

Where does the traditional model stand on this? The industry makes several observations. First, if the photo agency hires the non-stock photographer, then it harms the veteran stock photographer who has been employed for years. Over time, the veterans see their income dwindle because their images are replaced by the newer non-royalty images from the uncooperative photographers. Secondly, the original photographer might have gotten a better deal if he hadn't capitulated so easily; all he

had to do was "stick to the code" and he would have gotten his own objectives accomplished without hurting anyone else. Third, most work-for-hire contracts are unnecessary, because most clients don't really need to own copyright or restrain the photographer from using his images for noncompetitive uses. In summary, the industry calls work-for-hire contracts "bad for the industry."

There are many issues raised here and clearly some of them have merit. First, work-for-hire contracts are found in many areas of the industry, not just stock photography, and many of the hiring agents do not need the copyright ownership they ask for. The industry says to combat this photographers need to unite and agree not to agree to such terms. The free-market model recognizes that not all photographers can be simplistically bundled together like that, and that many *would* find it more beneficial to agree to work-for-hire terms under the right conditions. Therefore, one hundred percent compliance is not possible, hence the desired outcome unattainable.

Whether it is appropriate to claim that veteran photographers deserve to be "protected" from emerging photographers is more of a cultural and social question. In a heavily competitive environment, the veteran has less clout than he does in a more socialist culture. We live in a market-based competitive economy, so there will always be a supply of photographers willing to unseat a veteran. (The only way to truly protect veterans is to have legal protection through law. This would require photographers to unionize, which they haven't been allowed to do since the 1970s.)

Given this, to what degree is it possible, let alone effective, to try to convince members of industry groups to cooperate on a condition like work-for-hire contracts, which isn't universally defined as good or bad? It's good for some, bad for others. The market-based model says that veteran photographers who feel that their royalties may be vulnerable to dilution should leverage the intangible value of their seniority (reliability, skills, etc.) and accept those contracts ahead of the new photographers who will assuredly take them. Smart veterans will also find ways to sweeten the deal. Some might say that this is capitulating to the agencies, but if the trend is inevitable it's incumbent upon those who have the most to lose to work harder to retain what they've got.

Five Truisms of the Photography Business

Whether you believe that the solidarity model or the free-market model is the more effective for building your career, there are certain realities about the industry today that you will have to contend with. I have categorized these realities into a series of axioms that I call "The Five Truisms of the Photography Business." These are not proposals, nor are they subject to broad agreement or voluntary consensus, nor are they terms that you can accept or reject based on your own business models. They are simply factual statements about how the industry works. To what degree you incorporate them into your own career planning is up to you.

1. Truism #1: More people practice photography as a *hobby* than as a *profession*.

 In years past, many hobbyists and serious amateurs rarely sold images into the photo market. Because of the Internet, *millions* of people from all over the world are selling images. Although most are not selling images for a lot of money, their sheer numbers dwarf the total number of "professionals" by orders of magnitude, thereby making the *non*-pro photographer the main driving force on what happens in the marketplace. One cannot educate the amateur or the hobbyist, so it is futile to attempt to shape the nature of the industry by advocating that pros "stick together."

 Amateurs notwithstanding, consider the number of semi-pros who have tried to get into the industry but couldn't because their portfolios were rejected by agencies, or because they had no other representation that could move their images. These people are now rushing in and selling more than the amateurs, who don't even care. In fact, many semi-pros sell more than pros because they're playing catch-up, and, unlike the hobbyist, they *are* serious about the business. So, instead of just selling images, they are accepting assignments under terms that the old pros would never have taken. Both the hobbyist and the semi-professional unambiguously imply this truism:

 "There will always be someone willing to work under less-favorable terms than you."

 Whether it's out of ignorance, or because it is a good deal for them, or because they simply have an interest in photography, this is a fact that you cannot change; the law of supply and demand dictates it.

2. **Truism #2: Prices are based on market factors, not clients' pockets.**

 Historically, assignments and license fees for images were based on "the media buy." That is, an ad campaign may budget for ad space in magazines, billboards, modeling fees, and so on. The price for the photography used to be about 15 percent of the "media buy" (less production costs). As photo buying and selling matured, it eventually got to the point where you might not even need to ask what the media buy was, you'd just know based on the nature of the client. If the client had lots of money, you charged X amount, smaller companies Y amount, and so on. Photographers just got used to pricing product based solely on the size of the company; the deeper the pockets, the more they charged. (The "media buy" calculation is still used in some cases, such as when the "supply" of images is tighter, or the client's needs are more narrowly defined.)

 Because of Truism #1, the market has shifted in favor of the buyer, and one cannot assume that because the client is wealthy the pay is higher. How much clients pay is now based more on market rates, not necessarily their ability to pay. "Market rates" *do* vary, and finding an appropriate fee to charge for any given assignment or license fee is admittedly far more difficult because of the flux in the industry. Clearly, some rates are higher than others depending on the specialty of the shoot or the specificity of the need. That means that you and I have to do it the hard way: by negotiating.

3. **Truism #3: It is not anyone's responsibility to do right by you.**

 Photographers often get upset when clients' contracts are clearly one-sided. Yes, publishers try to "grab rights," or claim copyright ownership, or don't compensate the way they used to. Many respond by blaming the offending client, often refusing to work with them or even attempting to "spread the word" to impose a boycott of some sort.

 It's true that there is a real problem with compensation and other "benefits" eroding from photo contracts; it does need to be addressed. However, there are constructive and destructive ways to go about it. The kinds of reactions noted above are the wrong way to go and are responsible for more misfortunes than just lost opportunities. Photographers also lose face because their collective efforts

fail more often than not to achieve the results they desire. (This is because of Truism #1.) When things don't go well—or not as well as they used to—no one is responsible for this other than yourself.

The more constructive solution is to first recognize that you are an independent entity, responsible for your own business interests and no one else's. One can't succeed in negotiation by simply chanting the mantra, "Just say no," and hoping others fall in line.

You may have heard the expression, "business is business." Like any other industry, successful professionals have a way of justifying their worth to a potential client, no matter how ugly and competitive the market gets. Most boilerplate contracts that photographers receive are written to favor the client and are intended to be negotiated (despite what the client might say). The nature of negotiation is to find grounds for mutual benefit: identify those things that you need and those you don't, and counter-propose terms where each party can get what's important to them. The more you understand the basics of business, the more you can understand the other party's objectives, making it easier for you to express terms that work for both sides.

If negotiation fails, as will happen from time to time, you move on. If this happens to you so often that you can't get work or income, then you've got other concerns beyond whether the industry is "fair." You either need to improve your negotiation skills or reset your expectations for your terms.

4. **Truism #4: Diversify your business.**
It used to be that a photographer's income was derived from one or two sources, where a "source" was considered either a single client or a class of client. For example, a wedding photographer was considered to have one source of income: couples who get married. News photographers tended to have a single source, whether it was the newspaper they worked for or the market segment they sold to. Unless they sold to a cross section of buyers, they were considered to have a single source of income.

As the market has gotten more competitive, photographers have found it problematic to earn a living from a single class of client. Therefore, it's imperative that you diversify your business model. The concept is simple, and it's also easy, for no other reason than photos

are assets that inherently have multiple uses. For example, wedding photographers have a plethora of "people" images that not only can sell into the wedding niche of the magazine sector, but also in any outlet that needs people pictures. (So be sure to get those model releases signed.) Architectural photographers often find themselves on locations with stunning scenery because of the nature of the client's property. So, in addition to shooting the gig, they pick up more pictures and use those images in other business contexts. Sports photographers, car photographers—just about anyone who has a camera—can shoot things that aren't part of the "assignment" or even part of their specialty. When you're doing this, you can pick up a lot of new assets, while the paying client has already footed the bill.

5. **Truism #5: Not all photographers are equal.**
The photo industry does not consist of an unskilled labor force, where all members have equal status, get equal pay, or do similar work. They cannot be clumped together as a "class" of worker for collective bargaining. This ties into Truism #1. When you see more experienced photographers doing better than you, it's usually just that: they're more experienced. This has value, and clients know it.

Now consider how the opposite can happen. Many new photographers come onto the scene by working for less (or for free) to get their foot in the door, sometimes displacing the previous shooter who used to do that job. I've displaced other photographers this way, and others have done it to me. Those that I've replaced should have moved on with their careers before I got there; and those who've replaced me usually did so with my blessing—it was time for me to move on. (Many times I recommend someone to take my place even though the client doesn't want me to leave.) If your career develops properly, you won't get displaced. Your name, reputation, portfolio, and general experience will be justification enough for you to choose which jobs you want and when you want them.

If you aren't moving fast enough, you'll be nudged—or pushed—sooner or later. If you're *that* vulnerable to the younger crowd, your career is already in a precarious position anyway, and you should be looking for ways to broaden your horizons. As I get more experience and solidify my reputation, I lose less and less business to others because of who I am, and my clients are willing

to pay for that. Just about any pro worth his salt will say the same. Sure, we're all vulnerable, but it's impossible to impose artificial protection schemes to keep our jobs.

The business world is harsh, and it's part of the package when you choose to become an independent, working photographer. Recognition of these realities will not only help you consider your business objectives more realistically, but should help you to think about how you should react to a given situation. I apply these truisms to chapter 3, "Photography and Business Sense," after which it all comes together in chapter 5, "Photography Marketing."

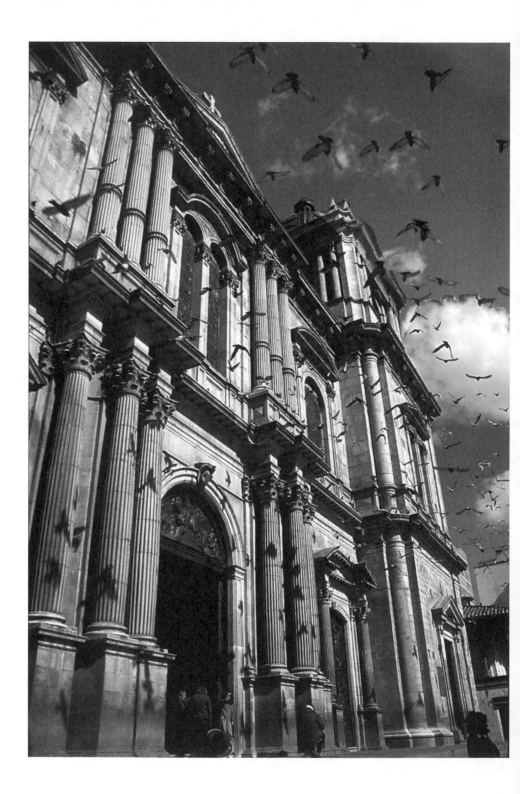

PHOTOGRAPHY AND BUSINESS SENSE 3

figure 1.

If you watch a dog chase a Frisbee and catch it, you could do the calculus to figure out exactly what the Frisbee's speed and trajectory are, and from that calculate what the dog needs to do in order to figure out the precise moment he needs leap into the air. Someone can explain the math, but we know the dog's brain isn't doing that. He just has a sense for it. To anyone doing business, the paradigm of business is an abstraction that "makes sense" once you clearly identify your objectives. The tasks themselves are important, but they are easily learned and become second nature once you get going. Besides, "tasks" don't make a business successful and, despite common belief, they rarely ruin a business either.

Unlike the sample objective of catching a Frisbee, developing a career involves more complex planning, especially because it involves long-term strategizing. The principles of "business sense" still apply, in that you must see the big picture of how all the components fit together in order to achieve results, but we can deconstruct these principles to form a framework that applies in the context of a photo career.

Figure 1 shows the hierarchy of how we think, interpret events, and respond throughout the course of a standard business cycle. Our analysis takes place first at the core level, where we have an abstract understanding of the world. We then form strategies that we feel are either appropriate responses to what we see, or that are proactive actions to be taken in order to obtain goals. The decisions we make are based on those strategic foundations, which represent the actions we take. Each component of this hierarchy starts larger at the base and gets smaller as it rises. This represents that we start out with many choices in our interpretations, strategies, and actions, but end up with a smaller set of choices. If our decisions do not produce the outcome we are looking for, we can make a new choice from the set we started with, or we can

derive a new understanding of the situation and come up with an entirely different set of choices.

What we end up producing in the world—the photos, our marketing materials, the prices we charge, or the terms and conditions we negotiate, must all remain consistent with our baseline sensibilities. If things go well, our sensibilities are healthy, and the more we go through this cycle, presumably, the better we get at it. If our core business sensibility is sound, we "succeed." If things don't go well, it is likely that our analysis of outside events is faulty, which causes us to make poor decisions.

Three Stages of Career Development

Our sense for business is a by-product of our experience with it. The more you do, the better your sense for it evolves. Yet, not all experience is gained through direct encounters; some come from observations of others, others through theoretical teachings. It's the interpretation of what we experience and witness from all sources that shapes our ultimate business sense. This process is much like learning math when we were in school, simple arithmetic being the basic form, leading to algebra, calculus, and so on. However, unlike math, which can be proven and disproved entirely through conceptual equations, the application (and hence "learning") of business is mostly done through trial and error. (Having an education in business beforehand can help, but it's never as useful as empirical knowledge.)

There are three essential stages in developing business sense, each of which corresponds to different stages of career development. (This isn't a coincidence; career development is usually the by-product of having mastered each of these stages.)

1. **Long-term versus Short-term Strategic Thinking.**

 Because most people make decisions all the time, the most active part of this hierarchy is the "decision" level. Accordingly, most people start by thinking only in terms of what they get for the work they have done. You sell a picture and you get money.

 The first step in developing a mature sense for business is learning to see the *long-term effects* of the decisions you make. This awareness often comes in retrospect, after you've been doing the same thing for a while and you can see how benefits (or costs) that weren't apparent before are now clear. Time's role in this is pivotal, because developing a career requires time to experience those events, to

witness the cause-and-effect relationship between decisions and actions, and to develop good analytical tools to objectively measure those results. The sooner you learn sound business analysis in terms of longer term benefits, the more quickly your career will develop.

2. Efficiency and Effectiveness.

As you go through the motions in the first development cycle, your having gone through many actions repeatedly has inadvertently given you some degree of efficiency: writing invoices, making portfolios, shooting assignments, budgeting your marketing plan, designing and redesigning (and *further* redesigning) your Web site, etc. The more you do things, the better you tend to get at them. It's good to build efficiencies into your business, because saving time is critical. Learning how to save time by being more efficient has obvious benefits, but you can get a false sense of security just because things appear to be running "smoothly." Why business isn't *growing* is usually attributed to confusing efficiency with *effectiveness*. More often than not, you probably shouldn't even be doing many of those tasks in the first place, but instead spending time doing other things that contribute more to building your career.

Effectively executing your longer term strategies involves making many attempts. Your first sale is a pivotal event, because you look back on what you've done up to that point and gain an instant (albeit simplistic) understanding of what you did right and what you did wrong. Seeing the cause and effect of your actions and results helps you to formulate what will eventually be the second stage of the learning process: your strategy.

3. Sense of Self.

Experiences contribute to your sense of self, not just in your own eyes, but in how others see you. Maintaining an honest assessment of your failures as well as your successes is important, but understanding where you are in the broader scope of your industry—your competition, your clients, and the market segment you work in—defines who you are (in the business sense). Sense of self does not necessarily imply a *positive* sense, just a *realistic* one. This is not a motivational speech. This is a business reality. You are going to be strong in some areas and weak in others—the smart business person knows his strengths and weaknesses.

By this time, you have developed efficiencies in your methods, combined your methods into strategies, and are applying them to real business growth. Negotiation: Should you bid on an assignment for more or less money? Strategy: Are you wasting time competing for assignments that are beneath you, even if you aren't getting the work? Social decorum: Are you overly confident when speaking in public or with decision-makers? Self-honesty: Were you lucky in getting chosen above others, or was it deserved success? Strategies help guide you in decision-making, but choosing among decisions is best done when you are aware of your own real strengths and vulnerabilities.

Now that we have identified the stages of developing a mature model for business sense, let's get into the details of each.

Long-term versus Short-term Strategies

When newly emerging photographers enter the market, they come from a wide range of backgrounds. Some come from school, others migrate from other careers, and still others drift into the craft, often unintentionally. (Photography being one of the most popular hobbies in the United States means that the idea of starting a photo business may cross one's mind at some point.) However it is that you came to photography, we can assume that if you're reading this book, you've got a sense of your subject of focus.

During those early career-development stages, opportunities will come your way—some will look like great breakthroughs and others duds. But what you see on the surface may not be as it seems. Weighing the cost benefits between short-term and long-term objectives is the most important aspect of smart business thinking. For example, consider this brief list of criteria that is often cited as considerations for a business opportunity:

- **How much does the assignment pay?**
- **What is the price I get for this image?**
- **Are the terms of this contract fair?**
- **Am I losing my rights to the images?**

There's no question that each of these is important, but not every business model requires the same answers to be true for it to be a

"good opportunity." For example, some assignments may pay a high shooting fee, but you don't get to keep the images. Someone who needs immediate cash may find this a good opportunity, whereas the career stock photographer wouldn't find it beneficial. Not all assignments will pay *both* a good fee and let you keep the images (where they license them back from you), though some will. Is it good business sense to *only* participate in those opportunities that have optimal returns? As Charlie Brown once said, "When my ship comes in, I'll probably be at the airport."

Sometimes, it's not just a choice between two conflicting factors, but many at once. I ran into this situation when I was getting started. I had been asked to shoot a film festival. There was no pay, and I couldn't keep any of the images, but I was able to attend all of the events and get into the movies for free. I agreed, mostly because I had never shot an actual assignment before and thought the experience would be useful and it might be good to add it to my résumé.

Many pro photographers said I was hurting their business by lowering the perceived cost for a photographer, and that I should charge money for my services. If I did it for free now, they said, I would establish a low-water mark and would never be paid for any kind of assignment in the future. To me, I saw one main problem with this logic: the film festival simply had no budget to pay photographers; everyone who did odd jobs during the event was a volunteer. In the case of the photographers, most were inexperienced amateurs like me. Hence, if I didn't do it, some other nonprofessional would. So, I wasn't hurting anyone's business, nor was I establishing a low price point for my services. Instead, I was simply gaining experience.

What I didn't expect was to be in front of filmmakers and others who, by the nature of their industry, became potential business opportunities for me. Best of all, I had almost no competition around me— the professional photographers boycotted the event, and everyone else was a non-pro with no interest in getting more photo work. Through the people I met at this event, I generated about $5,000 worth of new business over the course of the next year.

This example illustrates that longer term benefits can outweigh the lack of short-term financial gain if you use them to your advantage. But it is equally important to maintain perspective. Today, I no longer "need" to shoot assignments for free, since I get work from clients who

are willing to pay my rates because they know what they are going to get. However, my analysis of business opportunities hasn't changed.

Assignment Evaluation Checklist

Knowing when to say "yes" is where the "business sense" comes in, just as it is important to know when to say no and move on. It's really not an issue of pay anymore; there is a more complete checklist of items that I review before I turn away any assignment.

- ❏ Is the pay too good to pass up? (Assuming there *is* pay?)
- ❏ Are there "resale" opportunities in the aftermarket? (e.g., stock photography)
- ❏ Is there sellable "art" that could be produced?
- ❏ Is there great credibility or other marketing aspects that can be leveraged due to the nature of the customer, the event, or the subject?
- ❏ Is there experience to gain in this area?
- ❏ Is this an entry into a niche market that is hard to penetrate?
- ❏ Is this pertinent to my specific career path or subject matter?
- ❏ Does this cost me time, money, or other restrictions or distractions?

I consider *all* possible ways I can make any given assignment favorable before I let it go, but that doesn't mean they carry equal weight. The values you attribute to each are dependent on your individual career goals. My only warning is that a disproportionate weighing of any one factor is often a sign of overly focusing on short-term strategies. For example, if you dismiss an assignment simply because it is a work-for-hire contract, without even considering the other items, you're not thinking strategically. Having good business sense means that you favor long-term opportunities.

JUMPING IN TOO SOON

A related problem that emerging photographers suffer from arises when their eagerness to get into the business allows them to conjure up all sorts of phantom justifications for any idea that will just get them going. This

is what I call the *solution-looking-for-a-problem* syndrome. (Psychologists call this *functional fixedness*: when all you have is a hammer, every problem you see is a nail.) For example, I once knew a photographer who was talented, creative, and in all ways proficient, but she really had no strong basis for what she wanted to shoot. Because she had good pictures, she felt that anyone would be interested in publishing them. She had a solution (her pictures), and she was merely looking for the problem that matched (i.e., a publisher that liked her work). One day, she was bursting with excitement about the following idea: "There's this art festival I saw when I was on vacation that's *so great* that travel magazines would just love it! I'm going to go back and take a lot of pictures, and sell them to editors, because no one else is covering this event!" She was so convinced that her enthusiasm would be shared by others, that in her mind it would only be a matter of unearthing this latent demand by showing the pictures to photo editors.

It's easy to conjure up successful scenarios to justify your desire for doing work. But this type of self-assuring rationalization is what leads to dead ends. Enthusiasm for your subject does not mean that there is a market for your pictures. What's a better "business case" to make? Let's say my photographer friend follows art festivals everywhere, and has insights into the social fabric and behind-the-scenes views on the inner workings of the culture. She also knows the magazines and other media outlets that normally follow this sort of thing, so she has a more intimate knowledge of the kind of interest this story would generate. Not only does the analysis of the "opportunity" have a stronger foundation, but a potential buyer would also appreciate the views from an experienced expert, who would tell a more compelling story than, say, a tourist who happened to be at a neat event. Best of all, her credibility within the art industry would give her a significant advantage over competition in the sales effort.

My friend's long-term objectives had not been defined yet; she was driven solely by short-term goals that were unlikely to succeed. And even if she were able to publish some photos, they wouldn't really amount to much. Career building involves capitalizing on previous successes to leverage future plans, rather than floating from one idea to the next without a coherent plan.

It's easy to get excited about business ideas and prospective opportunities, but you can see signs when you've become distracted. A common

example that I see on most amateur Web sites is when photographers try to sell 4 × 6 prints. First, prices for such sales are so low, that the time necessary to fulfill product orders doesn't justify the income—the infrastructure required to do volume sales would require a considerably intricate business model. Furthermore, you can't get to that level of sales until you have sufficient traffic to your site. To get *that*, you have to invest a lot of time into doing other things to build your business. In the end, if you were doing those activities, you wouldn't be bothering with sales of 4 × 6 prints because you wouldn't have time. If you're thinking that such sales don't hurt in the early days, you're also not taking into account the perception held by more serious photo buyers and agencies who hire photographers. Sure, consumers may spontaneously buy a 4 × 6 print, but this isn't growing a business.

The broader point is that long-term strategic thinking involves looking at every moment of time you spend, and justifying how it contributes to growth. We'll return to this subject later in this chapter.

REALISTIC TIMEFRAMES

Assuming your business strategies are sound, you have framed your imagery around a subject you know intimately and you are good at weighing your long-term benefits wisely. It may now seem as though your photo business is just a matter of setting up shop. After all, you've got the foundation that justifies the business model, and perhaps you've inadvertently made a modest income by selling photos or have been asked to shoot assignments. But it's here where people make their next fundamental business misjudgment: the assumption that if you're already getting a little business with a little effort, then *just a little more effort* could turn into real revenue.

This is what I call the *low-hanging-fruit fallacy*: the false illusion of an optimistic future generated by easy sales early in the business cycle. It's easy to pick the low-hanging fruit, but that will soon run out, and the rest of it will require real work. In reality, there is a rather high hurdle that separates the time, work, and effort required to *start* a photo business from the making of a self-sustaining and viable business. That is, the growth curve isn't linear, and what often happens is that people get too optimistic when the quick sales happen right away, only to be completely unprepared when the low-hanging fruit runs out. A common example is when someone tells her friends she is starting a portrait business and she

gets all her friends and family as first clients. Words spreads, and things seem to be running fine, but after the first round of easy sales has been exhausted, business dries up. I have seen many amateurs, many of whom are far more talented than I, simply give up because of the frustrations and pitfalls that follow after an initial boost. Success isn't easy, and one should be wary of any successes that seem "too easy," especially when it happens quickly.

To keep a business going beyond the first few rounds, one needs not only to see the long-term strategy, but to begin to make effective decisions that realize those goals. In the development cycle of business sense, the first level may have been achieved, but the second level hasn't yet. Let's discuss that next.

Effectiveness and Efficiency

Your most valuable resource is *time*, and how you prioritize and implement your strategies will determine the rate and degree of your success (or failure). Prioritization is choosing strategies that are effective. Doing them smartly, cost-effectively, and in a "timely" manner is efficiency. Or, put another way:

- Efficiency is getting the job done right.
- Effectiveness is getting the right job done.

Both are critical, but don't confuse one for the other. Whatever you're doing at any given time means that you're not doing something else. Are you doing what needs to be done? Might something *else* be a better use of your time? When emerging photographers fail to achieve this balance, it's because they either choose to do things they "like" (or want) to do, or to do those things they incorrectly prioritize (even if they're bad at it). This is a phenomenon that I call *peddling in first gear*. When business stagnates, it's because of the circular dependency of feeling that business can't progress until other tasks are done first, which never get done because business isn't progressing.

A photographer I know shoots weddings at moderate prices, but does it all using a single mid-range zoom lens. She has no portfolio, no Web site, no contact information available, and limited equipment (her camera and *one lens*, no flash). She gets business through other photographers

who send her jobs when their own schedule gets too full. Between her day job and weekend shooting, she is doing "well enough" that she isn't suffering, but she is clearly aware that her business isn't moving forward. She attributes this to a variety things: the wedding-photo business is saturated, the pay is going down because new photographers are willing to work for so much less, the economy is just too tight, people aren't getting married as often, etc.

Because I know her, I see what's going on at home. She spends most of her time repeating the same tasks over and over: when she writes an invoice, she starts from a blank page in her word processor and redesigns the entire thing from scratch, unaware that she can make a template. She's constantly recalculating her budgets, cleaning her studio, and calibrating her monitor. All these activities are justified because, she says, "When business comes, I'll be prepared." Why not invest in other things first? "That costs money, and I'll spend that money when the business can pay for it."

You and I can see all sorts of things she's doing wrong, and a bunch of things she should be doing to move forward. But, don't let your ability to see the fault in other people give you the false confidence that you'll see it in yourself when it happens to you. Those who get stuck, including (*especially*) the pros, never see it in themselves; they always have rational reasons for their lack of progress.

Choosing between tasks is easier when you're the objective observer. You can see that my friend doesn't need to be calibrating her monitor all the time. But, will it be so easy to see when you find you don't have enough time to do things that seem important? Will you make a portfolio to send to the art director, or will you get that Web site up and running? Making tougher decisions is where the exercise gets more challenging. We'll be looking at this in more detail in chapter 5, "Photography Marketing."

Sense of Self

If you've established a good foundation for your business and are doing everything right as far as you can tell, and business is moving along just fine, it's easy to think it's all because of your having good business sense. Well, sure, you probably do. But, then, here's an uncomfortable reality check: the next stage of business development is coming to the realization that you're in a very competitive, unforgiving business, where your

main product is *art*, and no matter how well you can articulate a business solution to a client, your product is still subjective in nature. Your client either likes it or he doesn't, and there's no science to it. When you're getting started, there are a lot of photographers that make great art, but not all of them will be successful. To some degree, you just get lucky. Even beyond the art world, one of the most famous and richest financial wizards in the world has acknowledged luck's value:

"If you can get rich either by luck or being smart, I'd choose luck every time."
—*Warren Buffet*

Your job is to diminish luck's role as you and your business mature. Part of having good business sense is knowing when luck ends and "deserved success" begins. The reason this is the final stage of development is because you may hit a dead end in your career if you don't really have a good sense of yourself that gets you by in tougher times. You may have good strategies and your business decisions may be adequate, but, as pointed out earlier, you come up with a lot more ideas than those you actually act upon. When your career is stuck, it could be that you are stuck in a narrower pattern of decision-making that isn't serving your goals, and it's all because your self-perception doesn't match what the outside world thinks. The graveyard of business failures is populated with many who look back regretfully and say, "I got too arrogant for my own good."

Consider this example: You are a talented but inexperienced photographer, and you send your portfolio to a series of art directors and ad agencies. After a few days, you get a call and are given an opportunity to bid on an assignment. Normally, this gig is given to experienced shooters, but it turns out that the usual list of photographers is unavailable and the art director liked your portfolio. This particular job is with a reliable client who's willing to take a chance on new talent, so the job is yours if your bid is accepted. How do you handle it?

Do you bid it straight up, as if you were one of the regular go-to shooters? Do you underbid a little in acknowledgment of your inexperience, or do you push it a tad higher because you know they're in a bind? There is no right or wrong answer here—it's a rhetorical challenge to get you to think in terms of yourself. You should review the "assignment evaluation" checklist earlier in this chapter as a guide, since a lot of those

items compel you to take into account your own sense of self. If you're right about yourself and your assessment of this opportunity, your actions will match the expectations of the client, and you'll get the job.

One very important factor in this scenario that you need to consider is the fact that you were chosen because of *potential merit*, not *realized merit*. Being hired for potential is great, but it's still a factor of luck—many people have potential. *Realized merit* is "deserved," merit you have earned from proven experience.

Compare this with a more challenging scenario: The art director's colleague highly recommended you as an experienced photographer, and you are then asked to bid on the assignment. Same questions as before: How do you bid? Here, your "deserved success" is present in both cases: the portfolio was strong *and* you were chosen as a known entity. What's more, your portfolio was not sent unsolicited *and* the client is in a bind because their regular go-to shooters aren't available. If you think it *is* a good time to bid higher, you may be right, but here's where people get ahead of themselves: you're still an unknown entity to that particular art director. If you want to establish a longer term relationship, this may affect your bid. If it's a one-time job for good money, you may bid differently.

> There was a survey done by the Department of Motor Vehicles in California in which people were asked to rate their own driving skills on a scale of 1 to 5, where 3 was "average" (on par with other drivers). Seventy-five percent of the respondents rated themselves a 4 or 5, whereas only 10 percent rated themselves a 1 or 2. A true bell-curve distribution dictates that most people should rate themselves a 3, and the number on either side should be evenly divided. The survey shows that people think more highly of themselves than they should. It has been repeated in different demographic groups for different activities and job functions, all yielding much the same results.

As your business grows, no matter how talented or smart you are, having the abilities to distance yourself *from* yourself, to see your own misgivings, and to see your situations objectively, are all critical to making better decisions. An inflated sense of self can be your own worst enemy, just as diminishing your own value can be equally crippling. Strive for

accuracy in self-perception, not just an ego boost. If you do this well, you may achieve a level that everyone in any art form hopes for: *name recognition*. (This is dealt with in detail in chapter 5, "Photography Marketing.")

ROLE MODELS: THE RISKY WILDCARD

I'm going to take an aside here to discuss a subject that's related to sense of self: *sense of others*. More precisely, the sense of other pros. Beginners in the photo industry invariably look to successful photographers as role models and for advice or inspiration. But blindly following them can be fraught with pitfalls. Are successful photographers really so much *more* talented or deserving than many of their peers who aren't as successful that their strategies are worth emulating? Were their conditions similar enough to yours that you should follow without question? Consider this fact: Failing photographers usually do the same sorts of things to develop their career as the successful ones do.

When it comes to listening to business advice, the analogy I like to draw is "the room full of lottery winners." If you take all the people who won more than one million dollars in the lottery and assemble them in a big stadium, most would claim to have "some technique" for picking winning numbers. But we know the truth: they were just lucky. (You're with me on this, right?) The fact that they are all together gives the illusion of credibility. Quote time:

"Even a clock that doesn't run is right twice a day."

It's important to understand that *anecdotal evidence* of success does not demonstrate a pattern. Analysis of advice should be tested across a wider sampling of the population, not necessarily just the one pro, or even the stadium full of lottery winners. This invariably leads to the bandwagon effect, that phenomenon where everyone does the same thing because that's what everyone else does. It's understandable, because it feels safe and reliable. When the 9/11 Commission gave its report on why the intelligence got it so wrong when they thought that Iraq had weapons of mass destruction, it made this classic comment:

"When everyone around the table says the same thing, you know someone's got it wrong."

Photographers have a tendency to succumb to group-think as information trickles down from the top. Advice often goes unquestioned, without scrutiny, and without unbiased analysis. Having good

business sense means that you see the pitfalls in any given advice, not just the benefits. Having the ability to argue both sides of a position, or being able to articulate both for *and* against a postulate, is a form of good business sense.

For example, I've heard pros say that their job is to be the "creative talent," and the rest of the tasks should be done by outside professionals who are skilled at such matters. The reason this doesn't work for the independent photographer is that there is loss of control, efficiency, and effectiveness. Obviously, you aren't an expert in every field of business, and outside help is critical and necessary sometimes—you need to rely on others' expertise. But if you don't know exactly *what* needs to be done, *why*, and *how*, then I guarantee that it won't be done right, even by professionals with the best intentions. Outsourced "tasks" aren't just robotic activities that someone does for you. Strategic business decisions need to be made that affect how each of those processes are done. You need to understand the ramifications of those decisions with their help as advisors and experts, not as hired hands who do the job for you. Hiring a lawyer for $250 an hour will cost you thousands more if you just leave matters in his hands. Worse, he may be ineffective simply because he doesn't have your long-term business objectives in mind. (Nor might he be able to identify with them.) If you don't know this stuff, your lawyer is not going to be able to advise you in any helpful way.

When you get outside help, your job is to learn as much as you can from these people so you can use them sparingly, if ever. And if you do need them, you will know why and can direct them efficiently.

My Business Model
To put all of this into context, I will describe my basic business model. First, I picked up photography as a hobby, as many other people do, on vacation. I took a lot vacations in the nineties, and I simply found that I liked the photographic process. In 1995, I put my first personal Web page together, where I posted images for friends and family to see. It wasn't long before I engaged in discussions with other photographers, from which I learned tips, and eventually I took it more seriously by buying a real camera. By 1997, I had started getting print orders, and not long after that I was getting license requests from corporate clients. By 1998, it was clear that I had a real business going, and this was also

when I got my first "real assignment" from one of the travel companies I used to travel with as a paying tourist. This is when I decided that I had transformed my photography into a career.

One could say that from the beginning my business has always been a Web-only concern, where most of my revenue comes from online sales. This doesn't mean that I don't engage in other offline marketing or promotional activities as well. I do. But the main goal is to bring that target audience to my site. So, my main checklist item is if there are stock/resale opportunities. Because my site is all I need, my marketing activities do *not* include sending mass mailings to unknown clients, or unsolicited portfolios to photo editors or art directors, or mailing postcards directly to buyers in hopes of getting new clients. For me, the cost benefit never justified those efforts or expenses (see chapter 5, "Photography Marketing"). I repeat: *for me*. Because the Net was already doing such good business for me, I didn't have the need to spend the time and resources in other ways. Most of my business is so saturated that it has never been a matter of getting "enough" business; it is more a matter of improving the efficiency of it, so that I can reduce the amount of time I need to spend on each sale.

I break my sales down into three categories: *stock*, *assignment*, and *fine art*. As per Truism #4 (see chapter 2, "The Five Truisms of the Photography Business"), I diversify my revenue across as many market segments as possible that lie within my photography specialty, style, and business model. This allows me both to spread the risk appropriately and to optimize the total return without diffusing focus. There's always a tradeoff in that delicate balance, which takes some time to discover for oneself. However, following the checklist outlined earlier allows that discovery to evolve naturally.

- **Assignments**
 While assignments only represent between 5 and 7 percent of my revenue, they provide images that fuel the remaining 95 percent of my sales. As before, I continue to shoot for active, adventure-travel outfitters who send me on trips with other guests so that they can use my pictures for their marketing. I shoot the entire experience: the country, the places where we stay and eat, the culture, people, architecture, whatever. The client uses these photos in their catalogs, direct mailers, or anything they create to promote their business. That's where my relationship with the client ends (except

for recurring assignments). Where the bulk of my business picks up is from the aftermarket sales of those same images as fine art and stock photography.

For a broader perspective of the market, there are many other kinds of models, such as wedding and portrait photographers, who pull in 90 percent of their revenue from assignments, and 5 percent or more from other sources like stock or print sales. What's more, a name-brand shooter in strategically placed markets or industry segments can make a respectable living. There are many models to choose from, so don't get caught up in thinking that mine or any other singular approach is "correct."

• **Print Orders**

About 40 to 50 percent of my business comes from selling "fine art prints." Briefly, I define fine art as a custom-made print that *I* produce and whose use is solely to display as artwork. This is my highest margin sale and most consistently priced. It's also the most efficient sale, since it takes no negotiation, no sales pitch, and no product delivery or follow-through. The order comes in, it's done, I move on. One doesn't have to try hard to illustrate the fantastic advantages of selling online. The question isn't "whether" to do it, it's how you get the orders, and what are the best price points.

Upon observation, you may ask, since fine art represents so much of my revenue, and it's easier and quicker with less overhead than other types of sales, why don't I price (and market) my "art" more aggressively to yield higher volumes? The reasons I don't are somewhat complicated because it's not just a see-saw of price versus volume. Other costly factors get involved as prices fluctuate: time and other customer service matters emerge as prices drop, because "consumers" become the audience. These are the "tire kickers," where the amount of time and resources necessary to provide customer service, shipping, and other things that go wrong in the day-to-day running of affairs can eat you from the inside out. Worst of all, there is a lot of time consumed with queries that don't lead to sales. Higher priced images appeal to a very different kind of buyer, making a smoother sales cycle, but one runs into another example of the law of diminishing returns: if prices are too high,

sales drop. So, the tradeoffs are challenging, but more frustrating is the fact that there is no reproducible formula.

What works for others never worked for me, and what works for me hasn't shown much success with others. My explanation for this is nonscientific, but I suspect that the nature of my imagery, topics, style, marketing idiosyncrasies, and other factors all create a unique demographic specific to me. Thus, my price points work with that demographic.

- **Licensed Images**
Thirty-five to 40 percent of my business comes from licensing images for commercial use. Those who license images span the spectrum in diversity, ranging from traditional media (publishers, newspapers, magazines), to consumer-product companies, to government agencies, all the way down to a small church in the middle of South Africa. The number and types of people who license images seem virtually infinite. Licensed images are usually priced and sold depending on use: advertising brings in the most money, usually several thousand dollars for one-time use in a catalog, whereas a small regional newsletter may only bring in $100.

Selling images for licensing is called *stock photography*, and that's an enormous subject to cover. For more on this, see chapter 8, "The Stock Photography Business." The price points for stock photography is also a bigger, more complex subject, which is addressed in chapter 6, "Photography Pricing."

CAVEATS TO MY BUSINESS
I've been asked why I don't charge more for my assignments. Yet, my assignment rates go up all the time; I just do fewer assignments, making the ratio of total sales appear smaller. So, it's not that I don't charge enough; I use assignments to leverage the growth of other revenue streams, which are more profitable when measured by the time and effort necessary to produce each dollar earned. My assignments are the goose that lays the golden eggs; it's unwise to overfeed the goose if its egg yield is already sufficient. Today, I only do a couple travel assignments a year, whereas before I did up to six.

Clearly, my long-term objective is to fill my stockpiles of images through my assignments. But that doesn't mean that all assignments

have value or are created equally. There are tradeoffs. I retain copyright and the right to relicense the images in the aftermarket, making the reciprocal value between me and my client beneficial. An assignment that doesn't let me keep the images must make up for that lost revenue somewhere else (usually in the assignment fee). Review the checklist earlier in this chapter.

I've done work-for-hire assignments where I don't own anything and don't have any relicense rights, but I also get paid $10,000 and more for a one- to two-day shoot. Those are great revenue generators that shouldn't be dismissed out of hand. They're just not part of *my* long-term strategies, but that doesn't mean they can't be part of yours. If your business model is to become well known for such assignments, you don't need to worry about stock photography and sales; you can earn good money if you get one assignment a month. (But don't get your hopes too high on that one; if it were that easy, everyone would do it.)

I made reference to the expression "well known." The reason some photographers can get $10,000 assignments is because they are well known in their market segments—fashion, for example. To get there, part of the business strategy has to be name-brand generation, as I discuss in chapter 5, "Photography Marketing." This is not a simple thing to do, but it's also not out of reach for people. I happen to choose a business model that doesn't require name recognition because I don't do well with notoriety. There's a personality style necessary to go along with that, and I don't have it. If you value this benefit *and* your personality allows you to develop "fame" in that way, you might choose a business strategy that leverages those traits in you. Again, this reinforces the notion that there is no one business model that's right for every photographer.

How much time does it take to develop a photography business so that you can make a living at it as your sole source of income? Should you quit your day job yet? What kind of time expectations should you have? There are *many* different kinds of photo businesses, from the portrait photographer in the mall, to the press photographer for the local newspaper, to the stock photographer out in the field who takes pictures of nothing but birds. Every field of photography has a different degree of demand for such products, different competition, and different regional variances that make the work more or less worthwhile as a career objective. What you develop your career into is entirely up to you. But it won't go anywhere unless and until you develop a sense for business.

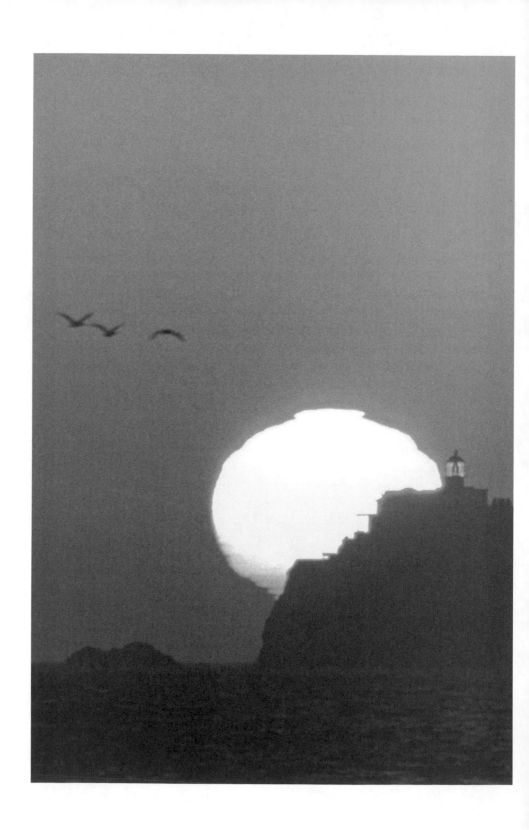

Starting a Photography Business 4

However you envision your future in photography, if you're going to make money at it, you're likely to start your own business. That's right, you're going to be an independent entrepreneur, where you set your own hours, are your own boss, and watch TV late into the night as you clip your toenails. And if you thought *that* was fun, just wait, because now comes the fun part: doing your taxes, writing contracts, collecting money from clients, paying your bills, and dealing with attorneys (yours and others). The good news is that I'm not going to get into any of that here. Volumes have been written on those subjects, and it's beyond the scope of this book. However, where I can be of service is to help you understand the principles behind these aspects of the business in order to clear up common misunderstandings and put you on the right track for moving forward. On the bright side, this isn't all that hard. Running a business is sort of like riding a bike: once you learn, you wonder what the fuss was about.

De-*Myth*ifying the Photo Business

First things first: despite many Internet rumors, you do not need a permit or license of any kind to qualify as a "professional photographer." Selling photographs or photography services requires nothing more than your desire to do so. The only thing that really matters is how you intend to have your income and expenses affect your tax returns. And that's where the IRS comes in. The agency has only one interest: whether you are *properly* paying (or not paying) your taxes.

The IRS and other legal entities use certain metrics to determine whether you're a bona fide business or just an enthusiastic hobbyist, or possibly even a criminal trying to evade taxes. Assuming you're not a criminal, the greatest concern you should have about the IRS is that it determines that you only have a hobby, not a business. Difficult as it may be to believe, there are those who spend a lot of money on photography, call it a business, and use their expenses as deductions against other income. There's nothing wrong with having a photography business while you have other income—the IRS just wants to make sure you're

55

not lying about your motives and inappropriately deducting expenses that are not business related. After all, people gain extra income selling stuff on eBay all the time, even photos, and many of them do not have businesses. Whether or not the IRS thinks you really just have a hobby (where you aren't allowed to deduct expenses) is by both specific and ambiguous means. In general, the IRS looks for the following:

- **Receipts**
 This almost goes without saying, but it's important to know that it's not just having receipts that matter. They look for *patterns of behavior*. Are you consistent in what you deduct? Are you thorough in your accounting? Is there a consistent correlation between the kinds of things you deduct and the kinds of income you declare? For example, if you're deducting expenses associated with trips to Hawaii, but your "photo-related income" is only from wedding assignments in your hometown of Tulsa, Oklahoma, the IRS might send some people over to ask you a few questions.

- **Separate personal and business expenses *and* activities**
 Again, it's all about patterns of behavior. Car receipts are always what people hate (and the IRS loves). If you're going to deduct your car and its expenses, you need to log mileage when you drive on business-related activities to demonstrate a correlation between expense activity and income activity.

- **Filing the *right* tax returns, and doing them properly**
 When you collect your receipts for the year and total up your income, you need to summarize all this for the IRS. Depending on the type of business you have, you attach an appropriate schedule to your personal tax returns. Many photographers consider themselves "sole proprietors," which requires filing a "Schedule C" along with tax returns. This does *not* change your tax obligations in any way—you still pay taxes on income (and deduct expenses). It's just that this formality separates your business dealings from your personal ones.

- **Consider incorporating**
 You might consider incorporating your business to further establish it as a separate entity. This is the most secure way of protecting

yourself from the IRS ruling your activities as a hobby, although it's not foolproof (since cheaters are known to use this method as well). Incorporation involves more paperwork and other administration overhead, but there are many other benefits to incorporation, which may include tax savings and legal protections. So, there's a tradeoff, and although incorporating is not for everyone, it's worth looking into if you feel strongly about aggressively pursuing your business.

So, myths aside, let's start the discussion with some preliminary framework.

Are You a "Pro" or Just a "Hobbyist"?

Regardless of what *you* claim to be, the IRS and other legal entities use different metrics to determine whether you're a bona fide business or just an enthusiastic hobbyist—or possibly even a criminal trying to evade taxes by masquerading as a professional for the purpose of deducting expensive vacations to offset income that would otherwise be taxed. So, the first decision you need to make is, which one of these are you?

The main risk in having a photography business is having the IRS determine that it is really just a hobby. That is, many people spend a lot of money on photography, call it a business, and offset expenses against their otherwise taxable income. So, if you're losing money in your photo business, you have a lot more to worry about than just the fact that you have less. The IRS might want to come and take *more* in the form of penalties, back taxes, and interest on the taxes you should have been paying against your other income. Yes, you may be stunned to learn that there are actually people out there living it up on vacations and fancy dinners, not really taking pictures, and writing off all those costs as "business expenses" (wink, wink!).

This all serves as another reminder that forming a business requires a concerted and intentional effort to take it seriously, and while that may be vague and/or ambiguous at times, especially in the beginning, the business is perceived to be more legitimate when you follow established guidelines sanctioned by the IRS. I will cover many of them here, but you are encouraged to do additional research, since there are state-by-state laws that you may need to know. A great resource for more information (which includes necessary forms for filing a corporate

papers and tax election status) is *Books on Incorporating*, published by Nolo Press (*www.nolopress.com*).

All that said, you are certainly allowed to treat your photo hobby like a business and still not actually form a business entity. For example, if you're selling prints on eBay, you can do this in your spare time and just file a Schedule C with your normal tax returns. (This is the form that declares "other" income.) If you sell something that requires "sales tax," you may need to do a few things with your state's local franchise tax board. But these don't necessarily require you to "start a business."

Deciding Your Business *Type*

Assuming you are not going to be a full-time employee of another company, and you are going to start your own business, pay taxes, pay yourself, and be responsible for the day-to-day running of your new enterprise, you now need to make the next decision about your business *type*. You have two choices: to be a *sole proprietor* or a *corporation*, although a corporation has various subtypes that you can choose from. Here's where the fun begins.

SOLE PROPRIETOR

Most freelance photographers typically consider themselves "self-employed" or "sole proprietors" and file a Schedule C on their tax returns to reflect business expenses and income. Anyone, doing any kind of business, can be a sole proprietor, including bookkeepers, construction contractors, videographers, journalists, independent cooks, contractors, or Web designers. One can even form a partnership with one or more people and still maintain sole proprietorship status on his personal tax returns. However, such relationships are better managed through another vehicle, the limited liability corporation, which is discussed later.

The sole proprietor method is preferred mostly because it has the lowest administrative overhead, and the tax filings are not much different procedurally from how individuals normally do them. If your photography business is profitable, or if you don't plan on selling the business in the future, this may be the *simplest* form of business. There are caveats (listed later), but if you are willing to live with them, and don't need the added protection of a corporation, then this may be your best option. But keep in mind that "simple" isn't always the most appropriate. Before you decide, consider the other options.

When you form a corporation, you assume a new paradigm for how you run your business. In essence, you have given birth to a new entity, at least in the eyes of the IRS. While they won't send you any congratulatory cards, your new child will be given a new social security number, otherwise known as the *corporate tax ID*. This is your hint that this new business is going to have a virtual life of its own.

While you may have already picked a name for your new offspring, you also get to make a choice that you can't do with human babies: you get to choose its sex. In IRS lingo, that's called the "tax status." And, thanks to creative legislators, you don't have only *two* to choose from, you now have *three*: the traditional C-corp, which is what most people are familiar with; the S-corp, which is used for "small" businesses owned by one person (or a small set of people); and the LLC, or limited liability corporation, which is kind of a hybrid between the "S" and C-corporations. Let's get into each of these as briefly as possible. (I know, you're getting woozy —that's why we're not going to cover Limited Liability Partnerships.)

The "C" Corporation

We'll start with the C-corp, because nonbusiness people are most familiar with this one, allowing us to establish the concepts quickly. Most companies you know are C-corps: Coke, Gillette, McDonald's, AT&T, Microsoft, and even Enron (*"Even* Enron?!" you ask. I point this out because, although it is bankrupt, it hasn't changed its corporate status.) Briefly, in the C-corp, the company makes money and pays taxes on it. If the owner of the company takes any money for himself (so he can live), then he pays tax on that income just like any other paycheck. That is, the company pays income tax on what it earns, and the money it pays to shareholders (as salary or dividends) is taxed again and paid by the individuals who receive that money. For big companies like Coke, this isn't so difficult. But, for individuals who own their own companies, the same money is essentially taxed *twice*, because the same individual owns both sources of cash. We'll illustrate this simple but frustrating math next, when we talk about the S-corporation.

The S-corp

The S-corporation was designed to alleviate the problem discussed above. Individuals who own their companies can earn money and only pay one tax rate. Here's how it works: whatever money an

S-corp earns or loses, it is declared on the shareholder's tax return, who pays the tax (or deducts the losses) as they would earning a regular paycheck. So, let's review some scenarios about how this tax consideration unfolds:

Example 1
- You personally earn $50,000 a year from various sources (a job, stocks, etc.).
- Your company loses $10,000 in operating income.

If you were a C-corp
- You personally pay taxes on $50,000.
- The company has a "tax loss carry-forward" of $10,000 that it can deduct against any earnings it may have in the future.

If were a S-corp
- You personally pay taxes on $40,000 (your normal $50,000, minus the $10,000 loss) from the company.

Example 2
- You personally earn $50,000 a year from various sources (a job, stocks, etc.).
- Your company *earns* $20,000 in operating income.

If you were a C-corp
- You personally pay taxes on $50,000.
- The company pays a corporate tax on $20,000, but the money *stays* in the company.
- If the profits are paid to the shareholders (you), you pay taxes on $70,000, but the payment of that "dividend" is an expense to the company, which would reduce its profit to zero, eliminating its tax obligation.

If you were an S-corp
- You personally pay taxes on $70,000.

For those reading outside of the box, there are several things to notice. First, your out-of-pocket tax payments are less in an S-corp if you

personally have "other" income at all, your company is an S-corp, and your business is losing money. Second, your out-of-pocket tax payments are higher if you have the same conditions, but your company is a C-corp, and it's *making* money. Anyone reading this can quickly do the math to see that those with lots of losses can offset personal income with an S-corp. One way the IRS helps to deter cheaters is by requiring a minimum tax payment for "S" companies, regardless of profitability. Specifically, S-corps are required to pay $800 a year, profit or less. (This amount varies on the first year, and it seems that tax codes may be changing again given the volatile political landscape of the twenty-first century.) You have to do the math for your own circumstances to see how much money your company has to make for this $800 to be a wash, loss, or benefit, since it depends on your personal income tax bracket.

One aspect of this that shouldn't be overlooked is that, like the C-corp, "S" companies can have multiple owners (shareholders), but only up to thirty-five. If you start a business with one or more partner, you can all participate in the S-corp. Here, the distribution of profits (or declaration of losses) is passed through to the shareholders in accordance with their percentage of ownership. There's nothing magical about this, it just means that each person's tax return needs to slice up the company's return corrctly.

Obviously, the advantages of forming an "S" versus a "C" company require planning wisely. This is when it is important to review these features with your accountant.

The Limited Liability Corporation (LLC)

To wrap up the different corporation types, we come to the LLC, or limited liability corporation. This is a combination of an S-corp and a "partnership." It is intended for those who have more than one partner or investor. From a tax perspective, the LLC is identical to the S-corp: profits flow through to the shareholders' tax returns, but *unlike* the S-corp, the *distribution* of those funds does not have to reflect the percentage of ownership the company. There also is not the restriction of thirty-five shareholders, as the S-corp. Also, the legal system for LLCs is, as the name implies, designed to give the shareholders "limited liability." This is attractive for those investors who may not be employees of the company. If your uncle Bob invests $10,000 in your new business, then you may want to opt for an LLC status. If you later get sued for some reason, the litigants can't go after Uncle Bob's money. Likewise, if Bob

gets sued for some reason, his claimants can't go after the company, although they can certainly go after his shares because they are assets that may have value. (For this reason, you should have buy-out clauses that permit other shareholders to purchase the shares of anyone else who may lose them due to such circumstances.)

LLCs are most common for doctors, lawyers, investment banks, and other concerns where shareholders need protection from decisions made beyond their control. Also, money is distributed differently: for example, a lawyer may become a "partner" in the firm and own stock, but the top brass may still keep all the profits within a tightly knit group.

The "liability" concern for a photo business doesn't apply in the same way as in other, more risky businesses (like medicine and law), where litigation is more common. However, if you're thinking of starting a collective "agency" of many photographers, it might be just the thing. For example, if you were going to do "adult entertainment," where the nature of the models is such that someone could sue because she wasn't really eighteen, then the other shareholders might want protection from such risks.

Caveats to Business Types

When faced with the decision whether to become a sole proprietor or one of the corporation types, the issues become complex, especially when you consider factors beyond just taxes. There are matters of legal liabilities, protections, and other financial concerns as well. So, let's compare each of these as they pertain to photography businesses.

CAVEAT #1: AUDITS

For sole proprietors, one caveat with filing a Schedule C on your tax return is that it is also a commonly used method of tax evasion. The IRS usually finds high-income wage earners or those with significant investment income (dividends, bond interest, etc.) using Schedule C filings to offset that income that they would otherwise have to pay tax on. A "photography business" with very ambiguous deductions and very little income (or sales) clearly looks suspicious, and it is a common way for people to avoid paying taxes. In fact, Schedule C filers are 50 percent more likely to be audited than those who use alternate reporting methods. (Put in absolute numbers, the IRS tends to audit 1 percent of the population, and those filing Schedule Cs have about a 1 1/2 percent chance of being audited.)

If the IRS audits you and finds that you really just have an expensive hobby and not a "real business," it may impose hefty penalties, require a revision of all tax returns for the years in which the Schedule C was used, reverse those deductions, and charge interest along with the back taxes you owe. Worse, they may even critique your photographs. It's not pretty.

The IRS Web site (*www.irs.gov*) is full of complete information on all this stuff, and it's surprisingly well organized. Don't forget to use the "search" feature to find relevant documents and IRS codes. For example, if you search for "hobby," you will learn quite a bit.

You may have a legitimate business with nothing to fear, so you may not need to worry about getting audited. Also, if your non-photo income is minimal, then it's even less likely that an audit would find you've done anything wrong. Still, audits are time consuming and bothersome (not to mention risky, if you have an overly zealous IRS auditor), so consider this along with the other factors below when deciding on your business type.

CAVEAT #2: ASSETS

The intent of a sole proprietorship is to provide the simplest method possible for filing a legitimate tax return. However, it doesn't address other factors, such as property ownership, liabilities, or partnerships. What all of these have in common is the principle that there is a separate entity other than yourself. As a sole proprietor, *you* are that entity. *You* own your property, such as camera equipment, photos, computers, or anything else related to your business. Thus, anything associated with you can stake claims to it. If you owe money, your creditors can tap into your assets: money, house, photo equipment, etc. If you're married, then this may apply to your spouse, too. That is, if your spouse owes money, then those creditors can come after the same things, even though those items are "yours." Then again, this may not be a problem, depending on if you live in a "community property" state, like California, and you set things up properly.

In states that have *community property*, a spouse owns 50 percent of your assets, unless (1) they were excluded in a prenuptial agreement, or (2) you owned them before you got married. So, if you started your business before you got married, anything you *had then* remains yours. Anything new that you acquire is 50 percent owned by your spouse. What's more, any *growth* is also split with your spouse, whether cash (from salary or dividends, etc.), or appreciated assets that weren't

excluded in the prenup. Say you started your company when you were single and it appreciated in value to $50,000 on the date you were married. That's yours. From that date forward, however, any cash (salary or dividends) you earn is split between you and your beloved, 50/50. All's well if you remain married. But if you get divorced, things can take a very different course, depending on whether you are a sole proprietor or whether you formed a corporation.

If you're a sole proprietor, then all your personal assets that you acquired *since your marriage* are divided, including any camera equipment, or anything else associated with your company. Of course, you can mutually agree to swap items to preserve the photo business, but you're negotiating for items that you might not have had to if you'd incorporated. In that case, the corporation is an entity in and of itself. Your beloved can make no claims to its assets individually and it can operate unimpeded. Whatever horse trading you negotiate at this point is limited to that set of assets that does not include company assets.

Also note that whatever money you earned from the company is still up for grabs, which is true of any money you obtain from any source after your marriage, regardless of whether you're a sole proprietor or a corporation. However, unlike salary you earn from an external employer, if you own a corporation you can refrain from taking a salary, thereby having it remain within the company. Here, the cash remains an asset of the corporation and is *not* part of the community property. You may still owe income tax on the money you didn't take, but that's irrelevant to the issue at hand. Compare again to the sole proprietorship, where there is no separate entity at all, so the company money is also your money and is immediately available to outside entities upon any triggering event.

While you may love and trust your spouse, that's not the only risk with community property: debts and other credit problems can be tapped into by creditors, like school loans, car loans, or other debts that come to haunt you later. This applies whether you're married or not; but if you *are* married, you inherit your spouses debts as well. Even your spouse's distant relatives could make claims against all your assets in the event of a death (where they may claim "inheritance"). Ask any lawyer for a running list of possible ways that someone can affect your business in a community property state, and you may end up staying for the weekend.

Lastly, consider the possibility that, one day, you may choose to sell your company. If you do stock photography, chances are you have a great number of assets that act like annuities: they continue to generate income year after year, even though you may have taken the picture years ago. If you sell a corporation, if the assets are properly declared, there is little worry or dispute about who owns the copyrights on the images. All the company's assets are transferred free and clear to the new owner. While it can be made just as easy for a sole proprietorship, it's not as clearly defined in the law about who owns what, possibly raising concern for a potential buyer.

CAVEAT #3: LEGAL LIABILITY

Because a sole proprietorship is not a separate entity, it does not provide the same legal protections that may be more applicable to your business. For example, insurance companies may cover your home but not your business interests, unless you are incorporated. Others may give you worse rates or coverage terms depending on how you characterize your business. You may also find that the best rates are those that *only* insure incorporated businesses, and no personal assets at all. This problem gets even more complicated if you ever hire people, or have clients come to your home or office, or travel, or do anything that may require liability insurance. This is often one of those considerations that cause more serious-minded business people to decide to incorporate.

And if you ever want to *borrow* money, banks look far more favorably on incorporated businesses than sole proprietorships, especially when it comes to an emerging photo business.

As for legal protection, the laws protecting individuals that have sole proprietorships are no different than if the individual didn't even have a business. In contrast, when it comes to protecting an individual's assets, incorporating can provide some protection in many (but not all) circumstances. That is, if you used a photo of someone without a release, and that person sued you, he would most likely be limited to assets within the company alone, not your personal assets. This is called a *corporate veil*. Similarly, if your company ran up debts and you failed to pay them when the creditors demand it, they could sue your company, but the courts would limit their claims to assets held within the company—not your personal assets.

On the other hand, if you form a company and do *not* transfer ownership of appropriate assets (including your photo copyrights), then it could appear to the legal or tax system that your corporation is merely a "shell" with no actual business assets. In this case, a judge would allow a claimant to go after your personal assets to settle the charges. This is called *piercing the corporate veil*. And it's not just the protection you have against your creditors; your legal ability to pursue others may be hampered as well.

Exceptions include gross negligence, intentional malfeasance, fraud, or other matters that involve civil rights or felonies, like whacking someone over the head with your tripod. Using a non-released photo in a way that is clearly beyond the normal course of business, like placing a nude photo of an ex-lover on a billboard in your downtown area with text that says, "Do Not Date This Person!" is another case where the corporate veil won't protect you.

Valuing Your Company

If you're a sole proprietor, you do not need to "value" your company because it is not a separate entity to own. So, this section is only for those who choose to incorporate.

The first thing you'll need to do (besides naming your company, which we'll discuss later) is to determine the company's initial value. You will issue shares (doesn't matter how many; it's largely irrelevant at this point) to the shareholders in proportion to their contribution. This is important if and when any of these scenarios occur:

- **You are starting the company with a partner.**
- **You sell the company.**
- **You can't sell the company and need to write it off.**

Your company's value is not unlike any other on the stock exchange in this regard: if you paid $10,000 for 1,000 shares of stock, your *cost basis* is $10,000. If you later sell the stock for $12,000, your profit is the sale price, minus your cost basis. In this case, you have a gain of $2,000. You pay a *capital gains tax* on that money at the end of the year. On the other hand, if you bought a stock whose value goes down, you declare

that loss on your tax return to offset other gains. When you form and own your own company, it's the same thing. The initial money you put into it is your cost basis, and whenever you sell the company your capital gain (or loss) is determined by the difference between the sale price and the cost basis.

If you think it's unlikely that you'll sell the company, you still need to know this value. For example, you may die someday. I don't want to predict when, but my guess is that you're not going to take anything with you. So, when your estate has to pay taxes, your kids or beneficiaries will have to know the initial value and the estimated final value for tax *and* inheritance reasons.

Another reason you need to know the value of the company is if you don't like the business and want to quit. Let's assume you decide to get out, but you can't find a buyer for all your dreadful pictures. In this case, you would sell whatever assets you have (cameras, computers, or anything you can or want to sell), and "write off" the difference between that sum and your initial cost basis.

INITIAL VALUE

Establishing the "initial value" of your company relies on one variable: *physical assets.* These can take several forms, the first being obvious—cash. The money you put into your bank account to pay for initial expenses and equipment is an easy amount to calculate. The other kind of asset includes your equipment—cameras, computers, scanners, software, and anything at all associated with your photography business that you *already own* that will be used by the business, and only by the business. These calculations can be a little trickier, but here are some guidelines.

- Equipment you purchase *before* the founding of the company is calculated at fair market value, and that contribution is considered a *capital contribution.* It's not an "expense" because you already bought it. You're using it as part of the "cost basis" of the company. If your equipment values at $10,000, and you add $15,000 in cash, your cost basis for the company is $25,000.

- If the equipment you turn over to the company is less than a year old, you can use the purchase price as its value. Otherwise,

you must use a "fair market value" formula, either by getting it appraised or by getting an independent source to verify its cost. A reliable and accepted method for doing this is eBay. There are almost always similar products to yours available on the open market, and you can use a proven sale price as the "current value" of your stuff. (Note: It can't be something that's "for sale" but unsold. It has to have been sold, because that establishes what someone will pay for it—hence, its "fair market value.")

- Equipment you buy *after* the founding of the company is just an expense. It is not part of initial capitalization.

- Equipment or expenses you share between the company and your personal life is usually a deductible expense as a proportion to its use in the business. For example, if you're going to share your car with your personal life, then it becomes a depreciable asset. If you drive 50 percent of the time for the business and the other 50 percent for your personal life, you simply divide the car's expenses (gas, insurance, etc.) by two at the end of the year, and those are business expenses. The same is true for a home office (as a percentage of your house), and so on.

Once you invest the cash and contribute your equipment, this adds up to the "value" of the company.

But, what about your photographs? They have value too, right? This is especially important for stock photographers, since they derive their income from the sale of their images, and presumably they start the company with a sizable base. Surely, they must have value. Well, they do and they don't. Unlike listing computers and camera equipment on eBay, you cannot objectively ascertain the value of photos because there are no identical photos like them to compare against. In other words, their value is a matter of *speculation*, which the IRS deems as "zero." However, you can use the cost of the film itself, as well as the cost of processing as part of your capital investment. These are known payments (provided that you have the receipts), which make them verifiable. What's more, any expenses paid that allowed you to *get* the images in the first place (such as travel, etc.) can also be part of your cost basis in the company. Note

that there is no tax benefit here; these are *not* deductions. They are simply calculated into what you've invested to form the company.

SELLING YOUR COMPANY

Spinning the magic dial, we fast-forward in time to when you want to exit the business. (Either that, or let it dissolve into nothingness.) Whenever that time comes, you must value the company again so you can file the final tax return and realize whatever gains or losses from your investment. The valuation process is no different from before, but now comes the moment of reckoning as to whether you did it right the first time. For example, if you claimed as a cost basis all those pictures and trips to Hawaii, but never sold any, the IRS could deem those investments as inapplicable. That is, they *could*; it doesn't mean they will. What they are looking for is a pattern of business that's consistent with your spending and capitalization. If something doesn't fit a pattern, the IRS may disqualify it, in which case you're starting down a class-five rapid, you have no paddle, and there's a waterfall not far down river. Once the IRS sees smoke, they are *going* to find the fire, so my suggestion is to be very conservative in your calculations for initial valuations.

Assuming everything is on the up and up and you've grown the business, your assets may amount to a great deal more than what you started with. Assuming you sell the company at a profit, you now deduct your initial investment into the business from what you get in the sale. So, if your assets total $100,000, and your initial investment was $10,000, then you made $90,000. Timeframe isn't important (as long as it's longer than one year), and your tax obligations are whatever the capital gains tax rate is for $90,000. Over the course of the past ten years, it's gone from 28 percent to 20 percent, and there are rumors of it going down even further.

Good Will

One more thing needs to be considered. To illustrate this, consider the following: If someone wants to buy your company and your assets total $100,000, but you can also show that the company earns $20,000 a year in profit, you could say that the company is worth more than the $100,000 in assets that it owns. That is, if the buyer is going to get a return of $20,000 in the first year from his investment, you would expect that his *return on investment* would pay for itself in five years. It is pretty

common for this benefit to be factored into the sale price of the company. I mean, how often is it you can find an investment that pays for itself in a short period of time? After that, you've got a money machine.

This intangible value is called *good will*. There is no formula for how to calculate the value of good will; it's all a matter of how badly someone wants to acquire your business. It's like how you value an old baseball card. It only has value if someone is willing to pay more for it. This does not have value in the IRS's eyes; it is only used as a negotiating token to justify a higher price for the company to the buyer. Once you sell, you do the math and pay your taxes.

On the other hand, if you're dissolving your company because no one will buy it, good will plays no role. Sure, someone may buy your old computer, but this isn't selling your company, it's unloading an asset. When you finally sell all the assets you can, the total dollars you raise is subtracted from your cost basis, and the difference between those numbers is your "capital loss" (as it is unlikely that you liquidate your assets for more than you paid for them). So, if your company was founded with a value of $25,000, and the sale of your assets totaled $5,000, you have a "capital loss" of $20,000.

Profit or loss, whatever cash comes from the sale of the company is distributed to the shareholders in equal proportions to their ratio of ownership in the company. The profit or loss is also declared on the shareholders' tax returns in proportion to their ownership in the company.

Tax

Taxes. Here we go. They're everywhere. You must pay tax on income (salary and dividends, which are different), sales taxes, social security taxes, and sometimes other taxes, depending on the complexity of your business, or what state you live in. Since volumes of books have been written in attempts to explain, let alone to codify, these very complex matters, I have no intention of rehashing them here. However, I will touch upon the most basic topics that apply to photographers.

SOCIAL SECURITY TAX

If you ever take cash out of the company to pay yourself, you have to pay social security tax (a.k.a. "SS Tax"). If you're thinking, "I'm not paying myself a salary, it's a dividend," I understand. But, the government wants to collect SS Tax because the system needs the money.

If you have any income, the government is going to try to characterize that money as a salary instead of as a dividend. It may not—if you do things right. And the way the government determines whether your distribution is deemed a "salary" or a "dividend" is, as mentioned several times before, by looking for patterns.

If you're consistently making money year after year, the government is going to rule that you've got a reliable income, and some of that money should have SS Tax levied on it. How much is meant by "some" is unclear; it depends on how good you are at convincing them that the sums are unpredictable. For example, if you earn $10,000 one year, $25,000 another year, and $9,000 after that, and it didn't come in evenly distributed throughout the year but only in chunks, you'll have a better time convincing them that you couldn't have predicted the income stream. If you show a profit of $10,000 one year, but a loss on the next two years, followed by another gain of $5,000, they probably won't even argue with you. But, if you earn a regular rate of $5,000 a month over the course of several years, they're going to ding you. (And you don't want to get dinged.)

If you have a regular pattern of profit, you have to pay the social security tax even if you don't take the money. For an S-corp, it can stay in the company, in which case, it is considered capital contribution; that is, you took the money, but reinvested it.

SALES TAX

If you have a business, chances are you're making sales. And if so, there is the matter of "sales tax" to deal with. Yet, not every kind of sale involves sales tax. Items sold between businesses are not taxed provided those items are later sold to a consumer who does pay the tax. That is, if you sell prints to a retailer, who then *resells them to the public*, you do not collect sales tax on your sale; the retailer collects the tax on his sale to the end buyer.

If *you* sell direct to the customer, then you must collect sales tax. To do this, you need a *resale license*. You usually apply for one from the franchise tax board with your business license (which you'll need if you have a place of business where customers can regularly go to during business hours and where you sell to the public). It doesn't matter whether you're an individual or a corporation; your "income tax status" has nothing to do with how you pay *sales tax*.

If you sell online, you do not need a business license. What's more, you do not charge sales tax unless the customer resides in your state. This is the same as with mail order catalogs. The big variance among individual states is what the sales tax rate is, or whether the state even has a sales tax. (As of this writing, Alaska, Delaware, Montana, New Hampshire, and Oregon impose no sales taxes. However, numerous boroughs and cities in Alaska have their own local sales taxes, which is not unusual practice, and is one that is prone for expansion to other cities throughout the country as budget deficits worsen.)

Another situation in which sales tax is not charged is when you *license images*. (Licensing is when you sell someone the right to use an image, but you're not transferring a physical asset.) In California, licensing images *is not* subject to sales tax, but some states have different laws on this.

Shipping and handling are taxable, as is the transference of any physical property, such as a slide, negative, or disk. For example, if you license an image for $300 to use on a Web page and you send the client a slide, then you would charge sales tax for the slide, say, $1, and any shipping and handling charges you may incur, say $15. But you would not calculate tax for the $300 license fee. And, you only have to charge the $1 sales tax if the client keeps the slide. If they return it, it's not an exchange of property. (Electronic transfer of assets like this—say, a *digital image*—is exempt from any sales tax because there is no physical asset.)

When you apply for a resale license, which is required in order to collect and pay sales tax, you will be given a booklet with all of the state-specific information.

TAX-DEDUCTIBLE DONATIONS

We Americans hate giving money to the government (yeah, like the French love it.) So, we try to find ways to reduce our tax obligations in very creative ways. As you know, you can deduct your business expenses from your company's income, but another way is through *charitable donations*. Again, nothing new, but where photographers get into trouble is when they assume that donating stuff that has "potential income" is deductible dollar for dollar for that hypothetical sales price. The error stems from this otherwise correct procedure: if you sell a print for $100 and donate that $100 to a charity, then you get a $100

deduction. Where the logic goes awry is when people think that they can short-circuit the system by directly donating the print and declaring it a charitable donation of $100. It doesn't work that way.

The IRS views any sort of donation in exactly the same way as you did when you valued your company upon founding it: by evaluating your *physical assets*. You can donate cash, like the $100 you got when you sold your print, as well as physical property. In the latter case, the deduction you take must be the sum of the *hard costs associated with producing the asset*. You can deduct the cost of the film, the paper, and the frame, but no other expenses, including the trip to Hawaii to take the picture. For example, it costs me about $150 to produce a 40-by-60-inch print, even though I sell it for $1,200. I can donate that print, but I can only deduct $150, because those were my hard costs.

When it comes to charitable donations, there is really no tax advantage at all. Since you've already "expensed" the hard costs of producing a print as a normal course of business, the fact that you are donating it to a charity does not qualify you to deduct it *again*. If you donate the print, you're just giving it away. But hey, if you want to support that charity, great! That's what *charitable giving* is supposed to be about.

If you're still looking for a way to get a deduction, and you're considering donating your services as a pro photographer, again, you're out of luck. The error people make is assuming that: "If I bill my photo services at $100 an hour, I can deduct ten hours' work and qualify for a donation of $1,000."

Nope. That doesn't work either. You cannot *deduct* your time at all. You *can* deduct any expenses you incur to do a photo shoot, like the film, auto tolls, gas, and other transportation expenses, but your time is not deductible.

Copyright and Photo Credits

Another benefit of incorporating is an artifact of the legal specification for displaying "photo credits" for artwork. That is, the credit must specify the name of whoever owns the copyright. For example, you often see this sort of attribution in photo credits: "© 2000 Tony Stone Images." Even though the name of the actual photographer doesn't appear, the owner of the copyright on the image is listed (in this example). Other times, you may see the photographer's name, as in: "© 2000 John Doe/Corbis." Here, John

Doe is the photographer, and Corbis is the photo agency. This type of photo credit assumes that both parties share copyright ownership of the image. Whatever the legal name of the copyright holder is, that's what is used as a photo credit. If you form a corporation under the name, "Big Lens Photography," then that's what the copyright text must say.

One way you can make this work for you is to incorporate under the name *www.yourname.com*. This way, your "name" must be used as the legal text for any photo credit given with a published photo. As you may have seen in my photos, my photo credits read as thus: "© www.danheller.com."

This is legally correct, since the *company* owns the copyright to the images. I, as an individual, do not own my images. The company not only owns all the assets for my photography business, but also holds the copyrights as well. Since I am the sole owner of the shares in the company, I own everything the company owns, but that's inconsequential. I could sell the company and, assuming the buyer keeps the name, the photo credit text remains.

But then again, so what? As nice as this advantage is, some of the higher profile companies (magazines and such) refuse to print my Web address as photo credits for my images simply because it's against their policy to do so. Their reasoning is that they don't want to "advertise" someone else in their print copy, nor do they want their readers to suddenly "leave" their attention span to go to my web site. If I push the issue, experience has told me, they'll simply not publish the image at all. So, while they are technically obligated to do so, I don't really have much leverage in enforcing it.

On the other hand, this "policy" isn't applied universally. Smaller, everyday-type clients are almost always compliant. And, as you build your career, as I've been finding, even bigger companies are more willing to comply. You can see the status tiers: the same publications that refused to print my Web address had no problem printing Corbis's or that of other well-known photographers. Clearly, status has a lot to do with this. So keep this in mind if faced with the same issue.

Copyright Your Images
With all that stated about photo credit and ownership, don't forget to actually *copyright* your images by registering them with the copyright office. If you are going to license your photos for others to use, like magazines, brochures, ads, or any other commercial use (including

private and noncommercial use, like fine art), copyrighting your images strengthens your case (and financial judgments) against violators.

What's more, it's insanely simple. Download and print the Short form VA from the copyright office: *www.loc.gov/copyright/forms/ formvas.pdf*. Fill out the one-page (eight-item) form and send it along with a check for $30 and a CD of your photographs. (Obviously, these would be digital images, so you have to scan film.) You can/should register as many as you can on one CD. As for the size: as long as the image is legible and can be easily compared with a potential "violation" (in a judge's eyes), that's fine. If it's so small that the judge might say, "I can see that they might be the same, but they may also be different images," then that's too small. I usually use a 250-pixel size, which allows for thousands of images on a single CD. You can even use a DVD, which holds 4.7 gigabytes.

There is one exception to whether you can or should copyright images: *work-for-hire* contracts. If you shoot an assignment for a client with whom you have signed a contract that specifically uses the phrase "work-for-hire," *the client, not you*, retains ownership and copyright of those pictures. You have no rights to them at all. Common examples include photographing a car for an ad for that car company, some celebrity events, or architectural photographers that shoot for real estate companies.

There is no universal subset of photography where work-for-hire is done, and there are many cases where such terms are inappropriate for the job. Indeed, there is much discussion about whether work-for-hire contracts are inherently good or bad, but this gets into a discussion beyond the scope of this chapter. For more on this subject, see chapter 6, "Photography Pricing."

This was a long and involved chapter. But, it was because I covered all the bases for all the different types of photo businesses that can exist. At the same time, remember that most photo businesses migrate, so you aren't expected to "do" or "know" all of this information at once. As you read through the rest of the book, there may be some back references to issues discussed here, because the legal basis of your company may affect other business activities as time goes on. It's best that you understand these concepts so that by the time you're ready for each step, you've got the basics.

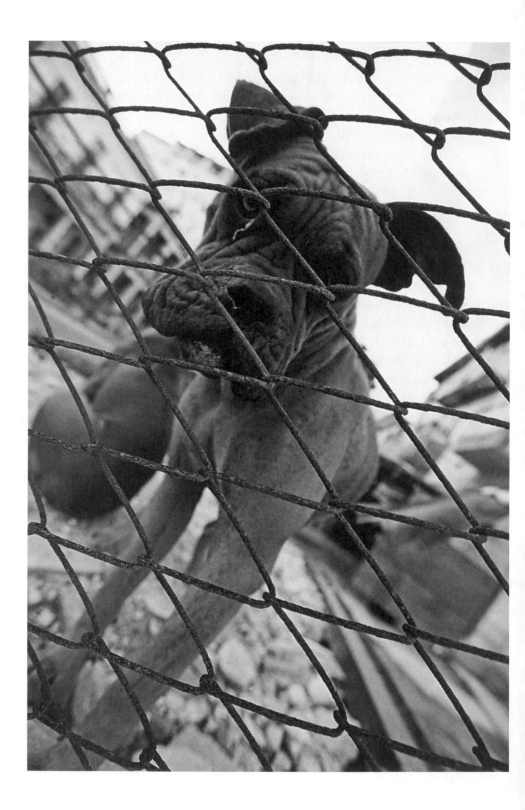

Photography Marketing 5

Photography is one of the rare businesses that supplies every *other* kind of business in the world. But not every photographer does the kind of imagery that may be required by any kind of client. Put it all together and you can have an infinite permutation of marketing strategies that can generate business. Despite what some might say, there is no one-size-fits-all marketing strategy. It's not just a matter of sending portfolios to potential art directors, or mass-mailing postcards to advertise your services. You can end up wasting a lot of time and money, not to mention stain your image, if you market and promote yourself inappropriately. What's more, to optimize your financial bottom line, you need to factor in how much time you spend on any given marketing approach, weighing its short-term and long-term benefits. You don't want to spend a week producing a marketing piece that may pay for itself but has no other long-term value.

The main objective of this chapter is not to help you figure out which marketing method is right for you, nor how to implement it once you figure it out. There is no one-size-fits-all approach to marketing. This chapter analyzes the various strategies that exist, points out their pros and cons, and sets the stage for you to decide for yourself which methods are right for you.

Historical Context

Odd as it may sound, the historical barrier to entry into the photography business has not been marketing so much as it has been *distribution*. As discussed in chapter 2, "The Five Truisms of the Photography Business," the old days of getting photos to a wide base of clients was costly and time consuming, and one needed a critical mass of product and customers to be profitable. Most individuals never had that kind of distribution capacity, so they relied upon employers or agencies to do sales for them because they were large enough (with enough images and clients) to enjoy those economies of scale (i.e., it's more profitable to represent a hundred photographers than just ten . . . or one).

Therefore, the kind of marketing that photographers did was always less directed toward the end buyer as it was toward those middlemen in the supply chain that controlled the distribution channel. Having a strong portfolio and getting it into the hands of photo agencies and "reps" was seen as the only way to build a career in the business.

When the Internet came into mass public use, the barrier of "distribution" evaporated, allowing photographers to market and sell directly to the buyer on a scale never seen before. Today, getting noticed among the "noise" of images that buyers see is why marketing has become the leading competitive tool. Because of this changed demographic from "agency" to "buyer," marketing itself has also changed. Sure, traditional marketing methods still exist and can be effective in some situations, but they are quickly becoming a smaller part of the overall marketing plan. Buying mailing lists or other resources to target photo editors and art directors may bring some success, but your chances are compromised by the shorter attention spans that these people have due to over-saturation. (That is, should you send expensive portfolios to agencies, when the time and cost of doing so can be redirected toward a more profitable sales strategy?) These questions have had a direct impact on the nature of how marketing is done, who you're competing with, and how any of these efforts contribute to the bottom line.

In this chapter, we'll explore all of this, starting with an analysis of traditional marketing methods. I present a checklist for weighing whether (and to what extent) any given approach is effective (and under what circumstances), and when it is not. We'll then look at how buyers and agents choose the people they work with, so as to guide you in how you should spend your time and resources when developing your own marketing strategy.

Push and *Pull:* **Two Approaches to Marketing**

The objective behind marketing is to yield the most prospective clients who pay the highest price for your product at the lowest possible cost. The process of marketing can be separated into two categories: you contact them first, or you entice them to contact you first. For example, all of these strategies should be pretty well known to anyone in the photo business:

• Sending portfolios to clients: buyers, editors, art directors, agencies.

- Sending direct mailers to target clients.

- Working with an agency or representative who does your marketing for you.

What all these have in common is attempting *direct contact with specific, prequalified targeted buyers.* This is called *push marketing*—an overt "push" onto a directly focused group of prequalified people who fit a specific profile. You are the one who attempts initial contact.

By contrast, there is another approach called *pull marketing,* a broad-based marketing approach using general mass media outlets, such as print and television, where potential clients are "pulled in" by a promotion. Here, clients respond by initiating contact with you. Examples of pull marketing strategies include:

- Television and radio.

- Newspapers, magazines, and other publications.

- The Internet.

- Fairs, art festivals, and public exhibitions.

- Trade shows and conferences.

The object of pull marketing is to reach thousands or millions of potential clients with the hope that a greater total of "qualified buyers" will see your promotion than would with the more targeted "push" strategy. Here's a simple comparison of the two:

- A push marketing strategy would be a direct mailer that goes to 1,000 art directors in a target industry (say, advertising agencies).

- A pull marketing strategy would be placing an ad in a magazine whose subscriber base reaches 100,000 art directors, of whom maybe 5,000 meet the target profile.

This suggests that the pull strategy is better because it reaches more of the target audience. However, the price of producing and placing an ad in such a magazine may be prohibitive. Moreover, a direct mailing may not be as quickly overlooked as an ad might be. Also, a mailing can be

somewhat personalized or include target-specific information that may not be effective in ad. On the other hand, the ad could be placed strategically next to a particular article that your target audience is likely to see. (Such placement often influences brand identity, which also increases the subtler influence of brand perception.) This type of pro-and-con analysis illustrates that one form of marketing is not inherently better than the other—it's more a matter of the circumstances. We'll get into more of this type of analysis throughout the chapter.

THE INTERNET

The odd man out to the various marketing strategies is the Internet. As the newest entrant into the "mass marketing" group of options, the Net can surpass television and radio in its potential to be seen by the greatest number of eyes (or ears). Additionally, it can be used to target specific individuals, since, unlike broadcast television or print publication, it's a bidirectional communication mechanism. Ironically, it can also be the least expensive way to capture those eyes, even less expensive than the most common direct-mail and cold-calling methods.

The hitch is, Web pages are everywhere, and where your site "ranks" in the noise can either make your business a smashing success or a huge waste of time and money. Getting it right isn't easy either; most photographers either under-invest by only having a short résumé and portfolio, while others over-invest by paying a designer to create a very sexy and unique site that fails to draw in sales or prospective clients. (Many such sites have won awards, which look great in a high-profile magazine but don't necessarily translate into actual dollars, at least, not for the photographer—the designer usually gets a lot of business, though.)

Despite the challenges, one fact is clear: *not* using the Web can actually be harmful, not just because of the lost opportunity, but also because it can give the impression that you are not the professional your clients expect you to be. Would you hire a lawyer who still used a typewriter because he didn't understand word processors? Because this subject is so big, I've dedicated an entire chapter to it—chapter 7, "Running a Photography Business on the Web."

EFFECTIVE MARKETING BASICS

For all other marketing strategies, whether push or pull, photographers on a budget often make the same mistake: they opt for the short-term

approach because it's more affordable. That is, they may send a post-card once to see what the response is, and if it generates enough income, send another. The old adage about being a penny wise and a pound foolish applies here more than any other aspect of photography (except, perhaps, for the equipment you use). No matter how you promote yourself, or what your profile is, you must identify a marketing *plan* that incorporates certain basic principles.

❏ **You need to *target* your audience.**
Whether push or pull, if you're casting too wide or too narrow of a net, your expenses may not be justified by the returns.

❏ **Your target audience needs to see your name *a lot*.**
Even in high-profile mass marketing campaigns that span multiple mediums, most people don't recognize a new name or logo in fewer than three exposures, and statistics show that initial contact isn't made in less than five exposures. Exposure rates and recognizability can vary depending on many criteria, such as long gaps between exposures and the number of media outlets used.

❏ **Remain relevant.**
As we'll get into later, you need to represent yourself and your product in the context that is relevant to the target audience. That can mean personalizing marketing materials, customizing a portfolio to match exactly what a specific client needs to see, etc.

Longer term planning not only helps in effective marketing, but you also get other benefits: lower prices for higher quantities, or the ability to foresee important events, such as conventions, news releases, holidays, or other things germane to your business. Most marketing consultants advise budgeting for an annual marketing plan that includes a series of cross-promotions using all of these approaches. The most aggressive marketing campaigns usually involve the purchase of media packages that include prepayments of up to three years in advance for ads (to get a lower per-placement rate). But, let's face it—that kind of planning is beyond the means of most photographers reading this book.

For everyone else, there's the dilemma: How do you execute a longer term marketing strategy on a limited budget? To answer that question, we need to master the technique of objective analysis of marketing.

Analysis of Marketing Strategies

The goal of good analysis is to understand which approaches are more effective under certain conditions and the time when such methods are cost effective (or not). This process can be broken down into looking at the data associated with the following items:

- Direct and indirect costs of reaching target audiences.
- The percentage of those who respond or buy something.
- The financial return from that investment.
- The longer term benefit of name recognition.
- The time and effort required to produce and execute any given marketing tactic.

Let's return to that hypothetical scenario of sending out postcards to promote yourself to a target audience and flesh it out to provide data we can analyze. Let's say you paid $1 per card to produce 2,000 postcards, and $.50 per card to have them labeled, stamped, and shipped. Your total cost is $3,000. One might gauge the success of this effort on whether enough buyers buy over $3,000 worth of product. If ten people responded, and three of them bought $4,000 worth of images, would this be deemed a success?

Does the fact that we made $1,000 define success? Not calculated into the equation is what the expected response rate should have been. If you do pet portraits and you bought a mailing list from a veterinarian that treats show dogs, wouldn't you have expected a much higher response rate? What's the average price per item that the buyers chose? If you are a flower photographer and were selling $15 boxed postcards of pretty flowers, that kind of response rate *would* be considered a success.

What about the indirect costs of time and effort required to do the mailing? Were longer term benefits realized? Put another way, could you have chosen another form of marketing that yielded a higher response rate, one that didn't require as much time or effort to produce? What about longer term benefits? Direct mailings expire anywhere from three days to a week after recipients receive it. Then what? Could time have been spent doing something that has longer lasting effects, despite the $1000 profit in the short term?

I once spent $500 on a postcard announcing my participation in an exhibition at the kind of fundraising event where the list of attendees was limited, they were definitely showing up, and they were going specifically to spend money in large amounts. I personalized each card in order to establish my relationship with these people ahead of time, which was then followed up by a face-to-face meeting at the event. This gave me a great chance at establishing long-term relationships at a justifiable expense. This kind of push was also done in conjunction with another type of marketing activity: finding effective co-marketing partners.

These two examples illustrate where push marketing efforts have different degrees of benefit. We'll look at more soon.

PULL MARKETING ANALYSIS

For pull marketing, the analysis is even more complex and imprecise. That is, a magazine ad doesn't reach a specific person—it reaches a hypothetical population base. You can measure the number of responses as a percentage of the expected audience size, but you can't gauge the quality of those respondents without directly contacting them. And then you have to make sales. The checklist is still examined, but each item is evaluated differently.

Pull marketing campaigns tend to be ongoing (for example, buying ad space in time blocks of multiple issues). So, one of the conditions that influences effectiveness is your degree of *name recognition*. If you were to offer wildlife photo workshops in Africa, you may place an ad in an adventure travel magazine like *Outdoor Photographer*, where your target client will probably see it. Many similar ads can be found in these magazines, so think to yourself: which of those trips would *you* sign up for, and how did you make that decision? Chances are, you'll scan the array of ads and cull out those whose names you recognize first. That will be your first deciding factor. Whether you find any or not, you'll then look for photos, ad sizes, trip descriptions, and, finally, price.

Test this theory by calling one or more of the photographers posting these ads, and ask how those placements have done for them. (Some magazine's sales reps have this kind of data that they will share with you if they think you're going to buy an ad yourself. After all, they want to help you make the best ad-buying decision so you'll keep the ad running longer. But make no mistake: their goal is to *sell*, so be careful of what

you hear.) If you interview the photographers, most will give you responses that, upon analysis, will demonstrate the direct relationship between name recognition and the "success" of ads. I've experimented with ad size as well, and there is a crossover between name recognition and initial response rates as the size of the ad gets bigger. (The same can be said for trade-show booth size, postcard size, brochure size, etc.) Those who are completely unknown and place small ads often do not get any business, or too little to justify the expense. The larger the ads, the better the response rates.

But then there's the problem with having a tight budget. And, just to be thorough, this all has to do with *response rates*, not necessarily *sales*. That problem remains, regardless of how many potential buyers you bring in.

Now let's consider an opposite situation. If you are an unknown wedding photographer, you may find it more effective to advertise in the local newspaper or telephone book, since name recognition is much lower on couples' priority lists. Many go by referrals from friends and family, but, by and large, most couples "fish" to find a photographer that works for them. Here, it's your portfolio and personality that closes the sale. (That, and price.)

As we can see, there are conditions in which any kind of marketing can work for or against you. To a larger degree, name recognition plays a big role. But before we get to that, we need to consider two more items: the *randomness factor* (i.e., luck) and the *decision-making analysis*. That is, why do people choose what they choose? (Hint: It often has nothing to do with the product itself.) So, let's approach these items in order.

The Randomness Factor
If you flip a coin 100 times and call "heads" randomly, you may be right 50 percent of the time, but that doesn't mean you had insight. You'd get the same results by choosing heads every time. This is easy for us to see because we know that coin flipping predictably yields heads close to 50 percent of the time. When evaluating (or learning) marketing strategies, many people often look to established professionals to see what they did. The question is, are they really successful because of something they *did*? Or was there some luck involved? We know that coin flipping is 50/50, but we don't know the degree of randomness in the photo business because it's not as simple a system.

As discussed in chapter 3, "Photography and Business Sense," luck does play an unfortunate role in the photography business. But it's not *just* luck; it's a matter of degree. We know that over the course of time, "success trumps luck." But early on, luck can play a great role in positioning someone to be "successful." As the saying goes:

"Luck is what happens when preparation meets opportunity."

Successful people tend to be so because they do things that minimize the luck factor. That's what we need to understand here. When you're getting started, competing head-to-head against others in a overly populated market, there's a higher degree of randomness involved. And, when you're talking about something as subjective and interpretive as *photography*, that randomness factor is multiplied. How do we test this?

To start, I'll reference several talks I attended where "successful advertising photographers" spoke about how to make a winning portfolio. (These talks were sponsored by the APA, the Advertising Photographers Association.) In each case, the featured speaker presented a slideshow of ads he'd done for a well-known consumer-product company. The oohs and ahhs from the audience were audible all the way to the back of the theater. Then came the discussion of "how to make a winning portfolio." The photos from each photographer then took on a very different look—usually very artsy, black-and-white imagery. But they all had one thing in common: none of the images were from assignments, nor did they look anything like them. They were clearly independent and creative efforts.

Everyone was so impressed that the room glowed, pens and pencils jotting down notes. But the analytical side of me couldn't help but wonder about the subliminal cognitive triggers in the decision-makers' minds. Were they *really* responding to the images, or were there other factors involved they might not have been aware of? I know that if I were sent one of these portfolios, I would not have hired the guy simply because his photos were unique. I would have been looking to see whether his photos addressed my business needs. I had no way to gauge this by portfolios. The woman sitting next to me believed that the concept he was trying to express was *be different, be creative, be unique*. True, but if everyone is different, creative, and unique, how do you differentiate yourself from others? Aren't I just flipping a coin at this point? To me, this wasn't enough to answer the "winning portfolio" question. I needed to know those other factors that no one was talking about.

As I pondered this, I considered the kids in the audience, many just out of school, getting the indirect suggestion that a $5,000 to $10,000 investment in an amazing portfolio project, like these guys had done, would enhance their chances for success. At the same time, their contemporaries would be putting $100 to $1,000 into a project and yielding exactly the same results. Is this the right thing to be teaching emerging photographers?

A sales rep once wanted me to buy an ad in a large photo-promotional book that contained nothing but ads for photographers (who would pay to have a full page or a double-page spread). This book was distributed to ad agencies and other high-profile photo buyers. Most photographers had many gorgeous pictures, each of which depicted the style and focus of imagery that was his specialty. I happened along one page that was completely white with "raised" letters that had his name in the middle. The rep who sold ad space in the magazine said, "He can do that because his name is so well known, all he needs to do is remind people he's out there."

When it comes to certain types of marketing tactics, including making a portfolio, there is a heuristic argument (rule of thumb) that states that there is a ceiling of investment (time, effort, money, and other resources) necessary to achieve a certain level of success, after which any *additional* investment yields insufficient results to justify it. This is what marketing people call the *85 percent rule*, stemming from the "feeling" that 85 percent of the job is usually the point of diminishing returns.

The reality of the presentation was that the photographer giving the talk was already famous, and didn't *need* a portfolio; he only needed to remind people that he was out there and available. In *this* case, that was the subliminal and determining factor that got the gig. If I was that art director, I would have seen the name, gotten excited about *that* first. On second look at his piece, I would then say, "Oh and, by the way, isn't that a nice portfolio he put together . . ." This doesn't teach anything about making portfolios.

THE PHOTO BUYER

Obviously, there is a matter of talent and other human features in photography that influence success or failure. But, once a certain

86

degree of proficiency is achieved, it's really about *other* factors that define success. We can find them by understanding what actually goes through the mind of the decision-maker (editor, art director) when choosing a photograph, a portfolio, or a photographer.

To understand this, I cite another meeting—this one sponsored by the ASMP (American Society of Media Photographers). Here, we have a panel of four art directors, each working for a different ad agency, each of which specializes in different types of clients and products. The topic: *Creating and Submitting Portfolios: What Art Directors Look For?* Rather than hearing photographers talk about their own successful portfolios, we hear from art directors who look at portfolios for a living: what they look for, what turns them on or off, and so on.

The bulk of the session was the question-and-answer period with the audience, which lasted an hour, followed by a "free analysis" of people's portfolios. When the questioning got started, the basic stuff was asked: "Should you use large images?" "Is it okay to use a portfolio book from a photo-supply or art store?" "Should you submit prints or slides?" "Do you care what kind of film is used?" Dozens of questions were aimed at the panelists in the attempt to see a pattern of how these people made decisions.

I had an entirely different set of questions, which I had to get permission to ask ahead of time because they had to be asked in sequential order, and because they didn't ask the "direct" questions that everyone else was asking. Almost all the panelists had roughly the same answers.

Q. How many unsolicited portfolios do you receive a week?
A. Hundreds.

Q. Why hire a photographer who sent you an unsolicited portfolio?
A. If none of the photographers on the regular "go-to" list are available. Also, to seek out new talent due to normal attrition.

Q. How often might you hire someone based on his unsolicited portfolio?
A. About once in three or four months. (Note: That's one in 3 or 4,000 who gets picked.)

Q. Do you seek other people that you don't yet work with before you go to the "unsolicited" list?

A. Yes. Known photographers, referrals, or names seen associated with other ads or competitions will be attempted before unsolicited portfolios are screened.

Q. Of those you hired, was a client ever not satisfied with the work?
A. Never.

Q. Have you ever regretted having chosen a photographer?
A. Well, photographers have egos that can sometimes be difficult to deal with. We've chosen not to work with some again based on personality conflicts, but we've never chosen a photographer that wasn't capable of doing a good job for us, or where the client wasn't satisfied.

My questions caught everyone off guard because they had nothing to do with how these people "chose portfolios." I noted the fact that they receive thousands of portfolios before choosing to work with one, and I'm sure that there were possibly *many* that were equally good, so the one photographer that was hired was, put bluntly, "lucky." No one really wanted to dispute that point, but they still felt that there was a lot more to it than that, although they didn't really articulate what that might be.

The fact still remained: Those who send unsolicited portfolios are at the bottom of the barrel, and their chance of success is comparatively small. That may not be the case with every art director, but does the photographer sending his portfolio know this? How many of those knew ahead of time any of these facts? None in the audience did. They all thought that they were going to learn how to send more effective portfolios, and, armed with this information, possibly get an edge against others.

While my observation of the randomness factor was important, that wasn't really my main objective. Instead, I was looking for reasons why any given portfolio would be seen in the first place and what the art director's mindset was when sitting down to look at it. Rather than ask what they look for when they review portfolios, I wanted to know *when* those who review portfolios actually stop to look at them. When they're home sick? When they're at the office after lunch? When they're feeding the baby? If I were to submit a portfolio to someone, I'd want to

know what her frame of mind will be so that I can present something that matches those conditions. Obviously, it won't be consistently the same conditions every time, but my process of getting to know the art director may tell me something useful.

One thing I know about *these* art directors on the panel: they look at portfolios when they're looking to solve a problem. Usually pretty quickly. That tells me a lot about how to design one for them.

Without intentionally looking for it, I also learned something from the statement that *every*

> Portfolios are considered when the reviewer is either in (1) "browsing" mode, making your chances largely subject to random selection, since you can't predict the reviewer's frame of mind, or in (2) problem-solving mode, in which case, portfolios should demonstrate your ability to solve business problems. Hence, don't send the same portfolio to people—*customize* each to match that person's specific business focus.

photographer satisfied every client. In other words, none of the art directors was ever wrong in deciding which photographer to hire. Why is this important? I'm reminded of a child's game where the two-year-old picks up rubber ducks from a plastic tub and looks underneath to see if he won a prize. He *did*! How exciting! He thinks he's smart, but little does he know that every duck is a winner. It may not be that 100 percent of photographers are winners, but if every photographer *these* people hired produced a satisfactory result, the chances are that those photographers were mostly all winners. Why? Most likely, it's because these directors worked at the kinds of agencies where amateurs or even less-experienced photographers never send their portfolios. By the time these directors saw anything, they were looking at professional portfolios from qualified candidates. In turn, choosing among them dissolves down to . . . well, *randomness* (just like picking one of the rubber duckies). The fact that they are always right gives them a false sense that they are particularly insightful.

Of course, no one is assuming that photographers are chosen based only on their portfolios; we assume that there has also been an interview and maybe even calls to references. But you'd be surprised how few clients ask for references, let alone call them. As for the interview, I've rarely been asked tough enough questions that any reasonably proficient

and experienced photographer wouldn't know how to answer well. But, what's your likelihood of getting called in for an interview, if the only criteria for doing so is your portfolio? And if your portfolio is subject to such random conditions beyond your control, how can you enter the fray while minimizing your costs, time, resources, and other detrimental effects?

Yes, portfolios *do* have value. Indeed, the same can be said of many individual marketing tasks. Some are better or worse than others, but it's the times and places for when and how they are implemented that differentiate one set of marketing tasks from others. We'll get into that in a moment.

MORE USEFUL DETERMINING FACTORS

Those aspects that show whether photographers are good candidates include qualities that portfolios don't show:

- **The ability to work with a team (from a team of twenty to a team of two).**
- **Contributions of good, constructive ideas during brainstorming sessions.**
- **Compatible attitudes with others on the set (models, etc.).**
- **The performance, reliability, and delivery of service-related duties.**

While a portfolio may get you in the door, it's often the interview itself and the rapport between the artist and the art director that really seal the deal. I have had few interviews that tried to establish this sort of thing, so it was incumbent on me to apply these attributes to the client. I've turned down assignments because I found the client to be appropriate.

The Psychology of Choosing

Up to this point, I've discussed traditional marketing methods, mostly using the "portfolio" as the example of the push marketing strategy and why it is important to analyze those conditions in which your investment into these strategies has varying degrees of success due to conditions beyond your control. I raised caution to avoid over-investing in any task that may have limited returns, may be disproportionately subject to randomness, or whose costs are not justified by the returns.

90

I would call these conclusions the result of *reactive analysis*, because it explores tasks that are already practiced widely, and which are often repeated from one case to the next, regardless of the conditions. To market intelligently, we also need to do *proactive analysis*, which involves exploring activities and approaches that are usually devised on a case-by-case basis, for the purpose of proactively focusing on a single individual or situation.

Since this kind of proactive approach involves focusing on individuals, it begins with understanding people's psychological biases. That is, how and why people make choices, how those choices change in various conditions, and how you can preemptively establish those conditions to match your presentation. Wouldn't it be nice, for example, if we could put the art director into that right frame of mind that makes *your* portfolio more appealing? It'd be better than blindly sending it in and leaving it to random chance.

There have been many studies exploring how and why people make choices, ranging from creative to analytical decisions. There are social, economic, and even chemical components involved, each of which can hint at certain biases that influence decisions. These can be used to predict ranges of outcomes before decisions are even made, so learning what they are for any given situation can aid in the effectiveness of your overall approach. Clearly, a portfolio, postcard, or any sort of marketing or sales presentation has to be appealing, and, in that sense, such items *are* critical. But, that's only half the challenge. The other half are those seemingly unrelated factors noted above: what are they, and how do we find them?

PERCEPTION OF NEED

A study done in England several years ago involved a series of experiments in which researchers asked a group of women to go into a store and select what they thought were the best products from a list of clothing items: sweaters, jackets, gloves, hats, shoes, etc. The list of clothing items they were given were designed for cold weather, but they were not told to shop in preparation for cold. They could choose whatever they liked based on any criteria they wished: color, size, texture, price, function, anything, as long as the items were on the list. The following week, the same women were brought back in and told they were going skiing, and that they should purchase anything they liked for the trip from the same list of items they were given before. When comparing the choices they made when

they didn't have a specific need to those made when they did, there was a pronounced difference: *not one item on the two lists were the same.* The clothing they chose for "no reason" were light, bright, and fashionable, whereas the clothing chosen for the ski trip was mostly heavy, functional, and durable.

A similar study was done with women and kitchen cutlery with similar results: when given a specific need, choices were very different from when they were just judging based on what they thought were "appealing" without a specific need or task. The hypothesis: When people are looking to fulfill a need, their searching techniques are focused on very different criteria than when they are just browsing. Researchers who study buying habits of consumers advise their retail-store clients to place the "browsing-friendly" items in the store windows, but leave the real "quality" items inside, past the so-called *decision zone*, where shoppers move from the objective, free-style browsing mindset to the problem-solving "I gotta have that" mindset.

When making a portfolio or marketing piece that you send to art directors, do you choose images that are artsy, abstract, and clearly demonstrative of your "tactical skills with a camera"? Or do you show those from other client shoots that demonstrate you know your market and how to address real-world client needs? In each case, how will your collateral be perceived by an art director under either of the following conditions? (1) Just browsing, looking for the interesting image that catches the eye; and (2) problem-solving, looking to find a photographer right away because no one on the "go-to" list of shooters is available. Answer: There isn't one. The same person can be in either mode at any time, so you have to know the client and the conditions.

Designing any marketing collateral must consider these factors, and we see evidence of this working sometimes: portfolios often have content that appeals to the "browsing mindset" when they use the artsy black-and-white photos. Yet, since there is that risk of not knowing which mindset the viewer is going to be in when reviewing *your* material, can you place that person in the right frame of mind to view them?

This is called *positioning*, which has a dual definition: you're positioning yourself, but you're also positioning the viewer to be receptive to the ideas you are presenting. It's sort of like setting up people in a photo (positioning them) because you know ahead of time where the camera is going to be (where you position yourself).

Positioning yourself in someone's mind before he sees your portfolio can only be done by direct contact and communication beforehand. Business is about relationships, and building relationships is rarely achieved by knocking at the front door where everyone else is also trying to enter. Circumventing the traditional crowds is not only smart, but it often has other indirect benefits as well. However, this isn't just a strategy that you "do," it takes planning ahead of time: you have to know about your clients, have awareness of their businesses, who *their* clients are, and any other information you can use to understand what's important to them. Once this is known, not only can you be useful in bringing in new business solutions, you also position yourself ahead of everyone else.

For example, sending an e-mail to the art director requesting an opportunity to send her a portfolio will get either one or two responses: yes or no. And, even if it's yes (which it usually is, if for no other reason than art directors have to maintain a certain degree of PR), your portfolio is going to be reviewed under the worst possible conditions, as we discussed. So, upon first contact, it may be more effective to send an e-mail that speaks more about your contribution to the company's business.

Dear Ms. Crabtree:

The ad campaign that your agency did for Acme Rubber Chickens reminds me of one I did for the agency that produced the campaign for Whammo's Whoopee Cushions a few years ago, and it struck me that my experience may benefit you. Since my client has since been under investigation for insider trading with the SEC, I'm in the market for a new client in this field. If you have time, let's talk on the phone about how my experiences can benefit your business.

Sincerely,
Dan
www.danheller.com

You'll notice that there's no discussion of sending a portfolio, a résumé, or anything. It's clear that you're already in the business, you know what you're talking about, *and* you have something to offer. It's assumed you have a portfolio, so if Ms. Crabtree has anything to say, it would *at least* be a request to see a portfolio. (Better art directors will reply to your e-mail and ask you to elaborate; some might actually call.) Even in this case, it's far more likely your portfolio would be reviewed with a more favorable mindset than merely sending it unsolicited.

It should go without saying, of course, that you actually have to have something constructive to say. You can't lie your way into this using clever dialog (as my example intentionally avoided). You'll be discovered right away. So, you must actually *have* the experience you say you have and the business advice to share on the subject from your past experiences. This all ties into some of the initial axioms discussed in chapter 3, "Photography and Business Sense": you have to *shoot what you know*. Knowing the business behind the subject of your photography is far more critical to your success than the mere ability to shoot good pictures. Walking into an industry without any preexisting knowledge or experience (whether you're a photographer or anything else), will not likely get you very far, unless and until you gain that kind of "insider" experience. This asset is pivotal to your marketing success.

THE VALUE OF BRAND RECOGNITION

The most influential aspect of any person or product is "brand recognition." If you have a good name and reputation, you're way ahead of the game. That's an obvious observation, but the deeper analysis is judging your proximity to others. Those with more or less name recognition than you can either be a benefit or a hindrance, depending on various contexts. First, let's examine the basics of this phenomenon and see how it ties in with your positioning efforts.

I call your attention to a very public and painful lesson learned by the Coca-Cola Company in the 1980s. Taste tests among consumers showed consistently, and by a wide margin, that people preferred Pepsi over Coke. Pepsi had its studies showing this, and marketed it as "The Pepsi Challenge." While the ad campaign was highly visible, the study itself didn't get much notice outside of the academic circles and industry insiders. This, until Coke themselves did the same study and found the same results. In fact, repeated studies from independent groups in

many countries showed that when people were not aware of which brand they were drinking, Pepsi was always the preferred drink. As a result, Coke launched an entirely new product called the "New Coke," shocking the industry with the revelation that it had changed it's secret formula of well over a hundred years.

A multimillion-dollar ad campaign featuring Bill Cosby declared that Coke now tasted better than the old Coke. Indeed it did, too. Even follow-up studies, also by independent groups, had data supporting this. Yet, despite this concrete evidence, it was perhaps even *more* shocking to witness the enormous backlash from around the world against Coke after the announcement. People were just as viscerally adamant that the old Coke did, in fact, taste better. After a few long months of terrible press, the company was forced to go back to its old formula under the new brand name "Coke Classic."

The event was so monumental that the word *classic* had gained its own marketing appeal; since then, products have been introduced ad nauseum with the word *classic* appended to it. "Classic rock," referring to the music of the seventies, was born shortly after the Coke fiasco.

So, what happened? Why did people like Coke so much, even though they *didn't* like it when they didn't know they were drinking it? Massive speculation and psychological pontification was dedicated to this subject for twenty years, but many people refused to acknowledge what was the only plausible explanation: brand recognition. That is, people liked Coke because they liked the brand name. But, can it truly be that simplistic? Can one actually change one's own perception of taste without being aware of it, simply because they are loyal to a brand name? The notion that a chemical response in the brain to alter one's perception of taste was so unthinkable that no one was prepared to accept this as "the" explanation. The only way to surely tell is to design an experiment that objectively tests for these brain functions.

Fast-forward to 2003 and a high school student with a spare MRI machine at her disposal. In a report from NPR titled, "Neuromarketing: The New Horizon," the results from the Pepsi challenge can actually be visually examined. In the experiment, "active MRI" scans of people's brains were done to gauge their reactions to Pepsi versus Coke in blind and control-group taste tests. People were first given a blind sampling of Pepsi and Coke, and their brains were analyzed to see how they

reacted to each. When they tasted Pepsi, the brain activity in areas known to be responsive to "pleasure" and "reward" spiked up. When given Coke, nothing happened at all. No pleasure, no reward. Simply no change. However, when the subjects knew what they were drinking ahead of time, the results were surprising: while the reaction to Pepsi didn't change (high spikes in the stimulation part of the brain), the reaction to Coke spiked even higher than Pepsi and even stimulated areas of the brain that had shown no reaction before.

Testing the Pepsi Challenge teaches several lessons:

1. Familiarity and a positive brand perception not only affects decision-making, but it also can have a more stimulating effect on the human brain than the product itself (similar to the "placebo effect"). We see evidence of this all the time—musical groups release a new record and fans love it, despite a later critical fiasco. Movies and actors benefit from the same effect. And yes, even photographers who achieve a certain degree of fame seem to "do no wrong" in the eyes of many.

2. People are unaware of how their own tastes are affected by product awareness *and* they will vehemently deny that they are influenced by such factors. I don't want to isolate photo editors and art directors out of respect for people in my industry, so I'll just refer to talent scouts who review bands for record companies. Or, better yet, the two-year-old who picks up the winning rubber ducky.

3. Positive brand perception can make your product appear better than the competition, *even if your product is inferior.* (Yes, this is brand *perception*, not brand *quality*.) If the Pepsi Challenge isn't example enough, how about *your photography?*

- **Real-Life Example #1**
 Nothing drives a point home more than seeing the results of this phenomenon happen to yourself. The first time I experienced this was when I entered two photo contests in my area. I submitted six photographs to two county fairs, the Marin County Fair and the Napa County Fair (in California). The Marin fair, in the county

where I live, was the larger of the two, and five of my six photos won ribbons ("Best of Show" all the way down to "2nd Place"). Only one photo didn't win anything. I then entered the same six pictures in the Napa County Fair, which is the county north of Marin. Here, only one photo won a ribbon, and it happened to be the very picture that didn't win anything in the Marin fair. At first one thinks it's just a matter of different judges. But then again, I am from Marin County, and my name and work are known in the community. Might that have had a subconscious influence on the judges in my favor? Might the same thing have given precedent to a photographer from Napa County for his work ahead of time?

FILLING A NEED

Earlier, we discussed the value of the "perception of need" and how people's choices are influenced by their own business objective, supplanting what their "creative" decisions might dictate. Yet, "brand perception" also plays a role that can exist on many levels. Now the question is, how do the two play off one another? Does the phenomenon of *filling a need* trump the value of brand recognition? The Pepsi Challenge suggests not, but let's face it: Coke has a pretty strong brand name. Most photographers don't achieve that level of success, so we can safely say there are spectrums of each. How can we test which of "need" and "brand perception" can have a greater effect at any given time so as to help guide our marketing strategy?

What we really want is a way to test the *same* subjects judging the *same* photographs, but each in different contexts: once when the subject knows the photographer, *not* in the problem-solving mindset, and once when the subject does not know the photographer, *in* the problem-solving mindset. At issue is whether one can judge the same material in two different contexts and not be aware that it is exactly the same material. It is hard to do with photography because one can't do a "blind test" on the same physical photograph. Once seen, it's judged. Or is it? Fortunately, I have had encounters with art directors that help to test this theory.

- **Real-Life Example #2**
 At another ASMP meeting (not the same as previously discussed), art directors were discussing how they like to be approached by photographers, how they judge portfolios, how they pick people for

assignments, and so on. It was a similar topic, but a broader discussion than the previous talk.

One of the panelists was with a very well-known magazine here in California. Getting work into this periodical was difficult, and doing so was worth putting on your résumé. Once again, the panel discussion was all the same old stuff: what kind of prints they like to see, what's the best way to approach them, yada yada yada. At the end of the meeting, the panelists spent time looking at the portfolios people brought and gave the kind of feedback normally reserved for those lucky ones who get their portfolios into the director's office on a normal business day. Oh, how lucky these people were. As each person went by the desk, it was clear that most of them had pretty impressive work, and the art director gave them thoughtful feedback regarding how the size of the prints could be adjusted here or there, or how not to use reflective pages where the photos slide into sleeves, or not to put too many photos in, how to have a good variety but not too broad, etc.

When my turn came up, I said that I didn't have a portfolio because all of my work was on my Web site (which was on the business card I gave to each panelist). The editor for the famous California magazine responded by saying that he *only* looked at physical work, that he doesn't trust what he sees online, and that he doesn't have the time to look at everyone's Web sites. He also had serious personal doubts about the use of the Internet as a viable platform for photographers, and he took the opportunity to express this doubt to the entire auditorium. He didn't take my card, so I took his instead.

About a week later, I e-mailed him reminding him that my Web site was as easy to review as the e-mail he was reading, and that if he'd just click on the link, he could spend a lot less time than if he were wading through a huge book of photos. He replied saying that he normally never looks at Web pages, but seeing as I was at the ASMP meeting, and that he'd agreed to look at portfolios, he'd make an exception in this case. After having seen my site, he determined that, while my photography was technically proficient, my work wasn't unique enough, that it was too similar to everyone else's, and that I didn't have a personal vision in my work. I thanked him anyway and moved on.

About six months later, I received an e-mail from the same editor, but it was clear he had no idea who I was:

Dear Mr. Heller,

I came across your Web site recently while I was searching for a photograph that we need for our front cover to illustrate a story we're doing on hiking in Marin County. But, seeing as we're based in San Francisco, we want to have some of the city in the background. You have such a great series on this subject, and your Web site is so easy to navigate and well designed, that I'm surprised we haven't done business before. Please send me some slides that we can use for this cover shot and we'll be happy to pay your normal license rate.

I was just *itching* to tell this guy the whole story about our previous exchanges! Alas, that had to be left for my own pleasure (and now yours). Instead, I replied that I do not send physical slides, that my images were already in print-ready digital format, and all he had to do was indicate which one he wanted and I would electronically transfer it to his layout department staff. He replied again that he was so encouraged because most photographers he dealt with only used slides, were not digitally aware, and that I'd just made his life easier. (And this is the guy who didn't believe that the Internet was a viable platform for photographers!)

This story is not unique, although it is the most entertaining and poignant. I've had similar exchanges with editors who use their positions to pontificate their opinions on portfolios or other aspects of photography, only to find that when it comes to making *business decisions*, those views rarely apply anymore. All of this supports the lesson learned by the studies talked about earlier in this chapter: the psychology of choosing yields different results when one has an idea of what one is looking for, versus when one is "just browsing." It is almost never the case that portfolios are reviewed in the right state of mind, making the entire effort risky at best.

Indeed, when it comes to photo editors, art directors, and publishers, they are so used to having people come to them, their shields go up. They're not in the frame of mind to objectively view works for

consideration. This is understandable (albeit not optimal), because they get so many people throwing themselves at their feet that shielding themselves is often the only way to deal with them.

The Status Pyramid

We've alluded to the fact that the perception of who you are (or who you aren't) has more of an effect on your outcome than your product itself. These variations can be encapsulated in what I call the *status pyramid*, a tiered hierarchy of four levels, where your ability to gain access, respect, sales, or other resources in business is affected by where you reside in the hierarchy.

1. **Brand Recognition.**

 As illustrated by the story about Coca-Cola and its lesson in public relations, brand recognition is the brass ring that everyone strives for. It is the hardest to achieve but also the most stable and long lasting. It carries the most weight of any other status level, and with it great benefits; it even has financial value, also called *good will* (see chapter 4, "Starting a Photography Business"). The scope of this recognition can also vary. Coca-Cola may have a strong brand when it comes to soft drinks, but they pale to the Nike "swoosh" logo when it comes to clothing (according to each company's income statements, which are available online). Applying your goodwill only works when directed properly. A well-known travel photographer is unlikely to compete as effectively in the fashion photography world and vice versa. The lesson here is not to let your head get too big when trying to broaden your target market.

2. **Indirect Name Recognition.**

 When someone *else* with status and influence knows you and escorts you through the door of opportunity, you are said to have *indirect name recognition*. Someone else gives you opportunity by letting you use his or her name, status, and influence. This person is also called the *coach*—the individual who champions you or your products to the decision-maker. The coach can be passive, like a fly on the wall who is your eyes and ears reporting back on what he perceives to be your strengths and weaknesses, what or who your competition is, and advice on what to do next. Or, coaches can also be active, overtly

promoting you. The coach has no decision-making power (or he'd just hire you, in which case, he's not a coach, and you have no "indirect" influence on the decision-maker). Instead, it is the coach's status and perceived objectivity by the decision maker that is often the most powerful leverage you have.

Whether the coach is within a client company or is the best friend of the woman whose wedding you want to shoot, your coach is often the person entrusted by the decision-maker to choose who to hire. A photo editor can be your coach to the art director. An art critic can be your coach to the museum curator. It can even be your mother-in-law. Whoever it is, the coach is the most used catalyst that enables an unknown photographer to get hired.

How you *meet* the coach is less a product of direct marketing, since you don't target them. Instead, you meet him through more informal means, such as a series of informal discussions on a photo forum on the Net. The coach may want to help his friend or employer or get the indirect benefits of raising his own status within the organization by helping with a problem.

Now come the warnings: coaches can be goldmines or disasters, depending on *their* status. If your contact doesn't have the status you thought, or his clout is not as strong as he led you to believe, you could end up peddling in first gear for a long time. I once had a contact at a company that I learned over the course of a year that he was demoted from management due to a poor recommendation he'd made before. He was hoping to use me as his redeeming act, but they never gave him the chance. Indirectly, I never got that chance either.

Many artists reject the tutelage of the coach because they feel they're cheating the system, or that it would discredit their status. ("Oh, John's mother pulled strings and got his work accepted at the museum.") That's your personal decision, which, from a business or financial standpoint, is dreadful. One's sense of accomplishment and success isn't always about making "good business decisions," which may be important to you. If your goals are beyond financial in nature, and you're strictly a purist, go for it, baby.

Understand that the coach is a double-edged sword, and both

parties have to be cognizant of this. You are at a disadvantage because of your lower status in the organization, so you are entrusting your coach to work on your behalf. And they are entrusting you to help them as well. This is a mutually dependent relationship. But if it doesn't work out, only *you* bear the responsibility of the consequences. Directing your misfortunes onto someone else makes for good sob stories, but it doesn't help your career.

3. Status Potential.

Someone with *status potential* is one who has no name recognition, and no coach, but enough tangible experience, skill, and ingenuity to get work anyway. This is the most noble of all forms of accomplishments loaded with romantic overtones, since this person was discovered for the "right" reasons (his talent). If you can do this, great for you. Often, it's because of this that you find a coach or gain the attention of the decision-maker, so one doesn't usually stay in this position long. (If so, maybe the "potential" wasn't really all that strong.)

At the same time, those who succeed based on their own merits fall into the trap of thinking that it was *all about them*. There is that lottery (randomness) factor that should never be forgotten; far more people have merit than there are positions for, so, if you gain access because of your merits, don't assume that you can always rely on merit alone. Your lottery ticket can be revoked as randomly as it was picked if you don't work diligently to establish your name recognition, which minimizes the randomness factor. In other words, you still need to apply smart marketing strategies, as well as use the analysis tools outlined in this chapter. Remembering this will not only help you to maintain perspective that will keep your head in the business realm, but also the quality of "humility" has great personal benefits.

4. The Bottom.

Everyone starting out asks, "How do you get yourself known?" It's the age-old dilemma, and a circular dependency, to boot. If you are continually overlooked because no one knows who you are, how do you get noticed in the first place? Asking this question is putting the cart before the horse; status is what you gain while you're busy building your career in other areas. You shouldn't strive for status; instead, it is a by-product of having done everything else right.

From a skill or creative perspective, there is no difference between the bottom of the status pyramid and being at the second stage, status potential. The *only* difference is where you get work.

Raise your hand if you have just been ignored completely by a photo editor or art director, despite repeated e-mails, phone calls, and other nice attempts at contact. Raise it higher if you have had a photo editor treat you condescendingly. Put your other hand up if she said it wasn't because of anything *you* did, but because of her having to deal with whiney photographers that can't take no for an answer. Yes, even those with status may run into indifference and downright rudeness from anyone, ranging from other photographers to potential clients. We're all familiar with the phenomenon. (Okay, you can all lower your hands now.)

Technically, one should never even *be* at "the bottom," and if you are, one or more of these conditions might apply:

- **You may have launched your photo career prematurely in the first place.**
- **You are focusing on the wrong market segment.**
- **You are not leveraging other resources that you have.**
- **You are simply poor at managing your marketing skills.**

If you are just getting started, you should enter from a background where you have some experience and expertise, as discussed in chapter 3, "Photography and Business Sense," because *those* are your assets. Remember, your contribution as a photographer doesn't start and end with "taking pictures." You're part of a team addressing broader business problems. Your marketing strategy is all about focusing on whatever *those assets are*. If you have none of these "assets," marketing just your photography won't do anything for you.

If you feel you need to crawl up the ladder, that's okay. But, that doesn't have to imply *clawing your way up* either. There's nothing smart or admirable about going at it "the hard way" if more intelligent approaches are available to you. If you're at the bottom and can't get out, you have other areas to address before your marketing plan can be put into motion.

The Status Switch

Photographers are usually at the short end of the "status" stick because the supply exceeds the demand (see Truism #1 in chapter 2, "The Five Truisms of the Photography Business"). This is especially true for those trying to break into the business. There is an indirect negative effect from this population because, even though inexperienced photographers may be inert, they are a "mass with gravity" nonetheless, meaning that those who hire photographers have to deal with them. It's sort of like having a store full of people who never buy anything: it's hard for the merchant to deal with the "real" customers simply because they have to deal with the distractions of the "masses." Figuring out who those real customers are is hard because they all "claim" to be. The one reason the "masses" hurt professional photographers is because the client's perception of "most" photographers falls to the lowest common denominator: the "masses". Here, you have to try *harder* or be *more compelling* than you'd otherwise need to be, just to rise above the fray. This challenge means that sometimes you can't just depend on raising your status on your own merits. It may have to be raised some other way to get recognition. One often resorts to the risky method of the *status switch*. This is the act of changing the perception of your status, either by "creative accolades of yourself," feigning intellect, bloating success stories, blatant lying, or, the riskiest tactic of them all: lowering the status of the other guy (to make you look bigger by comparison).

Sometimes, these tactics actually work. Don't pretend to be surprised at my suggestion! How many of you have "enhanced" your résumé by glamorizing the success of a previous job or assignment? *Hmmm?* Or by citing an award you got that appears to be much more worthwhile than it actually was. One photographer who applied for an assistant job for me said he won "best of class" at a prestigious photo competition. But, when I looked into it, his was the only entry because the designer who made the entry form failed to add that class into the competition, so no one else entered it (nor was it prestigious).

There's no question that fabrication of successes and other status-raising tactics are used in self-promotional materials, interviews, and general discussion. But, as you can guess, there are risks with this. Failed attempts to raise status are usually the result of a misconception

of the photography business, or by a social faux pas, intentionally or unintentionally committed. Several examples follow:

- **Money Doesn't Have Status**

 As discussed in chapter 1, "Read Me First," money does not hold the "high status" for photo buyers or agents. It definitely won't get your foot in the door ahead of more seasoned pros. In fact, most photo buyers want to work with photographers who are "hungry," because there is a sense that they are more ambitious, that they'll work harder, and that they have more to offer creatively. If anything, a photo editor or art director doesn't want to be upstaged by the photographer, especially one who makes his financial status so conspicuous. Sure, editors want to pay very little for images or assignments, maybe even get someone to work for "free"—after all, business is business. But, at the same time, these people know the difference between getting a good deal from a bona fide pro photographer and getting a white elephant.

- **Name-Dropping**

 The main problem with name-dropping in general is that most people perceive it to be pretentious and immature. At least, unprofessional. There are several forms of name-dropping, including the obvious: feigning or exaggerating your relationship with someone else with higher status. This is a fool's way to pretend you have an inside coach. As noted in the earlier discussion, the coach is either actively involved—in which case, you don't *need* to name-drop—or quietly and passively acts as your inside secret agent—in which case, you don't *want* to name-drop. If you have a relationship with someone of status, you shouldn't be name-dropping; you should be actively and intelligently utilizing this person to your benefit. If this person is uncooperative, there's either a good reason for it (so you wouldn't want to use him), or he's just not going to be the effective advocate that you need.

 Another form of name-dropping is to identify a high-status school you attended or a client you worked with, if neither has anything to do with photography or the business into which you are entering. For example, if you want to break into news

photojournalism and went to Northwestern University, a school with a great journalism department, but it turns out you majored in computer science, then you'll get dinged for that. Using myself as an example, I've had a photograph published in *National Geographic*. Twice! But I don't use them on my résumé because all the magazine did was license a couple of dumb pictures from my Web site, and they weren't even used in major articles. It's not like I got an assignment from the magazine, which is where the real status is. If I had, you bet I'd highlight them! But, as it is, I already have great references; if I padded it with irrelevant citations, like *National Geographic*, which didn't really use an important image, how would I look if I were ever questioned on it? Using quality references is good, but keep them relevant. If it's obvious when you're trying to pump yourself up dishonorably, it suggests that there really is no substance under the hood.

- **Social Status Is Not Transferable**
 If you happen to be famous for something other than photography, don't assume it's transferable to the photo community. Status is established very differently here, because the industry is very insular and incestuous. If you're a well-known microbiologist who found the cure for a rare toe fungus, you may bring the house down with your keynote speech at a pediatrics conference in Des Moines, but you're not likely to get *Travel and Leisure* to publish your vacation photos.

 Having achieved a level of personal success is a double-edged sword. If you feel you have status for whatever reason, and the other party doesn't acknowledge it, the relationship usually fails to materialize. Hence, fiddling with status is delicate and risky to a business relationship.

 For some, the act of raising one's own status has the unintentional and undesired effect of lowering others'. And *that* is threatening to many people. A common example is where an insecure photo editor deals with a photographer whom she feels threatened by, due to his higher status. Here, she may focus on sustaining or raising her own status. And while all this status wrangling is going on, photos will not be judged fairly. The lesson: Do not become a threat. Status jousting is never successful, and arrogance is a sure way to start a fight.

We've reviewed the techniques and pitfalls of artificially raising your status. But there are times when you unintentionally raise your status, or just have to deal with those potential negative situations in which having a higher status can be an albatross.

For example, if you actually *are* dealing with someone who isn't as senior, or isn't that bright, or both, and you really should be dealing with someone at a higher level, you can be in a real pickle. Often an art director uses a junior-level photo editor to "weed out" nagging photographers, which can cause the "threat" problem mentioned in the previous section. Or, it may be that smaller publications use less senior photo editors to fill a needed position, and those editors are given too much responsibility for their level of experience. (They are often hired because the publication can't or doesn't want to spend the money on more senior-level people, or that they simply misunderstand the true nature of the job and oversimplify its character: "Go find pictures! How hard can that be?")

Here, you have no choice but to deal with these junior-level people. Some are aware of the difficult situation they are in, and some aren't. Those who are cognizant and accepting of their role can be good partners because you can help them through some tricky aspects of their own jobs that you may know more about than they do. I've worked with enough photo editors that it's easy to spot those who are less experienced. Fostering a good relationship with such people can work to your advantage. (In other words, you can be *their* coach.)

In so doing, beware of those who are insecure and are more afraid of looking bad to a more experienced person. It's hard, if not impossible, to teach or help someone who may be predisposed to defensiveness, leaving you with no other option than just employing good old-fashioned interpersonal skills. For advice on *that*, I have none; you either have it, or you don't. But please understand, whether you think you're from Mars or from Venus, remember one thing: we're all still here on Earth, so don't stray too far from reality in this department.

Presenting your "intellect" has the potential drawback of making you appear arrogant and presumptuous. Yet, I have learned that those who draw such conclusions are generally shortsighted themselves in

how they conduct their own businesses, and you're probably better off without them. Those who are threatened by others with higher status often see them as arrogant, even though they aren't. If you've achieved any level of success, you have undoubtedly run into someone who told you that you were arrogant, and there's nothing you can do to convince him otherwise.

My goal in this chapter has been to highlight the issues you will face so you can choose effective marketing strategies. Historically, the *push marketing* method was the best and only choice for most photographers, despite its drawbacks. But, as digital imaging and the Internet allowed for cost-effective marketing and distribution, the lure of *pull marketing* quickly supplanted the push approach. Most photographers should prioritize their Web implementations before others, since it has become the most ubiquitous and easily accessed form of communication and portfolio presentation. (It doesn't have to be a full-fledged site, just the preliminaries.) Specialty photographers with clients in the local community may also need to focus more on regional marketing tactics, such as newspapers, magazines, and phonebook ads.

Once you've decided on a set of strategies, be resourceful and find good reference materials that help you implement them. For example, if you've determined that a glossy portfolio is required for sending to market directors in ad agencies, don't just pick up any old book on "how to create a portfolio"—find those that specifically target the advertising market for your kind of imagery (fashion, consumer products, glamour, etc.).

Most of this chapter challenges the well-accepted assumptions of traditional marketing techniques, not to discourage their use but to bring attention to the effectiveness of these approaches; you can best manage your time and resources by focusing only on those activities that have the highest chances of success for you.

Since the ideas presented here are general issues for each person to consider for himself and his own personal goals, it follows that no two photographers should follow exactly the same plan. And if they do, it will have been by happenstance if they yield the same results. There is *no* predictable, reproducible formula for marketing yourself

in this business, no matter how convincingly it may be portrayed in some book, class, or workshop. To best grasp how to apply these techniques to your specific objectives, you need to be clear in what your specific goals are, and not spend time on tasks or processes that aren't leading in that direction. I realize that may sound like I'm skirting the issue, and if so, I direct you to chapter 3, "Photography and Business Sense."

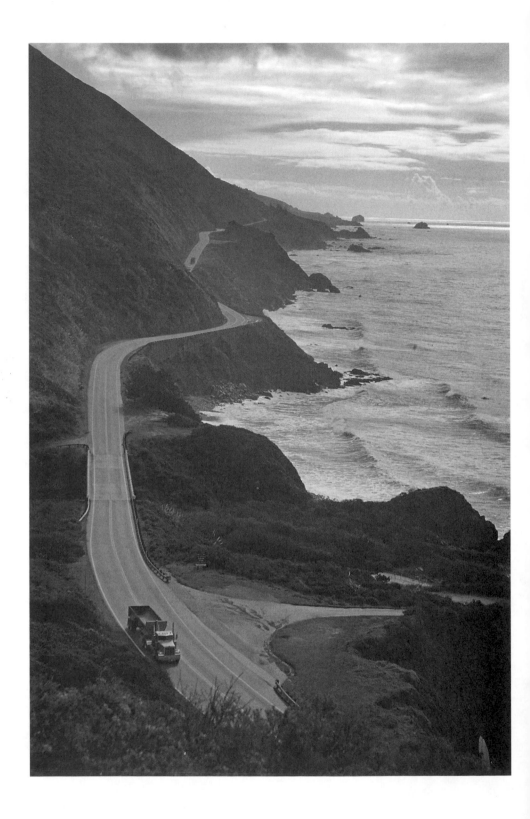

PHOTOGRAPHY PRICING 6

Wouldn't it be nice if there were a game show like *The Price is Right* for photography?

"Bob, I bid $200 to use that photo in a corporate brochure, printing 5,000 copies!"

Bzzzzzt!

"Sorry, Dan, but that photo is worth $3,000 for that use!" (Huge gasp from audience.)

Finding the right price points for selling photography or bidding on an assignment is the Holy Grail of the photography business. What do you charge for licensing an image for an ad in a magazine, a billboard, or for a local merchant's Web site? What about pricing a photo shoot of a parade for one of the corporate sponsors? How about a wedding? No matter what the product or service, pricing is the most daunting problem facing all photographers in their first years, and it seems there is no sure-fire method to finding what works. The natural thing to do is research price charts or guidelines, but as the industry has evolved and competition has grown, such data points are no longer reliable. What's more, it's not that simple. Even veteran professionals get frustrated by the volatility in pricing, not just among different clients but in the way the same product can vary dramatically from one case to the next.

Photography is unlike any other profession in the world, in that it's perceived value straddles between two definitions. On the one hand, it's a *commodity*—a mass-produced, unspecialized product ready for commercial exchange. Here, the same product can be found from many sources, and it's just a matter of finding the lowest price. This usually applies to consumer items like radios, cars, or any sort of widget you find in the mall. Making it more challenging is the perception that photography is "easy," and getting easier with digital photography. On the other hand, it's a *value add*—a conceptual representation with individual uniqueness that enhances another, greater product, be it a consumer item, a service, or a public image (like a corporate logo). Here, a photo can demand its own price based on the degree of

111

perceived value and need of the buyer. Unlike a commodity with fixed and comparable price points, a value-added sale is subject to negotiation. What's more, there is no consistency in those negotiations. Two different sales scenarios that involve exactly the same image, for the same purpose, and in the same marketplace, can demand greatly different price points, simply because the client is different (or the photographer).

This chapter looks at the various strategies associated with pricing images or services. This includes more than just pricing "policies," which may be rules of thumb for price adjustments based on certain variables. "Strategies" exist at a higher level, where policies are modified according to an intuitive sense for sales as unique transactions.

Sales Basics

To understand pricing, one must understand the *sales cycle*, which starts with the product itself, then how it is marketed, and, lastly, interactive negotiations (otherwise known as the *sales process*). For purposes of this chapter, I will only discuss the commercial realm (licensing images and assignments and services). I will not talk about photos sold as fine-art here.

THE PRODUCT

What makes selling photography difficult is its intangible qualities; it has little "functional value," unlike software, whose value can be analyzed quantitatively by the amount of work produced. Photography's biggest disadvantage of all the art forms is its perceived value. A famous and rare print by Ansel Adams may only go for several thousand dollars, compared to the millions garnered for a painting by an equally well-known painter. Contributing to this is photography's "ease" and low expense in reproduction.

On the flip side, these characteristics become benefits: more people can more quickly identify and understand a photograph than a painting, making it more suitable for commercial use. That it can be easily reproduced makes it easier to sell in quantity in broader markets. But, these contradictory qualities don't always work in tandem. For example, the value of an image is higher if it is being used to advertise an expensive vacation package to Hawaii in Conde Naste's *Traveler* magazine versus an image used for a local newspaper ad for a pet shop. The fact that it's

an image has, in itself, no real value. Its perceived value is defined more by the buyer. (Hence, the seller has to detangle his emotional attachment to it.) Therefore, the *product* must be regarded as something that has no value until it is presented to the appropriate buyers in an appropriate market segment. This is vague right now, but that's why it is important to understand marketing.

MARKETING

The critical step in the sales cycle is marketing. Yes, before pricing comes into play, the most important component of selling photography is how it is packaged and presented (or the name recognition of the artist, if applicable). Marketing can preempt the perceived value of the product. Since marketing and pricing go hand in hand, they must conceptually agree with one another. Thus, the marketing "message" must be customized to the target buyer. The product itself is clearly important, but as we all have seen (and are frustrated by), even the most mediocre images (and photographers) can sell quite well if marketed properly. This isn't a new concept; it also applies to software, vacation rentals, horoscopes, and political candidates. So, above all, get your marketing right. It is strongly advisable to read chapter 5, "Photography Marketing" before this chapter, if only to grasp the bigger picture here. But, marketing can only go so far—it "sets up the kick," as it were. To really score, the performance must come from you personally. This comes in the form of the sales process.

THE SALES PROCESS

The sales process begins with pricing structures that must lie within the *circle of plausible possibilities*. That is, the customer has to believe it. You may have heard the expression, "If you don't like the price, counter-offer!" Well, that's way too simplistic for serious business discussions. Setting arbitrary prices with the expectation that you'll just negotiate from there will only alienate more prospective buyers than necessary. You can't begin the sales process if you don't start with the right pricing structure. As mentioned in the beginning of the chapter, most people think of pricing as data that can be listed in a chart. Indeed, there are such charts, and you may end up using some. But how you use them is an important part of the larger strategy. So, we must begin

by establishing a plausible pricing structure for your products in your marketplace. I propose the following foundation:

"Pricing a photograph involves finding that range of values that most of your likely buyers are willing to pay."

There are several elements to this statement that need to be made part of your sales paradigm.

- **First, I used the words "a photograph."**
 I didn't say, "Pricing photography. . . ." I said, "a photograph." Because each image is different, it will likely be of more or less value to any given client. You must establish a mindset that disassociates photography from the "commodity" pricing model. Sales is not done with a shopping cart. It's a process. This won't always apply, of course, and there will be times when you sell directly from your published price list (discussed below). *Negotiated sales* requires breaking from the price-list paradigm, and that will happen more often than not. Many photographers resist doing this because they feel they would be regarded as weak negotiators or that breaking from a fixed price list establishes a lower price precedent. That is definitely not true. Weak negotiators are so *not* because they "deviate" from the price list, but because they do so *poorly*. Accepting the fact that price lists are not etched in stone requires a mindset that you are not selling a bunch of identical widgets, nor to equally qualified clients.

- **Next is the phrase "range of prices."**
 It's counterproductive to think that you're going to set price points that (a) people will either accept or reject, or (b) apply to the broader global market. Selling is ultimately about negotiation, so your pricing tables should really be thought of as starting points for discussion. It's true that if you're selling "commodity products," like calendars or even prints, one rarely deviates from the price list. However, when it comes to a *consultive sale*, where someone wants to license an image of individual and unique uses, variables come into play that don't apply to the commodity market.

 For example, consider an image to be used at a size of 18 × 22 inches on the box for a game being distributed in the Pacific Northwest. There's a price somewhere for that—what, we don't yet know. Let's also say the request for the image is for two years.

That's a price adjustment. Let's also say they just want to use it in black-and-white—another adjustment. You don't go to a price list for this, and although you can establish "pricing policies" to cover various modifications like this, you optimize your return by understanding the "importance" the client places on the product. The greater their need, the greater the value of your image, the more you can edge those "policies" in your favor. Conversely, the lesser value your client places on it (or the lack of "uniqueness" of the image, etc.), the more willing you may be in relaxing those policies. The policies are considered your legitimate vehicle for justifying pricing proposals, up or down. Yes, it will happen that you need to lower your price to make a sale, but you need to save face; you can't just lower the price arbitrarily, or it'll appear your pricing was arbitrary. **Pricing** policies help protect your legitimacy because they give you "good reason." This is a fancy way of saying *negotiation*.

In summary, don't look at price lists strictly as the high point, after which you expect to come down. They are best thought of as "typical uses," where different terms and conditions can make the prices rise or fall accordingly. Your published "policies" may even articulate this point. (This sets up the buyer for expecting to negotiate.)

- **Last is the phrase "most of your likely buyers."**
As noted at the top of this section, you can't expect a price list to apply to the global market. Granted, that's a very loose and vague term. We live in a global market, but I'm not referring to geographical boundaries. You must identify your *target market*, preferably one that you know quite well (perhaps because you came from that industry in a previous career). For example, you make take pictures of cars to sell to racing magazines. Your pricing cannot be arbitrary; it has to be based on either empirical experience, where you know the business model of your buyers (consultive sales), or it has to be researched, where you understand the buying behavior of the market segment (such as commodity products). Whoever the buyer is, he usually has a preconceived notion of the value of what he is buying before he sees your product, and you have to either meet those expectations or convincingly justify a deviation. A discussion of this is found in chapter 3, "Photography and Business Sense."

When photographers seek out pricing tables based on published reports of historical sales, they fail to realize that those prices are based on negotiation sessions for specific uses, by specific clients, for specific markets. Having data about ranges of prices for very narrow market segments *may* be useful, but the narrower the segment, the less likely it is that there is a sufficient sampling of data points to give validity to any of them. In short, they're all circumstantial. We'll address this again later.

Deconstructing a Sales Strategy

Drawing on the information above, we can identify three major components of the sales process:

- Price list.
- Pricing policies.
- Negotiation.

Each of these can be considered a separate stage in the sales strategy. Once potential clients have responded to a marketing effort of some form and an image they're interested in, the first thing they see is your price list. From there, they usually establish contact, where you discuss various policies. (These can also be printed as part of your price list.) At this point, negotiations begin. Let's take each of these independently.

ESTABLISHING A PRICE LIST

Figuring out initial price points is the hardest part, because you need to establish that circle of plausible possibilities we discussed earlier. So frustrating, this is, that you may think you should have taken up cooking instead. (I'm just kidding; cooking isn't nearly as fun as photography because it requires a kitchen, which is dangerous for those of us who are cleaning impaired.) So, where do you establish your initial price points? Doing research on this is like having a severe mental disorder with hundreds of voices in your head: you don't know who to believe! Charts, research reports, coaching software, prices quoted on other photographer's sites, what your friend, Ed, told you, peer pressure (what other photographers on the Internet claim), and

industry associations all have something to tell you about the subject. Rarely will any of these sources agree on actual numbers, but they'll all claim to be right. The thing is, sometimes they *are* right! Given the thousands who constantly chime in with opinions, such as, "Hey Steve! Your advice to quote $500 for that image was right on!" it can sometimes appear that someone knows more than the others. When it comes to anecdotal evidence, remember this quip:

"Even a clock that doesn't run is right twice a day."

You can never base business decisions on anecdotal evidence, whether yours or that of a select group of people. You have to see in much broader terms.

There are various philosophies about the most effective strategy for determining appropriate price points. Most photo-industry groups point to formulas for determining prices based on historical models, for example. The price for an image licensed to a magazine was typically based on their advertising rates. For a full-page ad, the theory held, if the magazine charges X to an advertiser, your price would be a percentage of X (and that percentage never changes).

While this certainly feels fair and beneficial to both sides of the deal, this pricing strategy is not as well received (if even recognized) to a degree necessary to recommend this method. Using this form of "formula pricing" will yield just as arbitrary results as reading your horoscope will predict the future (unless you're a Libra and your moon is in Aquarius). While it's true that such formulas *were* the standard for the industry decades ago, and some media companies still use such methods for determining pricing, these exceptional cases cannot be relied upon in the general open market (unless you're a Leo).

There are software programs that can be purchased to assist in coaching pricing strategies. An example of this is one called Fotoquote (*www.fotoquote.com*), which is built from a database of statistical pricing from sources in the photo industry during the previous year. You can look up hundreds of different photo uses, with thousands of different variations on those uses, and see how the prices range from one extreme to another. To be sure, each of these provides some useful context by which you can gauge good pricing guidelines, complete with discussions on people's empirical experiences for such markets. Yet, despite the fact that I base my own price lists on this same data, very few of my sales actually match those prices.

There are two reasons for this. First, as mentioned many times already, most sales are the result of negotiations based on discrete conditions that cannot be generalized. It's like having people choose numbers between one and one hundred. The more people you add, the closer you're going to get to an average of fifty, but this doesn't mean anything. The numbers are random. If your objection is that there must be *some* basis for pricing in these scenarios, I would partially agree, but then I raise the second reason the numbers aren't justified: many license agreements are often based on multiple images, multiple uses, nonstandard sizes, or any number of complex exceptions that outnumber the "normal" rates described by a price list. We don't see any of that data at all. This emphasizes the randomness factor of the data points.

But that's not the only problem with sources that claim to establish standard pricing models. The broader problems that apply to all sources that claim to have pricing data are these:

- The data obtained is entirely voluntary, and there is no oversight whatsoever on the validity of sales data.

- Surveys only go to professional photographers, agencies, and companies that buy from them. Truism #1 in chapter 2, "The Five Truisms of the Photography Business," states that this is such a small and disproportionate representation of the entire market that the data itself fails statistical integrity.

- Even if one were to accept that the data only represents the narrower market segment of professional photographers and media buyers, the number of respondents still represents a statistically insignificant percentage of that target population.

Because "photography licensing" is entirely unregulated, because it's mostly comprised of semi-pros, amateurs, and even consumers, asking "photographers" how much they got for any given photo license is like asking a fisherman how big his catch was at the lake on Saturday: his hands spread a little wider every time he tells the story.

Does that make a program like Fotoquote and other sources invalid? Not at all! The positive spin is that it's still a tool; you just have to know how to use it wisely for it to be effective. Most people don't, which is why more warnings have to go out than praises. In fact, these are extremely valuable data sets if viewed through the lens of experience. I use Fotoquote myself on those few occasions when I'm asked to give a quote for a use that I've never come across before. I'd get a sense for some data points, and then I'd return to my modus operandi: talking to the client. More often than not, I'd get a sense for how he values his product, and its position in his business model, and use that to gauge whether the Fotoquote recommendations are closer or further from the reality of my situation.

At the end of the day, I'd say about 10 percent of my sales actually go for the prices listed in Fotoquote, but this isn't saying much in the bigger picture. Only time and experience can tell when to rely on data. I never recommend its use to beginners because it doesn't teach the far more valuable lesson of effective negotiation. (And, frankly, no one can.) As an initial bargaining position, Fotoquote can cause sticker shock for many buyers, and it only gets worse from there. A new photographer in the business has absolutely no idea how to recover from this kind of reaction. And since that will happen more often than not, the tool can be more harmful than useful.

Pricing Assignments

When it comes to assignments, whether "day rates" for an ad agency or the services of a wedding photographer, the same kind of data is available but, again, it's not that simple; in this case, for more tangible reasons. That is, a photographer doesn't wake up one day, decide to shoot weddings, and then look up price lists in charts. Instead, one eases into the business, either as an apprentice for another photographer or has some other affiliation with the industry. In short, one who starts his own wedding-photo business usually knows something of existing rates from previous exposure, experience, or contacts.

That *should* be the process for any photographer breaking into his chosen fields of photography, whether journalism, advertising, or even the adult market. No industry is simple, so it's best approached from the inside.

If you have an opportunity to quote an assignment and are completely lost about where to start the bidding, you should review the checklist in chapter 3 (see page 42). This won't help you determine a good bidding price, but it will remind you that the value of the assignment itself is probably worth far more than the money you may receive from it. (Therefore, you should do what you can to *get* the gig.) That's not to suggest you should bid low, just bid "appropriately," keeping the bigger picture in mind. If you lose the opportunity, you could be losing more than just the money you didn't get.

For what it's worth, I still get requests to quote prices for image uses that have me scratching my head. Sometimes, the best thing to do is just ask the obvious question: "Do you have a budget for this?" And if they squirm at that answer, squirm back: "I can't give you a price quote unless I get a better sense of what your overall project is like." People always know how much they want to spend on the entire project, if not the bits and pieces of it (like photography). Once you get a sense of the project, it's easier to figure out what their expectations are. If they're going to use a photo for a banner, and the banner costs $5,000 to make, they clearly place importance on the photo. If it's for a quarter-page ad that only costs $200 in the local paper, that's another piece of data for you. The rest is somewhere in the middle.

If you are reticent to establish your price points because you think they'll be set in stone, don't worry. I modified my price lists many times in my early years as experiences dictated and as refinement was necessary. In fact, as market conditions change, price revisions are inevitable. This is an ongoing process.

PRICING POLICIES

Once you establish an initial price list, even a grossly simplistic one, the next step is to formulate policies for how and when to deviate from those lists. These are usually simple, codified terms, such as:

- Per-image discounts for multiple images.
- Price tiers based on image sizes.
- Multipliers based on volume or distribution.
- Per-year reductions for multiyear terms.

- Incentives for encouraging behaviors that help you (such as listing your Web address in photo credits or other co-branding opportunities).

- Premiums (mark-ups) to discourage behaviors that don't help you (like *not* listing your Web address).

Pricing policies are necessary because most clients are going to have an infinite number of variations that you cannot write into the basic price chart. It would be confusing, let alone unwieldy. Buyers expect some sort of pricing policies to be in place, which even have the added advantage that such policies are regarded as "accepted price variations." For example, if someone tries to negotiate down a license fee, you could counter that he's getting a bargain because you've dropped the "multiyear multiplier, which would have added an additional 25 percent per year." He may still negotiate, but you're on a stronger footing when you have policies to justify positions. He may continually beat you back, but policies act as protective fortresses. Through all this, though, remember that you still need to sell the product, and your price just may be too high. Therefore, a finger on the pulse of reality is advisable. As you can see, discussing pricing policies borders on how to negotiate.

NEGOTIATIONS

Before engaging in any discussion on negotiation, one must have read and understood Truism #5 in chapter 2, "The Five Truisms of the Photography Business": all photographers are *not* equal, and are rarely paid similarly for the same work or image. How much you are paid, whether for an assignment or a license fee for an image, has everything to do with how well you *negotiate*.

While negotiation is a test of wits, and you can perform better or worse based on your command of communication (written or oral), it's important never to forget what you're negotiating about. It's not about the product, it's the *perception of value*, as discussed earlier. This is not a straightforward science, because it doesn't start out having anything to do with your images. It's the sense of value that the client has for the use of an image—*any image*. If the client has an ad to produce, there's a sense of value the company has for the photo that will eventually become part of that ad. Some clients value text, others layout, others

"imagery." Determine what's important to that client before you enter into negotiation but, no matter what, understand that you're *not* going to change this perception. You may be completely correct in your client's poor marketing sense, and that he should value images more highly in his overall message, but not everyone feels this way. If he does, that's great, but you're still in the same boat: you have to convince him of the value of *your* images (or the one(s) he's selected). Where you expect to end up, however, must take into account the client's abstract sense of value for images in the first place.

Once you know the client's general perception of value, there are a number of things you can do to influence his perception of *your* images. At the top of that list is who you are. The better you are known in your given market, the more value will be perceived by those in that market. (This is why it's important that you target the right market in the first place.) This isn't just about how well known you are for photography, nor does it even require your name to be recognizable. (Although, all of those certainly help a lot, as you know.) The broader point is that the better you know the client's industry (part of the "who you are"), the more legitimacy your arguments carry when you discuss business.

The next most important thing is how critical the image is to the client's need. If the image is to be used to promote a highly priced or image-branded product, like a cruise ship by a major cruise line's brochure, it's going to garner a much higher price than the same image used by an editorial magazine that writes about one of the trips from that cruise line. Same image, different use, different client. Hence, different perceived need. Where it gets more complicated is when multiple variables are at play.

To illustrate a more realistic example, let's consider two scenarios. In each case, we have two photographers, each of differing skills and backgrounds. One shoots headshots of corporate executives, the other shoots travel photography for vacation magazines.

1. Scenario 1.
 A company wishes to hire each photographer to shoot its building for the cover of its annual report. Neither photographer has extensive experience with architecture, but the "portrait" photographer has already worked with the company photographing its executives.

(Hence, he and his prices are known.) The company asks the travel photographer for a competitive bid.

2. **Scenario 2.**

A travel outfitter wants to hire one of the two photographers above to shoot a hotel that will be used in an upcoming brochure. Like the portrait photographer, the travel photographer also has little experience shooting architecture, but the outfitter already has experience with the travel photographer, and the travel photographer's prices are known. The company asks the portrait photographer for a competitive bid.

In a sense, you could say that the "job" is identical: shoot a building. Shouldn't the pay be the same? Unless both companies know each other and exchange notes, the likely case is that their price expectations are going to be based on the fees of the photographer they know, not the nature of the job. They're asking for a competitive bid as a sort of validation check—a form of "due diligence," as it were. Think about the different ways this could play out: If the travel photographer bids low in scenario 1, what does the client decide about their regular portrait photographer's bid? What if he bids high? Switch scenarios with the same question.

Now, assume that the travel photographer is perceived as the "better" of the two (by both companies). Consider how that affects the two questions above. Here, the complication adds a "reality twist" that many people underestimate. Once "need" has been established, the question is how it affects perception of price. That expectation is based on the history with the known photographer in each scenario but is complicated by the fact that each photographer's skill varies. Now consider these questions:

- How do the photographers bid, knowing that the other is involved? Does the better photographer lower his rate because he knows he's competing against a lesser skilled photographer who may have lower rates, and he doesn't want to lose the bid? Does the lesser skilled photographer lower *his* rates for the same reason?

- Do clients think they may be at risk if they hire the lesser skilled photographer of not getting what they really want, thereby prompting them to pay the higher rate for the better photographer?

- Does the client use the lower price point from either photographer to negotiate against the other?

If you think you know the answer to these questions, you're not thinking wisely about this sort of thing. There is no way to predict how people think and feel about this stuff at face value—you have to *know* them to understand what they think. What's their risk aversion? What's their price sensitivity? How important is it? As for the photographers, they too have challenging questions to ask. Should they lower rates in order to win the assignment? Should they keep rates higher to maintain integrity in their pricing? However you look at this, remember one thing: there is *no* universal truth about how to play this strategically.

The example above illustrates how perception of price and value play into the decision-making processes on all sides. Pricing "policies" are useful for handling whether to add or subtract a little here and there for variations on use. But, as you can see, it has nothing to do with how you handle negotiations.

Negotiation Sticking Points

Sticker shock is probably the biggest reason sales don't happen. And it isn't always because prices are high. Clients can dismiss products because they're too inexpensive, too. For example, the rage over royalty-free images on CDs was initially hot, but time has proven that, for most serious buyers, these images are pretty useless. The $300 or so that they spent isn't the real cost, it's the lost time associated with searching volumes of CDs, only to come up with nothing that useful.

Furthermore, sticker shock isn't always from the client; you might dismiss a client who offers a price you feel is so low, it's not worth negotiating. When you do negotiate, how do you find the middle? What is the "best" price? Again, review the checklist in chapter 3, "Photography and Business Sense" for other benefits beyond just the money you receive: you don't always need to reach the highest price, just the best price.

For example, look at the above price chart, where it indicates a price point of $1,575 for a full-page ad for a catalog with a press run of 500,000 units. What do you do if you get an offer of $250? Do you turn it down because you're under the impression that it's worth more? Which "truth" came first? The amorphous "statistic" of $1,575 from Fotoquote? Or the *tangible* offer of $250 that you know you'll receive if you accept it? It's a good question, and one that has very impassioned arguments on both sides.

Some clients actually do this: they dismiss price lists and negotiations completely and just offer a price. This is actually fairly common among bigger publishers or those who license images frequently. Here, the negotiation is easy: you accept or reject. (It may or may not be a good deal, but it is easy!) Here, the business decision changes a little. There's no question that by *not* taking the offer, that's $250 you didn't get. The question is, What are the longer term ramifications of this decision? One argument is that you've established a lower price point, making it more difficult to get a higher price from the same client in the future; or, that you've set your expectations unreasonably low and that you will under-bid future opportunities, undermining your own business. Many who

work in the industry would also curse you for doing so, arguing that you erode prices across the board, affecting not just your own lower rate but that of the industry as a whole.

The counterargument is not so straightforward. First, you never know what the reality of pricing is until you try it yourself. Everyone in the business has stories about how they dramatically underbid a sale (or many of them) when they were just starting out. In each case, they chalked it up to beginner's naïveté, that if they'd just "known better," or were more confident to stand their ground, they would have gotten the better price. While it's comforting to believe it's as simple as that, there's more to it. Sure, confidence and other elements play a huge role in negotiation, but you can't manufacture such a quality out of nothing. It's transparent. It's like pretending to be a tough guy in a fight. Unless you've fought before, you won't fool anyone.

For my business model, anything that requires *time* is costly, and I want to be paid for it. Whatever I have to do to close a sale is work I'm not doing for any other purpose than *that* sale. Once the sale is done, the time and work I invested is lost, and that's lost opportunity to be building my business in a much broader sense. Even the process of negotiating is time-consuming. The more work it requires, the more money I'm going to charge. Negotiations start on my price list, then I get to know my client (this isn't a drawn-out process; it's a short exchange of e-mails), and then it's about how much time I have to spend. Beginners often bid low because they do not yet have such awareness of time and other factors. Thus, they don't incorporate this sense into their communications, making it harder to justify higher rates or terms.

Broadly speaking, I like to confine any work I do to things that contribute to my business as a whole. When I work on my Web site, that work enhances my entire business. When I do research, I am getting new information that eventually translates to optimized prices. When I produce marketing materials, I do so in a way that I can reuse them over and over. Anytime I have to do something *again* is time wasted. Similarly, immediate payment speaks loudly, because I hate having to bug people in e-mail about late payments. When I can spend time doing things that generate new revenue, I'm happy. Slow me down, I'm unhappy and I charge money. (Okay, I'm happy then too, but I still charge money.) I stand firm when I know I *can* stand firm.

126

Seasoned professionals learn the subtle nuances and other cues that may suggest when it's time to stand firm, or how to maneuver the client in a way that makes the price more persuasive. Moreover, these cues are so subtle, they don't always know when they've sensed it. It's similar to looking at a human face that has a wide-eyed look. Is it fear? Is it surprise? Is it anger? Is it laughter? One can't always articulate what it is they see, but there is an intuitive sense for it that we develop over time. The same is true for negotiation: just because you may start out with lower bids doesn't mean that you could have done any better. Moreover, it doesn't mean that low bidding in the future is a bad idea either. You just have to develop the sense for it.

An example that illustrates how my thinking applies to a "low-bid" offer follows:

I happened to get two calls at the same time from two different people: one in Kansas, and one in New York City. Both were realtors, both dealt with high-end real estate property in their areas, and both wanted to use a (different) photo for a 4 × 6 postcard used for direct mailing to a targeted mailing list. The New York City realtor sold properties only over $3 million; the Kansas realtor's properties maybe would get to $250,000. By fortunate coincidence, I talked to the Kansas realtor first. He looked at the pricing guidelines on my site and paid the listed rate of $645. The New York realtor wouldn't even consider it. She wanted only to use the image in exchange for her putting my name and Web site (in small print) on the card. As most clients will tell you sooner or later in a negotiation, "Your name will be seen by thousands of people!" (Clients always use this as a form of negotiation to beat down prices. They also believe they know how to market you better than you do.) Anyway, there was just no way she was going to pay a dime over $100 for the image. But, as I've pointed out, that's $100 I would otherwise not have at all.

You probably assume I took the $100. Before I say, think about what you would do and *why*. Think of all the reasons for and against both decisions. Okay? Ready? The envelope please . . .

I didn't take the sale to the New York client, probably for reasons other than what you predicted. First, while it wasn't a main issue, there was an unusual problem in that I didn't immediately have the image in digital format, ready to go. I would have had to go locate the slide, scan it, and photo-touch it for dust and color calibration before giving

it to her. This often takes long enough that no sale is worth less than $300 (for me). Remember: time is my most valuable resource.

The more important reason was that she was just a difficult person. You never really appreciate how costly it is in time and other intangibles to deal with such people until you do it a few times. You quickly learn that it's never about the money; if they have a problem or an issue, you have to deal with them. A lot. If you think they were difficult in negotiations, imagine how they'll be as you continue with business. Whatever their problem is, it won't be an easy one to solve, because they often have issues well beyond that of business. Difficult people are so for reasons other than business, and they will continue to be difficult as long as you continue to work with them.

The third reason, which can apply to many more types of sales, was that I had no future opportunity with this client. She was a realtor who didn't license images often, so I had no incentive to give her a discount. I've had clients who are in need of images on a regular basis, and these customers deserve (and get) price breaks. In some cases, people "promise" to be future clients, and I always counter with, "Great! So, I'll give you a discount by selling you multiple images at the same time (now), and deliver the future images to you when you need them." This always shows their true colors. (Hint: I've never had a long-term client actually tell me he was going to be before the sale.)

Pricing Summary

Pricing is the hardest part of the photo business. You start with a target market segment, then create your marketing strategy, and then you go through the sales process. In each of these steps, you're going to fumble around a bit before you get it right—they do not have to be executed to perfection before you go to the next step. What you'll find, if you play it smart, is that successful pricing is the result of knowing your client's business model and the subtler nuances in their negotiating styles. So, let's review:

1. **Don't set pricing expectations on single-data sources.**
 While pricing charts provide great information to know and reference, you need to dispense with your emotional attachment to them. When you're getting started, consult many sources to get a handle on various price structures, but don't expect to reliably use any of them right off the bat. Keep in mind all the truisms discussed

in chapter 2, "The Five Truisms of the Photography Business," as these will help you maintain a business mindset and perspective.

2. Consider the cost of doing business.

All things considered, if it takes thirty seconds to e-mail an image to a client, that's worth a lot of money in the form of time and over-head saved, more so than if you have to locate a series of potential images that you have to send to the client, who then chooses among them. Even a paying client can be costly in indirect ways if you're not careful, so be sure you don't find yourself chasing what appears to be a hot prospect, only to find out that they suck up time and other resources. (And don't worry, you can't always catch it right away, as it's easy to accidentally fall under the spell of a high-paying prospect; I still do from time to time.)

3. Consider the benefits of the ancillary aspects of your business.

There is value in the form of marketing and name recognition for certain clients, and you should consider the intangible benefits of any given sale beyond just the money. While I don't place much value on some "photo credit" exchanges (I just "require it" out of hand and don't allow it to become a negotiating token), there are always exceptions. As such, certain barters are more valuable at one point during a career path than they are at another.

4. It's all about volume.

When it comes to total annual revenue, there are two basic sales mod-els: lots of volume of low-priced items, or fewer sales of high-priced items. The key is *all* about infrastructure and administration. If you work better alone and with clients on a one-on-one basis, you're probably better off with the higher price/low-volume sales model. If you are good at setting up and managing workflow processes involv-ing employees, you'd be better at the high-volume/low-price model.

If I had to part with any last piece of advice, it'd be to maintain crit-ical thinking. I found that simply knowing how the industry worked gave me better negotiation skills and a more credible platform to state my case for higher rates. But, the reality is that pricing is and always will be an amorphous concept that we never really grasp. You just have to get better at it without expecting to perfect it.

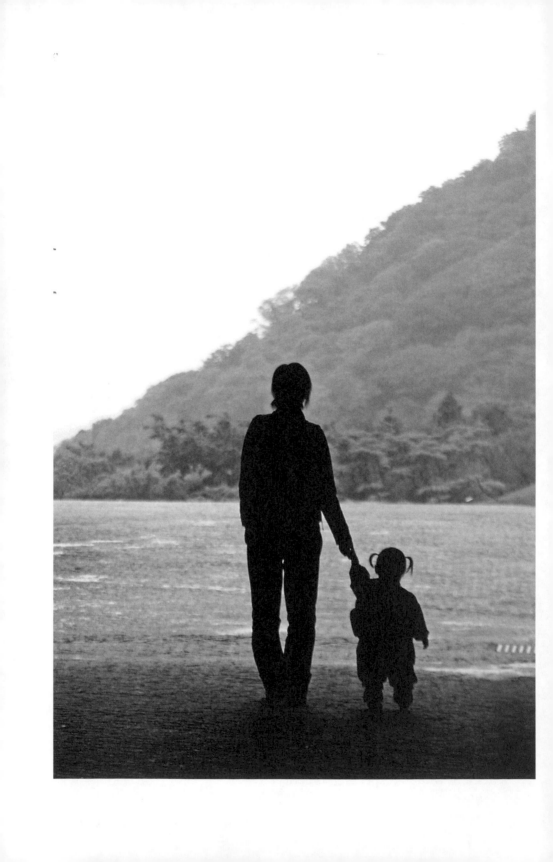

Running a Photography Business on the Web 7

In this era of digital imaging and information technology, some sort of presence on the Web is absolutely mandatory for every photographer. Whether it's just a simple portfolio page with contact information or a full-blown storefront, you not only *have* to use the Web, but *not* using it can hurt your business. Imagine going to a doctor who doesn't believe in X rays. That's how most people feel about photographers who don't have a Web site. Depending on the type of photography you do, the Web may play a larger or smaller role. For some, it may act as a business card or portfolio; for others, it can be an entire online repository where orders are fulfilled.

The sword cuts both ways. While the advantages can be considerable, following a poor strategy in implementing an online presence can be costly in time, money, and lost opportunity. So, it's imperative to understand your objectives ahead of time. This doesn't mean you have to know how it's going to look and function from the beginning; you can and should approach this slowly, in a stepwise fashion. What appears simple and easy at first can be overwhelming, so try not to bite off more than you can chew.

Note: I do not discuss the technical details of how to build Web sites. Entire books have been written on that subject, and simple research yields many that can be quite helpful. My only word of caution, however, is to be discerning in your sources. More specifically, looking to other pro photographers as role models can be fraught with problems. First, most pros who have nice-looking Web sites may not necessarily be doing good business there. More often than not, successful photographers these days became so well before the days of the Web, so, by the time they implemented a Web presence, they not only had an existing business infrastructure that could finance the effort, but they also had the photo assets necessary (not to mention the name recognition) to justify a more prominent placement. Most books written by photographers on the subject fall into this category as well. While there's nothing wrong with this, these books often pitch themselves as having secrets to success that really don't exist. The Web is an

inherently difficult and volatile business model, and there are no proven strategies that can be easily mimicked. As my favorite saying goes, "If it were that easy, everyone would do it."

A better way to learn how to build Web sites is from sources that are not trying to sell a business model. Books that teach about the technology and the paradigms behind the Web are the most useful because you can apply them to whatever business model you are developing. Also keep in mind that photo businesses vary dramatically from one to the next and there is no one-size-fits-all methodology for them, let alone for how to build or design a Web site.

First Steps

Let's start by addressing the most common questions people have when they consider using the Web for their photo businesses:

- How long does it take to develop a good Web site?
- How many images does it require before you can get online sales?
- How good do images have to be to sell them?
- Can I expect to make a living online?
- Can't I just have a gallery of pictures where people click on a shopping cart and order them?

It may not surprise you to know that there are no answers to these questions. There are no formulas, no quick equations, and, most of all, no empirical data to support sweeping design formats that are proven to garner a successful Web site. Therefore, one person's experience should not necessarily be held up as a model for others to follow. That said, there are small, more subtle guidelines based on emerging findings (that span many industries, not just photography) that support the notion that certain design *elements* are more effective than others. Like any science in an emerging field of study, it's easier to identify what *doesn't* work than what does, such as unsolicited e-mail, to name an obvious one. However, even just a few short years ago, these very techniques were thought to be the best tactics

for drawing Web traffic. The challenge is to find those "known" techniques and to utilize them (or avoid them) in combination with your particular business type. This type of analysis *must* be individualized for each photographer. Professing a "formula" for success at this point would be like selling snake oil. This fact may disappoint those who seek quick and easy solutions, but if you read this chapter carefully and thoughtfully, you'll see that there is some diamond dust in the coal.

For context, I'll present my story: I started my Web site in 1996 after I placed some poor scans of my vacation pictures online for friends and family to see where I was and what I did. Needless to say, it never dawned on me to consider a career in photography; I did it for fun. But, as time went on, my interest in photography grew along with my photo skills. The one thing I had going for me was a strong software and Internet background, so I knew how to develop Web sites using a plain-text editor. (Back then, that's all you could do.) The other advantage was that I actually bothered to *use* the Internet, at a time when every single pro photographer and interest group not only said that the Internet was a *bad* model for business, but were dubious as to whether you could make things worse for yourself because your images would be available for anyone to steal. Because I wasn't really serious about business, I didn't care if people "stole" my images and basically ignored these warnings. Ironically, as I'll elucidate later, it was this very act that propelled my photos, and then my Web site, into broader public awareness. This, as it turned out, is what created my business opportunity.

Because of this ill-perceived notion professionals had about the Web, I had very little competition on the Net in the mid-1990s, allowing my business to grow at a much more accelerated rate than if the professional community had adopted the Net sooner. On the other hand, I wasn't a very good photographer either, so it sort of leveled the playing field. But this is also what taught me an invaluable lesson: quality is not as important as other factors when it comes to the photo business.

As I became a better photographer and increased my quantity of images, my business spiked in 2000; I was getting about 2,000 visitors a month to my Web site, with about $1,000 a month in sales. At the time

of this writing, I get about 10,000 to 13,000 visitors *a day*, and my Web site hosts more than 22,000 images. These photos represent a small percentage of my entire photo collection, which exceeds 350,000 images. (I never expect to put them all online.) I add about 5,000 pictures to my collection for every assignment, and about 10 to 15 percent of those make it onto my Web site. When I'm not traveling, I manage to get another several thousand a year in various local shoots and personal projects.

That's *my* story, but it is by no means representative, as there is no "typical" story. I do not necessarily pitch my experiences as the secret to success, because I know it's not that simple. However, there are things to learn from what I've gone through, along with more general lessons, which are all discussed here. One of those first lessons is to understand what people do when they come to your site, why they are there in the first place, and what frame of mind they are in.

First, the premise of your site is not like that of Amazon.com, where most people already know what they are looking for and just want to buy it. The exact opposite will happen for you: if people come to your site, 99 percent of the time it will be because they stumbled upon it. Hence, they are not in a buying mood. While the impulse purchase may happen from time to time, it's an extreme exception that you should not depend on for sales. Most importantly, you can't push them into this mindset by designing your site with a pushy selling style. It will not enhance rare impulse buys, only turn people away. Worse, you may deter potential clients who want to license images or hire you for an assignment. We'll get back into the visitor mindset again later.

As for timeframes, getting your site up and functional depends on how much you want to do (just a portfolio, or do you want to sell pictures?). This is why it's important for you to have a sense of your overall business objectives first. The options for getting your images online are many, so the long-term timeframe cannot be pinpointed. However, since it's easy to get images online in *some* manner within a few hours, it may merely be pragmatic to get the quick and easy work out of the way first, then reexamine your Web strategy as your business evolves. It can take a day to get a basic Web site up that has your name and info, and it can take years to

have a full-fledged shopping site. The wide spectrum in between will come in stages.

For these, let's discuss some options for how you can get started.

JOIN EXISTING WEB SITES

The simplest way to get your images online is to use existing Web sites that feature the work of photographers. Here, you aren't really building a site at all, just getting your images onto other, more established sites. This means that you must either have your images in digital format already or have a plan to scan film. (That's a technical matter not addressed here.)

Since most sites allow you to customize and populate "your area" of the site with your own photos and contact information, this beginning step is "good enough" for even the most skittish beginner. Most are free to use (you only need to register), ranging from well-known names, like Yahoo (*http://photos.yahoo.com*) and Microsoft (*http://photos.msn.com/*), more focused sites, like *www.photo.net* and *www.pbase.com*. There are other specialty sites as well, for wedding photographers, portrait shooters, fashion (for both the photographer and the model), and so on. A simple Web search yields many options.

The two drawbacks to using photo-forum Web sites are:

- **Customers will not find you**
 While you may get a lot of visits from other photographers that also share the site (and it's rare that photographers buy others' work), no one else will find you. Most traffic that comes to a typical Web site is the result of people submitting keywords to search engines. But search engines do not index photo sites like this, so people looking for pictures online are not likely to find yours.

- **You can't sell your pictures**
 These sites are designed for photo enthusiasts, not business, so you're not going to appeal to the typical photo buyer. Not only will the appearance be non-businesslike, but you won't have business infrastructure, like a shopping-cart system for taking orders.

None of these "drawbacks" is a surprise—sites like these are not designed to be anything more than this. The goal is simply to get your

pictures online quickly and inexpensively. You have to spend more of your time marketing yourself through more traditional, non-Internet methods to drive potential clients to your images.

Whatever you do, I strongly advise *against* putting your images on photo sites for which you implicitly grant "usage rights" to the company that is hosting your photos, *unless* you are given some sort of commission in return. That is, some sites will use your images for commercial use and give you a commission when your images are used. While it's a great idea, the business model is unproven as yet. (That said, I've got my eye on the trend—it could be promising.) Even then, not all sites are equal. I've seen an emerging number that sell cards and other trinkets that have photos in them and pay the contributing photographer a royalty based on the number of images sold. You should read the license terms of any given site before joining up and also probe discussion forums for independent accounts from others who may have experienced the site.

A similar (but not entirely identical) brand of Web site is the *photographer community* Web site. Again, the usual suspects are well known and highly visible, such as Yahoo Photography Forums (*http://dir.groups.yahoo.com/dir/1600019181*) and Microsoft Photography Forums (*http://groups.msn.com/browse.msnw?catid=124*). There are hundreds, perhaps thousands more, as they come and go as rapidly as the Internet evolves. You should always use a good search engine to find sites that suit your tastes. As with all these sites, you can display your photos, but the real benefit to the "community" sites is that you can interact with other photographers through discussions, question-and-answer forums, and photo critiques. (In fact, even if you don't post your own photos, these sites are good for this reason anyway.)

As is always the case with online communities, be a critical thinker: not everything that everyone says is gospel, or even true. You are advised to spread your time among many forums to gather the broadest set of possible truths.

Sales: Very Basic

As I noted, most photo-community sites do not allow you to sell your own photos. There are some exceptions to this, and one is *www.shutterfly.com*,

which is one of many that do the following: you sign up as a "professional photographer" (which requires an application and approval process). Once accepted, you then upload your photos and set your own prices on prints. You can direct people to your gallery on their site, and visitors can place orders themselves for the size and format of each print. The advantages are clear: you don't have to build a Web site, and you don't have to be part of the ordering or printing and delivery process. Customers pay Shutterfly directly, who will print and ship orders. You'll get your check after each month's worth of sales. (This applies to prints only—they don't handle licensing of photos.)

All sounds good right? Well, there are drawbacks, and it doesn't apply only to Shutterfly; just about every site that does this sort of thing suffers from drawbacks. The main one is that these sites are designed for one kind of shooter: the "event photographer." For example, if you just shot a wedding, you could upload your pictures to the site and then tell your clients to go there to order all the prints they like. You don't have to do anything beyond that. Unless you're *that* kind of shooter, the usefulness of such sites is limited. Paper sizes are fixed, and styles are limited (often to only one of glossy or matte finish), which may not match your artwork. Customer service—like the rest of the site—is really designed for consumers, not pros, so you're not going to get the kind of attention you may need to help *your* customers if there's a problem. And, once again, search engines never index these sites, so you're never going to be seen by anyone that you don't explicitly inform.

OUTSOURCING WEB DEVELOPMENT

Eventually, you may find the above options either too limiting, or inappropriate in other ways, which means you need to have your own Web site, complete with your own domain name. There are two ways to accomplish this: do it yourself, or hire someone else to do it. The decision here has everything to do with time, control, cost, and the end result. That is, are you really designing a complex shopping site? Or just a platform to display your own photos and provide contact information? If it's the latter, then in this day and age, personal Web sites are easy and cost-effective. You can easily use them for business as well, but here's where the tradeoffs begin to emerge: the more you want to do, the more

technical and complex it becomes. If you get beyond your own technical skills or interests, then you might want to outsource the job to a Web designer. But, buyer beware: this path comes with some risks.

First of all, photographers tend to be artistic, and so do Web designers, and if both want to control the process, this can be a recipe for disaster. You may think you want to step back from the process and let the expert do his work, but what ultimately happens is that the business owner wants to direct the designer like a cab driver: "You do the actual driving, but I'm telling you where to go." As is always the case, the first part of the job goes quickly and smoothly because it's just a matter of setting up basic foundations (the site's structure and basic functionality). This is why outsourcing the job is adequate for photographers who do not depend heavily on the Web or who do not need to update it often. But, anything more than that, and you will probably find that finer details become increasingly more important, requiring more of your time and attention to oversee development. There eventually comes a crossover between whether you're actually saving time and money using an outside developer and whether you should be doing it yourself. In the spirit of the stepwise approach to developing the Web part of your business, it may make sense to hire an outsider to do the initial groundwork, with the understanding that you will eventually take over. How soon this happens is more dependent on your technical aptitude or your willingness to develop it.

BUILDING YOUR OWN WEB SITE

Building your own site, even from the ground up, is not hard anymore. Nor does it necessarily have to cost a lot. In fact, most Internet service providers (ISPs) give you Web space and tools to create Web pages as part of your service agreement. If you go to your ISP's homepage, you'll probably see a member login link, where you'll see information on how to create your pages. America Online (AOL) offers three options, ranging from their "1-2-3 Publish" tool, which is mostly a fill-in-the-blank series of forms, to their "Easy Designer" package that's slightly more sophisticated, offering a set of design templates.

Similarly, Earthlink allows its users to create free Web pages with a tool called "Trellix Site Builder," which runs within your Web browser. Again, you select from a series of design templates, including some that are geared toward small businesses.

There are also many places that will host your site for a monthly fee, where you can choose your own domain name. I recommend using a name that's easy to remember, and especially one that's associated with *you*. I chose to use my own name, simply because it's the easiest way for people to remember me. This may not work if your name is hard to say or spell. On the same note, people with extremely common names may find their name already in use by another site owned by someone with the same name. In these cases, you have the arduous and frustrating job of finding a good, creative name to use as your domain name. This can take many days before you're happy, so get started soon.

As great as they are for initial setup, there are barriers to how much the basic templates can do, which may lead you back to the Web designer idea in the previous section. But, before going in an endless loop of if-then-but circles, you may consider biting the bullet and just learning a Web-design tool yourself.

There are plenty of professional-level tools that allow you to build a Web site from the ground up. Macromedia's Dreamweaver (*www.macromedia.com/software/dreamweaver/*), Adobe's GoLive (*www.adobe.com/products/golive/main.html*), and Microsoft's Front Page (*www.microsoft.com/frontpage*) are typical examples of such tools and are probably the most common for those who build pages, whether they are individuals or professionals. The Web pages that these programs build can be uploaded to the same Web space that your ISP gives you or that you "rent" from some other hosting company. Choosing which product to use to develop these pages, however, is a matter of research and testing. Technology is evolving way too quickly to rely on this book to have the most up to date information, so your research should include learning what other photographers have to say about any given product. (See the discussion forums listed above.)

In summary, the time and attention you devote to your Web site should be in proportion to its importance to your business. In other words, *never hand over critical business tasks that generate income to others.* Things like tax and legal issues are not revenue generators, so that's different. If your Web space is part of how you generate income, *you* will eventually have to do it yourself. If it's just a portfolio, having someone else build it is fine.

Deciding on Design and Content

Numerous books have been written on the tasks of Web design, and many more will be written before you're done reading this one. Most are very good in general design aspects and technical details, but none specifically address the niche of a *photography* Web site. What may be good design for some sites (even most sites), may not necessarily be appropriate for a good photo site. In that spirit, here are some fundamental guidelines that *should* apply to a well-designed photography Web site (all other advice notwithstanding):

❑ **Keep the quality of your images as high as possible.**
Because you're a photo site, it's obvious that bad images degrade the experience of going to your site. Determining what constitutes a good or bad image is the hard part, because it's entirely subjective, and there's no way anyone can figure that out for you. However, the underlying issue is salability: what images can be sold? Remember, you yourself are solely responsible for what *you* think are good images. How good your self-assessment is will ultimately be told by your sales figures.

❑ **Quantity is just as important as quality.**
Populating your site with as much good content as you can is critical. The more quantity you have, the more content search engines have to index your site. This translates directly into more traffic. But, the more quantity you have, the more important *quality* becomes. More of a good thing, in this case, is good. But more of a bad thing can be disastrous. Beware of just throwing a lot of content on your site because you have it.

❑ **Use reasonable image sizes.**
More people in the United States use high-speed Internet access via DSL or cable modem than dial-up. What's more, *serious buyers* are usually in companies with even faster Internet access than home users. The days of designing sites optimized for low-speed modems are gone. The size of the thumbnails you use for low-res images don't have to be all that small, but they shouldn't be too big either if they're together with other images on a single page. The issue is a matter of site design, not the speed in which a page loads.

You can dilute the quality of a page with too much "noise," just as you can underwhelm the visitor with too little to chew on.

❑ **Navigation should be easy.**
You'd be surprised how painful it is to come up with a design that makes it easy for a complete idiot to use a Web site. Visitors *do not* read plain instructions, or see the menu bar across the top, or realize that an icon does what *you* think it does. There are some de facto standards, such as using a shopping cart icon to represent a purchase point, but there are very few of these rules to rely on. So, as you go through the design process, expect to make changes frequently as you discover the "use" habits of your visitor base. (If you've hired a designer, keep your costs in mind here, and don't necessarily believe they know best. If that were the case, every Web site on the Net would be designed identically.)

People often make the mistake of designing their sites with their own Web habits in mind, or based solely on artistic reasons, where design prevails over substance or usability. My most important rule of thumb is this: Going from any one part of your site to another should require as few clicks as possible.

❑ **Have good content *besides* images, if possible.**
Photos are great, but if you can add something (of substance), then it can help. If you can write, give advice, provide helpful links, tell stories, or make your site useful, your site just becomes more popular. What's more, search engines have more content by which to index you. (We dive into this later.)

❑ **Don't have a "login page" before accessing content.**
Also, don't require people to "register" for anything (except, perhaps for opt-in newsletters, etc.). Statistics show that sites that require registration or *any* sort of "agreement" to enter are abandoned by a margin of three to one. Similarly, don't have an opening "splash page" (an intro screen or photo) whose only purpose is to offer the user a "click to enter" button. It just wastes time.

❑ **Avoid *reliance* on Flash or JavaScript.**
Flash and JavaScript are Web tools that allow you to do animations and perform other kinds of neat special effects on Web

pages. While it's fine for aesthetic purposes, it's really just style over substance. It's not that I advise against the *use* of such technologies, but sites that have *no other access* than to view them with Flash or Java are statistically prone to lose more visitors than they win. Also, as the Internet becomes more accessible across non-computing devices (like touch-screens, phones, etc.), not every aspect of the traditional mouse/keyboard-based user interface will be present. In short, be judicious about using flashy technology, and try to assure that your site has cross-platform compatibility.

❏ **Avoid using frames.**
Frames are ways to segment a Web browser into subwindows within the main frame so that you can have separate parts appear to do separate things. The menu across the top can be in one "frame," whereas the picture-viewing window can be in the main area in the middle. As wonderful as they look, and as convenient as they are for the user and other navigation schemes, they are not search-engine friendly, so your site is not likely to be searched at all. Yes, some engines "can" look through some frame content, but most can't. Getting indexed by search engines is half the battle, so don't make it hard for them.

❏ **Don't use pop-up windows (ads, slide shows, etc).**
It should go without saying in this day and age, but pop-up ads on Web sites are a sure way to lose customers. Because of this, people use pop-up blockers to prevent *any* window from coming up, including those that aren't ads. You may be tempted to use extra windows to display images separately (such as enlargements or other material you really want the user to see), but the user's browser may block them, and you won't know it. So, keep everything in the same browser window at all times.

❏ **Don't be pushy.**
Nothing turns off people more than a hard sell. Don't use big fonts, flashy graphics, exclamation points, money-saving offers, and, by all means, don't design your site as if you expect the person to buy something right off the bat. Providing a shopping cart icon next to each photo is sufficient.

❑ **Identify yourself without being arrogant.**

Obviously, you want to let people know who you are, and you should provide as much contact info as you can to be informative. Many people advise putting up a bio or résumé, but be conscientious about how you portray yourself. Referring to yourself in the third person often appears pretentious. Example:

"Dan Heller started his photo business from his modest, rat-infested studio apartment that didn't even have heat or running water. Yet, through his artistic craft and enduring love for photography, he has become the successful artist for which he is beloved today . . ."

See how stupid that sounds? Don't do that. Humility is a very attractive quality, and talking about yourself in the first person underscores that quality. Example:

"I started my business at home as a hobbyist and eventually found inspiration in my travels."

This sounds much more believable. The one occasion where you should write about yourself in the third person is when you are writing text for someone else to print about you. If you're going to hang your pictures in a café, or on someone else's Web site who is featuring your work, those are the times to do it.

❑ **Be active in the community (forums, etc.).**

Being active on the Net, in discussion forums, newsgroups, photo-related Web sites, and outside photographer communities (photo clubs, etc.) not only helps your career and knowledge evolution, but also gets you noticed. Whenever you participate, your name is out there, and search engines figure this out *fast*.

❑ **Don't worry about letting people use your images.**

Stealing is one thing, promotion is another. While you want to protect yourself from theft, don't throw the baby out with the bathwater by prohibiting or discouraging people from downloading your photos. If you warn people not to download your pictures, you just might be discouraging a graphic designer from using one of your images as a mock-up for an ad layout he is proposing to a client. This usually turns into big business, and you don't want to stand in the way of that.

The money to be made in this business comes from customers who license high-resolution images for use in some sort of media (print or digital). Worrying about downloaded images is putting a huge amount of effort into a slim segment of the business model that yields little money at all. Sure, you can and should sell low-res images to people who license them for Web use, but that business will come, protections notwithstanding. That said, you *do* want to watermark your images (using your digital-editing software) to put your name and Web site on your low-res images, so that you and others can identify your images. This is the extent to which this issue should occupy your concerns.

Don't forget that you're a photographer, and the Web advertises you. While it was never my intent, it turns out that one of my most effective marketing strategies is to *let* people spread my images around. These are like *free ads* that lead people back to my site. (Twenty-five percent of my Web traffic is via links from non-search-engine sites.) As long as your images have an identifying copyright mark that visibly incorporates your Web address, you're going to get a reasonable return of traffic. Private use of my images is the greatest conduit for getting those images in front of the eyes of *buyers*. Those buyers are either from commercial sites that want to use images for licensing or individuals who buy art.

Search Engines: The Holy Grail of Web Traffic
I've mentioned copiously throughout this chapter the value of *search engines*. These account for 75 percent of *my* traffic, but most new sites rely on search-engine traffic exclusively. For example, go to *www.google.com* and type "photos of sunsets" and look at the first page of results. Most people will look at this first page *only*, and as they visit each Web site listed, they either find what they want, or they search again using different search terms. If you advertise or engage in other self-promotion that brings people to your site, that's great. You should do what you can to optimize this kind of visibility. However, nothing you can do will yield the kind of traffic that comes as a result of a highly ranked placement on search results pages like this.

Therefore, the question that most people ask is, "What are the secrets to getting search engines to rank me higher?" That's not an easy

answer. Problem is, whenever someone thinks of a sneaky way to artificially raise their site's rankings in search results, everyone does it, leveling the field once again. The easiest thing to do is simply buy advertising space on the search engines so that you are guaranteed placement. But that can be costly, and if your business isn't general enough to appeal to a wide demographic, you could be paying for a lot of traffic that doesn't turn into sales.

There are ways to help your site improve its rankings, but there are no guarantees. Whatever there is to learn, it's all abundantly available on the help pages of every major search engine. You *don't* want to buy into those e-mail offers that will submit your Web site to the top one hundred search engines for some amount of money per year (a simple task you can do yourself). Note: Getting your site *indexed* is not hard. Getting it *ranked highly* is.

MAKING YOUR SITE IMPORTANT

Assuming two sites are identical in quality, quantity, and design, we cannot necessarily assume they are ranked equally by search engines. The reason for this is that rankings are also set by how many *important* sites link to it. Read carefully: It's not just the total *number* of links, but the number of *important* sites. This distinction illustrates how important it is to promote your site, but not just anywhere—you need to get it linked to other important sites. More often than not, these sites are highly trafficked sites, like photo forums, discussion boards, news sites, industry associations, trade groups, or even high-profile clients. When you license photos, request clients to link back to your site. If you participate in photo critiques or reviews, your Web site should be part of your signature. If people see you from there, and they talk about your work in new discussion groups, your rankings go up.

This "secret" is not really a secret per se. However, there is a penalty for implementing it in the wrong way. For example, "link-back programs" (where sites agree to exchange links with as many sites as possible) attempt to raise the rankings of sites artificially by merely cooperating with others to maintain reciprocal links. Since this adds no value for those who are searching for legitimately good content, this scheme doesn't work. In fact, sites with "artificially high linking" are ranked lower than sites that don't participate in such schemes.

Although my Web logs indicate that about 75 percent of my traffic comes from search engines, those engines are more likely to rank my pages higher because the sites that link to my page are also ranked highly.

Now, let's not fool each other: getting important sites to link to yours is really, really hard. But, as with the other items noted, it's the natural by-product of good content *and* active participation in other Net activities discussed above. If your images are visible and people want to use them, if people are talking about you, if you are talking to others, and you are doing everything *else* associated with building your broader business model, then important sites will eventually link in your direction. How long this takes is anyone's guess. Some people are better at self-promotion than others. It took me about three years before any of the pages on my site created enough interest to rank highly. And even to this day, not every page on my site is highly ranked.

BACK TO BASICS

Content comes in three basic forms: *quality, quantity,* and *design.* First and foremost: *quality.* The fact that I have marketable material that appeals to the broader general public is pivotal to my success. In my case, I also try to have as much diversity as possible. If I were to only have black-and-white photos of abstract swatches of cloth, I probably wouldn't have the traffic and interest that I do now. But even diversity isn't enough—it has to be "good." Yet, judging that isn't easy, because it isn't consistently the same for everyone. Lest we forget the first rule of artwork: "To each his own." There is a reality about what does and doesn't sell, but it's not always easy to grasp due to cultural and artistic variances. At the end of the day, it's whether your notion of what's good matches those who visit your site. It should be stressed that you should be honest with yourself about the choices you make in what you put online. Be proud, but realistic.

Next is *quantity.* Whoever said, "Too much of a good thing is bad" never designed a Web site. Having quality images is one thing, but it's the *volume* of them that attracts more and more traffic. Similarly, uniqueness helps. By that, I don't necessarily mean that images are unique from those of other photographers; what I mean is that you should strive to have photos that are unique from *each other.* I've seen people post twenty-five images of the same, great looking picture, but

146

this doesn't help. Combining quality and quantity only makes sense if the net sum of it all is a unique enough package to hold visitors' interests.

Lastly, *design*. That is, organizing the images coherently with an intuitive navigation so people can find what they want with the fewest number of mouse clicks. How does this affect your site rankings in search results? Remember, if other people link to you, your rankings are higher. Other people will link to you if you have a site that's attractive but *useful*. Design involves aesthetics, but that's something photographers almost always put ahead of functionality, so I should warn you not to neglect functionality, which can make or break your site's popularity. (Many photographer media organizations have awards for Web site design, and the winners are almost always those with great-looking and impressive design work, but whose functionality is so limited, that it brings very little actual business . . . that is, to the photographer. The Web designers usually fare pretty well.)

Images Online: Promote Them!

In keeping with the spirit of the previous section, here's the lesson: When it comes to promoting yourself, your greatest asset is your photography. Use it to promote yourself. As you will soon learn, I am rather liberal about how I allow my images to be used on the Web, including allowing people to download my images, and I make no attempts to stop this. Don't get me wrong: I am not suggesting that you don't need to protect your images or make an effort to stop *unauthorized* use. (I'll address that later.) I'm just saying that, in the grand scheme of things, there are tradeoffs that must be considered before choosing to keep your images in a locked box. Before going further, I strongly recommend copyrighting your images. This is an amazingly simple process, discussed in chapter 4, "Starting a Photography Business."

SIZE MATTERS

I've seen a lot of resistance to putting high-res images on Web sites, leaving only the smaller thumbnails for visitors to see. The motivation for this is born out of the concern that images will be "stolen." Understandable. The question then becomes: how big do your images have to be before they become "worth stealing?" Also, it's not just

a matter of size; there are other usability considerations as well. Let's address the size issue first.

Long ago, I felt that it was important to keep people from downloading "bigger" pictures in violation of my copyright. When people complained that they just wanted to see them bigger, I wrote it off as a reasonable tradeoff between allowing photos to be seen "well enough" and having them stolen. But, the impact on business never really hit me until I got an e-mail from someone that said, "We can't use your images to layout a page we're considering for an ad campaign, and time is tight; can you get us a higher-res image to use as a prototype?" Because I was away on assignment, I couldn't get to this right away, and they had to go somewhere else.

Ouch.

So, I started linking my low-res images to higher-res versions, placing my copyright mark on the side (See chapter 4, "Starting a Photography Business," for more on how and why such techniques are used in conjunction with your business). This higher resolution image was only 550 pixels long: big enough to see in detail, but nothing that could be copied for print use. I was happy to now be able to accommodate a potential client's workflow by allowing them access to what they needed. But the better lesson had yet to occur: bigger images encourage longer visits, more page views, and more interest, all of which translate to more business. The average time people stayed on my site increased from two minutes to thirty. Page views per visit went from twelve to thirty-five. About a month later, orders for prints not only increased but became a lot less erratic, and have been ever since. What's more, the rate is consistent: I've found that the amount of traffic, the number of e-mails, and the number of orders directly and proportionally increases with the number of high-quality, desirable images on my site.

Best of all is *efficiency*. Rather than having to deal with every request for a high-res image, the work is already done, and I can spend my time doing other things. I don't need to monitor every potential client; I just respond to those who order. In other words: *Don't irritate your real potential customers.* They shouldn't need to contact you to download comps, and if they do, you've inserted an annoying and unnecessary (and worst of all, *time-consuming*) step into their workflow. Worse, they're interfering with *your* workflow. (If you have time

to deal with constant requests like that, you aren't spending time doing far more important things.)

WATERMARKING IMAGES

There are various ways to "mark" your images to identify them as yours. The obvious method is to use a visible watermark, which is a copyright symbol, name, or other identifying feature, digitally superimposed on the image itself. (You see this on all my images.) This is not only useful for identifying the image's owner, but makes the image less useful in any commercial context. Because someone can "crop" the watermark out (by cropping the image), some choose to avoid this by placing the mark on the center of the image. Problem is, doing so often interferes too much with the image's aesthetic, making it (subtly perhaps) less desirable. I actually had a client that bought one of my images over that of another photographer because his was too difficult to see.

How much to "obscure" the image to protect it from being "stolen" in a usable way, and how much to leave it unimpeded to maximize the image's salability is a cost-benefit analysis. Me, I choose the minimal imposition in favor of happier clients. If a client requests a series of even higher resolution images as samples, I'll send them larger versions, but with the watermark in the center. This tradeoff only goes so far. I trust the client, but images can find their way into the hands of people I don't trust. Print-ready, high-res images are definitely worth protecting.

SOLD IMAGES

So much of this discussion has revolved around the issue of protecting images (and Web sites) from clients before they buy. So, what do you do *after* they buy? You have to deliver a clean image, right? And once you do, it's out there. How do you know they are going to protect it from being stolen by someone else? Or that it won't somehow end up floating around the Net, into other companies' hands, or be used by the *same* company in ways they didn't license? The awful answer is: you can't. This business is all about trust. You can protect yourself with legal language in license agreements as deterrents, or using digital watermarking to make sure you can track images on the Web. But, as stated before, Web use isn't going to bring in the big dollars, thereby hardly making the time and effort as worthwhile to the bottom line as other

business-building activities. The best thing you can do is make sure you have a good working relationship with the company that licenses your photos.

Sales: Payment Methods

When designing your site, the highest hurdle you'll face is that of taking payment. At first, it appears easy: just get a phone number and call them to arrange for a check. But then, you figure people like using credit cards, not to mention the sense that the easier you make it, the more the sales come in. There is some truth to the notion that "ease of payment promotes sales," but, as has been the case with everything we've addressed so far, it's not that simple.

One can certainly do lots of "good" business on the Net without accepting credit cards. Implementing the technical side of credit card payment has its pros and cons, so your decision isn't "if" as much as it is timing. If the overhead and technical barriers of accepting credit cards is holding you back, checks are (and will be) just fine. In fact, I only just started accepting credit cards in June 2003, well after I'd passed the milestone of $5,000 per month in sales back in 1999. Until that point, everyone sent me checks, and even though people would ask if I accepted credit cards, I can't think of any serious buyer that didn't purchase because I didn't accept cards. Sure, I may have missed some spontaneous "impulse purchasers," but then, I also don't use price points that spark an impromptu purchase. So, for me, that artifact didn't apply. Again, my business model may not match yours. If you sell lots of low-priced consumer products, then accepting credit cards should be on your list of necessities for your site.

The key ingredient here is discerning the difference between an *impulse purchase*, and a *consultive sale*. In an impulse purchase, a credit card makes it quick and easy, so anything that interferes with this process disrupts that impulse. If it's quick and easy, there are people who will buy. This isn't the case for the consultive sale, where people want to talk and discuss an item before they lay out the big bucks. Once they decide, sending a check or using a credit card is no big thing.

When the time comes that you want to take credit cards, there are two ways to go about it. First, there is the merchant bank approach. This is just like any other bank, but instead of their clients being

everyday people like you and me, they are businesses. (The larger consumer banks also offer merchant banking services as well.) So, if you are a business, have a tax ID, and have a resale license from your state's franchise tax board, you can apply for a merchant banking account. With this account, you will get the necessary tools to accept credit card payments. That's great, but it also sounds like a lot of work, doesn't it? We'll get back to that in a minute.

Another payment option is Pay Pal. This is a convenience that many find useful because you can avoid much of the administrative overhead because you pay Pay Pal to do it for you. But there's a price for this convenience. The way it works is rather simple: rather than your accepting credit cards, Pay Pal interfaces with the customer and takes payment on your behalf, depositing the funds in your account (minus their fees). What those fees are varies, but it can be as high as 3 percent of each sale. That's not bad, actually, especially for not requiring any of the licenses and forms that a standard merchant bank would require. What's more, Pay Pal's fees have been drifting lower as competition with the merchant banks heats up. (Note: when comparing rates to merchant banks, keep in mind that the "low" rates that banks charge are usually for "card present" transactions, where you swipe the card with a reader. Rates for Internet transactions are going to be much higher, which makes Pay Pal's rates not seem to bad.)

Granted, you eventually have to get licenses and permits for your business anyway, but when you have to do that is sort of sketchy, much the same way that there's a wide gray line between when you're a "real business" or just an elaborate hobby that happens to get a little income. Hobbies don't require licenses.

The point is, you can begin by taking credit cards through Pay Pal before you get those licenses and then move over to handling your own transactions as the fees justify it. But, regardless of where you finally end up down the road, beginners should almost assuredly avoid running credit card transactions entirely until a stable and moderately consistent sales trend is established. This has nothing to do with fees or anything else; it's a matter of biting off more than you can chew in your site's initial development. You can delay or even prevent your site from ever getting off the ground if you try to deal with too much. Don't worry that you may be losing sales because you don't take credit cards; you're not missing anything in the beginning.

Communication and Contact with Visitors

Bringing people to your site is one thing, keeping them is harder, and having them come back is even the hardest. This is why it's important to provide a quick, unobtrusive way to get feedback from them, to be responsive to them when they do contact you, and, most of all, to be able to maintain that contact.

People love contacting photographers about their work, and it's your duty to reply to each and every one of them. Anytime someone asks a question, I reply to it personally. If they have a comment, I almost always reply to those, too. Of course, you have to use your time judiciously, which is the hard part. (You can't and shouldn't reply to every fourth-grader who asks whether sand in the Sahara Desert *really* was shipped in from Arizona, a joke I once had on my Web site.) When I answer e-mails, it's amazing how much positive feedback I get from people who simply say, "Wow, I never thought I'd get a response from you!" I can appreciate that—I'm offended (and bewildered) when I e-mail a photographer about how much I like his or her work and they simply don't reply. It shows arrogance, even if that isn't their intention.

A great way to solicit feedback on your site is to have a *feedback form*, a page where people can type anything they like and click a "submit" button, which e-mails their statement to you. Sure, they can send e-mail, but people seem to be drawn to forms. (I've found that feedback forms generate more feedback than e-mail links at the rate of 15 to 1.) Once you've bought into the forms idea, options open up. The simpler the form, the better: checkboxes and lists get even better return rates because people don't have to type. Very early in my Web life I had a checkbox under every single photo, where people could check whether they liked it or not. This not only generated good feedback (and it keeps people longer because they like the interactivity), but you can also get an accurate sense of how many visitors you get. You may not know the percentage of the total traffic that is filling out the forms, but you *do* know that the more you get, the more your traffic is growing.

E-MAILING: NEWSLETTERS AND ANNOUNCEMENTS

I have an "opt-in" e-mail list that I use to keep in touch with those who want to hear from me. But be careful: in these days of spam and other

unsolicited email, you can kill your business if you don't handle e-mail properly. If you do send bulk messages out, make *sure* you only send to those who want to receive them. What's more, give clear instructions on how to get off your mailing list. (Some who sign up will forget by the time you get around to a newsletter, and then think they're getting spam.)

Unsolicited e-mails increase your chances of having your entire domain added to spam registries' *blacklists*. These are used by most spam filters on most major ISPs, from America Online and Hotmail down to your local neighborhood portal. Once on such a list (and there are many registries), any message you send, even your legitimate ones, may be filtered before your recipient even knows you sent it. Getting off those lists is extremely difficult, so if you had thoughts of getting one of those bulk e-mail programs, think again.

It takes time for an opt-in e-mail list to grow, but these people invariably become great contacts for continual feedback, support, and even critique. Many may become clients, too. I send out a newsletter once or twice a year, and most people tell me that isn't often enough. (Truth is, I just don't have the time.) If you update your site with new images often enough, that might be a good excuse to reach out to your e-mail base.

Having a photography business requires *some* sort of online presence, but how much you need is not etched in stone. Your business model governs the degree to which you should invest in this format. For those more technically adept, the more investment you make in a Web site, the more dividend you'll receive in the long run. For photo businesses that focus on consumer services, like portraits or weddings or other events, the most applicable use of the Web will be to allow clients to see your previous works and possibly to order prints from a session they've had with you. But the common denominator for anyone is to have at least a sufficient portfolio that represents who you are and what your business function is.

For those looking to do online sales, your e-commerce solution does not have to be an all-or-nothing approach. It's far more important to build it incrementally as your business develops rather than tackling your final objectives all at once. As for payment, asking for checks is fine; you won't lose business because you don't accept credit cards.

When time and efficiency reaches a certain point where credit cards make more sense, it should be easy to set up because you've already got a reasonably mature site, into which "card technology" can integrate rather seamlessly.

Regardless of what you do online, it should be balanced and integrated with a broad business model. All aspects of the business require time to evolve, so don't focus on one over another in such a way that drags down your progress.

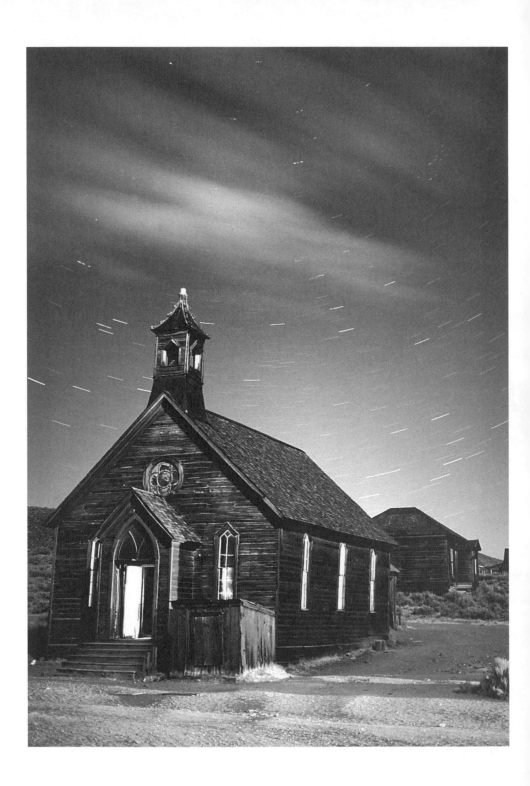

The Stock Photography Business 8

Whether you shoot for fun or are a class-act assignment photographer who shoots specialty subjects for a living, you probably have considered the possibility of selling your images as *stock photography*—that is, selling your existing supply of photos to buyers who need them for catalogs, books, magazines, ads, or a variety of other uses. There's no question the opportunity is out there; the real question is whether you should do it yourself or have someone else sell your images for you. If it were as easy as simply turning over images to someone else, there wouldn't be a whole lot to say about it. Indeed, there are many factors, both pros and cons, associated with deciding whether to sell images directly yourself or to work with an agency. In fact, many people do both.

One of the main determining factors will be your propensity for starting and running your own business as a full-time endeavor. It's not that you *have* to do this to sell stock on your own, but if you make anything less than a seriously concerted effort, the payback may not seem worthwhile. Yet, even if you have what it takes to run your own business, it doesn't mean you'll want to. There are also lifestyle considerations: taking pictures is one thing; running a business is another. Doing them at the same time demands a different quality of time that is often incompatible with the photographer mindset. "Context switching" from the creative mind to the business mind is not easy or enjoyable for those who already find business a struggle to begin with.

For these and other reasons, it may be preferable to work with a *stock photo agency*. This is a company that markets and sells images on behalf of photographers in return for a percentage of the sales. In short, agencies are the middlemen in the supply chain between the supplier (you) and the buyer. In theory, this is a great win-win scenario, since the agency handles everything, leaving you to just go out and shoot as the money trickles in. In practice, however, it's not quite so simple. The discerning reader might see the yellow warning flag that says, "If it's too good to be true, it probably is." Indeed. And my

favorite quote comes into play once again: "If it were easy, everyone would do it."

If you're attracted to this idea, remember, you're not the only one to think of it, and everyone else *is* doing it. At least, they're trying to.

Scope of Discussion

This chapter addresses the nuances of the stock photography business. I'll begin with an analysis of the stock photo business model and the roles of its players: buyers, photographers, and agents. The next chapter addresses the intricacies of working directly with a stock agency.

These chapters do not discuss *what* to do, or *how* to go about it, which is an entirely different set of considerations. Nor do I discuss pricing methods in this context. For a general discussion on pricing, see chapter 6, "Photography Pricing." The goal here is to dispassionately illustrate the *business issues* with an unbiased lens, to help you draw your own conclusions about whether stock photography is for you, and, if so, what the issues are in dealing with stock photo agencies.

AUDIENCE

I draw attention to my word choice above: *dispassionately*. As anyone who does research on this subject knows (or will know), there are vastly differing opinions—many of them vehement—about whether stock agencies are inherently good or bad for photographers. I pass no judgment on whether any particular business method or mindset is right or wrong, good or bad. The reason is simple: different people have different business objectives and personal goals, either financially or in terms of lifestyle. There are often tradeoffs, and each person can decide for himself whether any given business model is appropriate. It's a "bad choice" if one goes down a path that doesn't serve one's own interests. It has nothing to do with whether that model works or doesn't work for *other* photographers.

I have worked with stock photo agencies in the past, but I currently do not work with one. I have instead chosen to represent myself, selling images directly to buyers. (You can read more about this in chapter 7, "Running a Photography Business on the Web.") This does *not* mean I am biased against agencies; it only means that I have found that my skills, interests, and business objectives serve me better as an independent agent.

158

The Stock Industry in the Digital Age

The historical reasons for the development of photography agencies is thoroughly discussed in chapter 2, "The Five Truisms of the Photography Business." That is, stock agencies were virtually the only option for most photographers to make a viable living on their own as independents, unless they shot weddings and portraits and the like. That business model held steady for nearly fifty years, until technology revolutionized the means of distribution. Today, a digital camera, a computer, and the Internet are all that are necessary for most photographers to get their images into distribution and make a living independently. In fact, that's exactly what happened, and the result is oversaturation. There are so many images in the market now, the challenge is just getting noticed.

In the broader perspective, the natural rebalancing of the supply-and-demand equilibrium caught most pro photographers and stock agencies off guard. Most pros didn't take advantage of it, causing buyers to consider other sources for imagery they might not have otherwise. The unexpected abundance of quality (and not-so-quality) images flooded the market from unintended sources (like amateurs and semi-pros), causing prices to plummet—so much so, that many stock photo agencies had a hard time selling images, let alone maintaining price points, even if they came late to the game. Scrambling to maintain revenue levels and to revive sales of images that weren't moving at all, the concept of *royalty-free images* (termed "RF") was born. CDs with several hundred royalty-free photographs sold for as little as $150, and the buyer had no restrictions on use. This would have been unheard of just a few short years before, when each photo had a market value of at least that much, if not more.

Photographers and agencies worried that royalty-free CDs would destroy the stock industry, but they only eroded the bottom-end of the market, where very generic, medium-resolution images of everyday subjects reside. Those images hardly made much money anyway, but the carnage didn't end there. As revenue growth slowed from the booming levels of the mid-1990s, so did the valuation of stock agencies. Bigger companies swallowed up smaller ones to reduce competition and increase image assets, to the point where today there are only a few big stock agencies. Small agencies pop up now and then but usually don't survive long enough to gain a foothold, let alone present any sort of formidable competition to the major players.

As we move into the latter part of the first decade of the millennium, the trend seems to be continuing: the larger stock agencies that have huge overheads and infrastructure cannot make ends meet with such low margins on images, so they are broadening their revenue streams. While those slim margins are still sufficient for individuals and very small niche agencies to realize healthy returns, the major agencies are expanding their services to include specialized photography services, where customized images are produced on demand for customers. The need for high-end images is still there, and the money is where one can provide personalized service. Agencies once again have a big edge on the individual photographer in that their size and scope avails them of equipment and space that most photographers only dream of. For example, in order to shoot a car ad, one needs a substantial studio space and lighting equipment that burns enough electricity, where the utility bill alone would be like small mortgage payment.

So, what does all this mean about the prospects of the individual photographer (professional or amateur) selling images? The answer is the same whether you're with an agency or not: it's a hard, competitive, and often conflicting market. Determining whether to work with an agency requires examining different data than simply the nature of the stock industry itself. So, let's look at the next.

Photo Buyers

Before you can appreciate the stock photo business, you must have a sense of who's buying images and why. If you think it's hard to get noticed in the market as a photographer because of oversaturation, think about the people who have to look for images. This saturation affects them as well. "Stock images" (as they are called because it's like any other inventory that's held "in stock") requires a huge amount of time to sift through. The more images there are, the more likely the buyer may suffer from "search fatigue," where all images end up looking the same. This ends up having a curious effect on the perception of value that the buyer has for the image he's looking for, as illustrated by this excerpt from an e-mail message I received from a client:

"If I can buy an image from Corbis for $100, why are you charging $250 for your image, if the end use is the same?"

My usual response is:

"You can pay $100 for an image you don't want, or $250 for one you do want."

Search fatigue is the result of "too many choices," especially when few of them satisfy the need. But the cause of this is not just because you (or an agency) has too many pictures to choose from—it's an industry-wide problem, because it's a worldwide phenomenon (Truism #1). As long as there is oversaturation, there will be a decline in the perception of value.

The real variable that trumps all this is the client's perception of how important the image is for its intended use. A photo to be used in a sixty-foot banner in Times Square would be pretty important, and the image will not likely be chosen because it cost a few dollars less than another image from another source. Alternatively, a photo used as a portion of a quarter-page ad in a local newspaper is not perceived to be as valuable, leaving the lower-priced image as the likely winner.

This illustrates that the market is often bifurcated between the high end and the low end, with a wide gap in between. Depending on the importance of an image, the perception of price can range along the spectrum between the commodity "widget," where one widget is no different than another, and the valuable name-brand photo that is critical to a company's public image. These high-end images command the higher prices, but those sales are few and far between. The low-end images are sold at fire-sale prices, but they often come in waves, where money is made on sheer volume.

This is the point at which buyers segment into two categories: *the commodity buyer*, for whom price is the driving consideration, and the *sophisticated buyer*, for whom the image itself is the more critical element. I don't mean to imply a discrete separation of these groups of buyers. In fact, it's more of a spectrum that graduates along the endpoints, not a strict division between the two. Most buyers are somewhere in the middle, although they do tend to bunch up toward one end or the other, graphed like a two-humped camel.

Stock photography is a business that, for the most part, requires volume, because the frequency and price of higher end sales will often pale in comparison to the volume of lower priced sales in a photographer's income statement. Buyers get used to this and form the impression that different *uses* demand different prices, and once the use is determined

(hence, their perception of the "value" of getting the right image), they don't see that *images themselves* command different prices. Given the same end use, they believe that any photo should cost the same as any other. This perception is further supported by the fact that most photo sellers (agencies and photographers alike) *usually* have price points that vary among uses as well, whereas the price points apply to all photos in the catalog.

If there are, in fact, different classes of buyers and images, then we should see a natural pairing between them in statistical data from stock-photo buying surveys. That is, we should see economic-minded buyers acquiring less expensive images from sources like royalty-free photo disks, whereas the higher end buyers will continue to license individual images for higher per-unit prices from established sources (stock agencies or direct from photographers). Indeed, the data does suggest just that. What's more, that information isn't nearly as interesting as the more pertinent data that shows no crossover between the two. That is, higher end buyers do not use royalty-free disks or certain stock agencies because they perceive their needs to be more "important," and thus seek those images that satisfy those needs, and they pay higher prices for them. Conversely, those who buy royalty-free images know that they aren't using them for huge money deals, so they rummage around in the bargain bin near the exit door. That is, you don't see people using a generic photo of a car from a royalty-free photo disk in a full-page ad in a magazine.

The net result: royalty-free pricing has *not* affected the price points for rights-protected images, and since different buyers exist for each discrete market, an agency (or a photographer) could find a viable business model doing either or both without compromising the other.

OTHER BUYING DECISIONS

Buying images involves more than just determining whether the right image can be obtained for the right price. Buyers also factor into their decision two other very important criteria in the photo-buying process: *speed* and *quality*. That is, they do not want to spend a great deal of time finding the image they want, and they don't want to sift through images that don't even come close to what they need. People will use any source on a regular basis if it is consistent in satisfying these criteria. Buyers don't want to waste time going from source to source; they like to hone in on a limited set of reliable sources because it saves time, thus

162

satisfying both time and quality requirements. Because most buyers who license images on a regular basis are the best customers to have, most stock agencies try to cater to such companies by offering specialty images that fit into the business model for their target market.

For example, a stock agency that deals strictly with weather-related images may be a primary source for government agencies, travel companies, or news organizations that need to license images to accompany a news story or promote a vacation idea. Consider the huge number of images on the Internet that feature "lightning." However, it takes a lot of time for a buyer to sift through all those sources to find a set of viable options. It's more time-efficient to go to a single source for this type of material, assuming that the source has a good track record for providing suitable images over time. Experience shows that buyers are willing to pay a premium for that convenience.

To summarize the buyer's perspective, the important elements are:

- Time and convenience when searching and finding images.
- High percentage of quality images that meet the buyer's needs.
- Price.
- Relationship to seller.

The last point was not discussed in this section because it is addressed more thoroughly later. That notwithstanding, the better you or your agency is at servicing these needs, the more successful you'll be at being one of those suppliers.

The Photographer's Perspective
Having an understanding of where buyers acquire their images and how, you must then consider how you fit into that model. What's your specialty? (Or, are you a generic stock photo shooter?) What is the market for your images? Who will buy them? For what uses? And most importantly, *where do the photo buyers for your target specialty acquire their images?* All photographers who want to sell their images must think about all these issues before they can strategize on the best way to conduct business.

Whatever your strategy, you will confront the single biggest hurdle that faces every single photographer and stock agency today, a point

that I beat into the ground every chance I get: the supply of photos exceeds demand. You may, in fact, satisfy all the needs and checklist items that satisfy the buyer. The question then becomes, *is the market big enough to fuel a business?* Consider the photographer who has tons of lightning photos. Let's assume he's also got stock photos of all sorts of weather conditions and other related imagery. Now consider all those buyers who need them. Sound like a viable business to you? If you think you know, I assure you, you're wrong. One cannot predict the size of any given market segment, unless one has been in the market in some capacity already. If you're "thinking" of getting into this business, but haven't already been in the business to know the answer to that pivotal question about whether your own market size is viable to support *you*, then it's probably a mistake.

But, all is not lost. For the serious *professional* photographer, the decision whether to get into the stock business, let alone to work with an agency, hangs on the answer to this question: *Is your stock base broad enough to appeal to a large audience, while assuring that your quality isn't compromised?* As is often used in scientific lingo, you have to exceed a "critical mass" of stock images in quantity and variety to achieve a stable, reliable, and self-sustaining business model.

RUNNING YOUR OWN STOCK BUSINESS
Here are a few of the most difficult aspects of running your own stock photo business:

- **Organizing and managing your photo base**
 It's one thing to shoot a lot, but maintaining a photo database is time consuming, not just to ramp up, but to maintain. This is a doable process, and those with experience with computers have a considerable advantage over those who don't. There are programs that assist with this, but it's beyond the scope of this chapter to review them. You'll need to do your homework on what's "currently" available, and gauge your own degree of competence in this area.

- **Marketing stock photography to clients**
 This task requires skills beyond photography. See chapter 5, "Photography Marketing" for a detailed discussion. Your ability to market well is critical to making it in the stock photo business on

your own. Again, it's doable, and more people can do it than think they can, but it still isn't for everyone.

- **Negotiating prices**
This is difficult at best, confrontational at worst. But, having a top-down view on business strategies and working within the scope of your long-term objectives makes this task more palatable.

- **Keeping track of your photos**
If you're still working with traditional film, you're going to find a lot of overhead that your competition doesn't have. The stock industry has moved toward digital faster than it has toward any other technological advance in the photo business. Whether film or digital, you still have to keep track of your clients, your photos, and who has what and what their issues are. Doing this with physical film requires infrastructure, not to mention the financial overhead of materials and postage, but you may also need to pay an assistant. Worst of all is getting clients to *return* images they have. With digital, that's not so much a problem, but it's equally frustrating just keeping tabs on who is considering what.

- **Getting clients to pay their invoices**
This can get really ugly at worst, and just plain time consuming at best. Again, how you weather this has everything to do with your ability to organize yourself in a business environment.

It's beyond the scope of this book to address any of these points in depth, but one doesn't have to read further to know these tasks are a huge investment of time, money, and headaches. It's not that going at it on your own isn't worthwhile, but it may not be for everyone.

If I've talked you out of trying to sell stock photography on your own, and you're now eager to work with a stock photo agency, don't get too excited. There are many downsides to this prospect as well, the most important of which is the financial bottom line: the supply-and-demand imbalance has forced prices downward, and the trickle-down effect through the supply chain has a ripple effect. The stock agency gets the first chunk of money, leaving the rest to the photographer, which, as you can guess, is pretty low at this point. Worse, the photographer's income is further eroded by the ratio of photographers to agencies: the more

photographers there are, the less the agency is compelled to pay them. In order for photographers to make money, they must be as aggressive with price as they can be (meaning, "willing to take less") or the agency will simply work with others. (Okay, it's not quite that simple, but we'll get into that later.)

THE MAGAZINE EXAMPLE

Putting this into perspective, let's say a magazine wants to license a quarter-page photograph for an editorial story. A fee for this might be around $175. If the agency pays you 40 percent, you get $70. However, the agency may need to outbid other offers, and it may come back and ask you to accept the license fee of $100, leaving you with $40. Also, if the agency has a lot of photographers, the chance your image is seen (or purchased) is diluted by the influx of images from everyone else with that agency. Some agencies may "suggest" that your images might be ranked higher if you were to, say, give up another 10 percent in your royalty agreement. So, now you're down to 30 percent, or $30 for a license fee that would have paid you $175 if you'd done it yourself.

Of course, many agencies may deny that favoritism is given to those with different royalty rates, or that royalties are fixed among photographers. While that probably is true for the majority of them, exceptions are always made for "exceptional" people or conditions. After all, business is business. We'll return to this issue, and many like it, in chapter 9, "Working with Stock Photography Agencies."

The hypothetical magazine example above doesn't even begin to touch upon all the problems in working with agencies. But, to quickly jump to it, here are the highlights of typical problems people most often complain about:

- **Photographers' images are often not seen by clients.**
- **Images are misplaced if not lost entirely.**
- **The constant influx of new images pushes older ones too low in the stack to matter.**
- **In some worst-case scenarios, internal photo management is so bad that no one knows who owns which images, and some photos are actually sold without royalties paid to any photographer.**

166

The frustration with stock agencies can be seen in empirical data. According to the Advertising Photographers of America's (*www.apanational.org*) 2001 survey of the stock photography business, 35 percent of commercially licensed images came from the big stock agencies, a drop from 70 percent ten years earlier. By contrast, 65 percent of images came from photographers either directly *or* through their own personal agencies, run by themselves or with partners. It would seem that stock photographers are moving away from agencies. But is that really the case? Stock agencies say that they are hiring more photographers than ever, and their stock bases are considerably higher too. What can explain this discrepancy? Back to Truism #1: the number of photographers has exploded. The answer is simple:

"Agencies are growing, but the number of photographers is growing faster."

This begs new questions: if the total number of photographers is growing, why are a smaller percentage of them working with agencies? Why do photographers work with agencies at all? We already examined the pitfalls of going at it alone, so is it a question of choosing the lesser of two evils? What about those who do *not* complain about agencies? They must be doing something right, or, at least, the agency they chose is doing something for them that keeps them loyal. To understand this, let's look at the agency's perspective.

The Agency's Perspective
While it seems that a photo agency has the upper hand on photographers, it too has business issues that aren't so easily solved:

- Managing a vast number of physical images.
- Managing the relationships with photographers.
- Managing the relationships with clients.
- Keeping a fresh supply of new images in the queue.
- Managing the business itself.

Each of these items could be a book by itself, and I can't possibly flesh out the details of each suitably. For example, the first point about "managing physical images" requires tasks like scanning images,

building and maintaining electronic databases, keywording and describing images, building and designing the hardware and software necessary to do all these tasks, synchronizing all this data with the Web server, keeping slides in the right boxes, tagging and tracking where the original slides *are*, where they go next, getting them back from where they were, and (*deep breath*) collecting them all back up and sending them back to the photographer after he's notified you that he's terminated his relationship with you because you haven't been able to sell any of his images.

You've probably got the idea by now. There's a *lot* to running an agency, which is why most stock photo agencies go under at the same rate that restaurants do (and often for the same reasons). A great cook thinks that he wants to open a restaurant, only to find out that he's undercapitalized and has no business experience. Well, the same often happens with stock agencies. But, of course, not all restaurants are a failure, just as not all stock agencies are. The point is, "it's hard," and keeping the photographer happy is only a small portion of the difficult tasks at hand.

RELATIONSHIPS: THE GREAT EQUALIZER

Ironically, and perhaps unexpectedly to many people, the most pertinent issue for the success of an agency is *managing its relationships*, including both its photographers and its buyers. For photographers, this includes not just how they are paid, but how they are represented, what kind of priority they are given with respect to other photographers, what kind of communication they receive, whether they are assigned a dedicated sales rep, and so on. On managing the buyers, it's a matter of getting them the right images, providing good service, and so on.

To see how these relationships can be rather tricky to satisfy simultaneously, let's review that magazine example, an image worth $175 (of which $30–40 goes to the photographer). To put things into perspective, this is not a huge revenue-generator for the agency. That image could have been provided by any photographer in the agency, so it's arbitrary whose is used. Or is it? Was the decision purely arbitrary? Given the low dollar amount, the agency didn't choose the photographer solely because of a more advantageous royalty structure. There must be more to it. To see how seemingly unrelated events fit together to form a complete picture, let's break

away for a moment and consider an entirely different scenario. We'll come back to this example afterward.

The Fashion Photo Example

Let's say the agency is trying to supply images to an ad firm in the fashion world. In this industry, photos are often licensed for tens of thousands of dollars for a high-profile ad placed on a billboard or in a high-profile magazine. Here, the photo agency must have access to top fashion photographers, or it won't get the business. It follows that the agency wants to keep its top photographers happy. If a photographer generates images that yield high income, that photographer (and his images) will (and *should*) get special treatment. After all, if it were you, wouldn't you demand that your income achieve a certain level? If you really *are* that good, you could easily be lured away by another agency who would give you that guarantee, even if you don't ask for it. It only makes good business sense for the agency to feed you, the goose who lays golden eggs.

Now let's return to that small $175 stock-image sale: sure, the client may have been shown an image from another photographer in the agency, but if the agency wants to keep its top photographers happy, it's more likely to promote their portfolios over the other, lower rung photographers. In the big picture, the agency must first look out for the interests of its goose that lays golden eggs. How can we measure whether this works? By looking at the income levels of the photographers in any given agency and running a graphical distribution chart and examining the results. According to reports from Getty Images, as an example, 80 percent of its payouts go to 20 percent of its photographers. That mysteriously consistent 80/20 split will appear again, which we'll address a little later.

HOW AGENCIES VIEW PHOTOGRAPHERS

If you're still stuck on the idea that "quality sells" and that the agency should present the photos that are *better* than other photos, regardless of who the photographer is, then perhaps I should remind you of the joke from chapter 1:

Q. How many photographers does it take to change a light bulb?
A. 50. One to change the bulb, and forty-nine to say, "I could have done that!"

If you're at all like most photographers, you will, at *some* point in your career, proclaim the very true and valid statement (usually in a high-pitched, very annoying voice):

"Hey! *My* photos are better than *his*!"

Yet, if your images were chosen, some *other* photographer would make the same valid complaint against you. In short, "quality" is subjective. When it comes to dealing with large quantities of images and making business choices on what to "push," quality, per se, isn't as responsible for a sale as "the relationship" is. This goes between the photographer and the agency as much as it does between agency and the buyer.

Controversy

Of course, I do not imply that there is a single star photographer and the rest are pawns. Many agencies treat all photographers the same, or try to. But, seniority (of all its forms) usually manifests itself somehow. In short, there is an "order" to the pecking, and this order is fluid and somewhat unstable and transient. (People move up and down the ladder often. As is often said in the film industry about an actor's career, he's only as good as his last movie.) This is why managing groups of photographers is so difficult. It may not necessarily be the case that a formal "order" exists, one could assume that the agency has to balance its need for profitability and management with its photographers to decide what to do next at any given decision. Thus, an "implied" order usually forms as a by-product of this business-management process.

Again, not *all* agencies work the same; this discussion is only to illustrate an abstraction by which an agency operates. There are some photographers who've witnessed this type of thing, even though the circumstances and conditions may have been different. Remember, it's difficult and costly to run a stock photo agency, and unless care is taken to assure profitability, the agency may not survive. This isn't necessarily because people didn't apply some of these rules—in fact, it could be because they *did* apply them, but did so poorly.

THE TOP-TIER PHOTOGRAPHERS

Based on the above discussion, the question becomes, What does it take to be one of the chosen-few star photographers in an agency, whose works are viewed more often than everyone else's? Put

170

succinctly, the top-tier photographers usually have one or more of the following qualities:

- Have been shooting for years—around twenty-five and more—and have already gained a personal reputation in the industry.

- Have reputations in specialty areas, or who come with a huge collection of immediately marketable images ready to go.

- Have moved up in the ranks from lower rungs.

One thing that all of these have in common is *years*. Time exposes people to experiences, and from those come maturity. A young kid out of college with exceptional skills, an innovative style, and a very unique vision may be a potential goldmine for a stock agency. But what is untested is whether this person will evolve, or how he performs under stress, how he interacts with the agency's staff or its clients. Sure, skill, talent, and vision are great, but nothing can replace what agencies really want: reliability. And *that* can only be developed through time. That young photographer may get hired and paid a salary, but he's not going to get good royalty rates or preferential treatment for years.

The 80/20 Rule

Okay, so the top-tier photographer may not be you. For most, that's just fine. Perhaps you're one of those people who says:

"I'm not that serious about photography; I just want to make a little money on the side with all of these pictures I've shot over the years. So, let the agency sell my images for whatever it can, when it can, and I'll take whatever income results."

There's certainly nothing wrong with this perspective; in fact, you're not alone. Most people who go to agencies today have this mindset. That's not to say that all photographers at agencies think this way. It's just that a large percentage of them are more casual about their income expectations. So, if that's the case, what kind of income expectations should you have?

To answer that, we can now put together various topics we've discussed so far to understand the bigger picture of how photo agencies work. As we've seen, some business yields small revenue, other business is lucrative. If, at the end of the year, one were to

itemize each "deal" on a pie chart graph, a very familiar pattern will emerge, one that seems to be intrinsic to most commodity-based businesses: *the 80/20 rule*. In summary:

- 80 percent of the revenue comes from 20 percent of the clients.
- 80 percent of the best-selling product comes from 20 percent of the suppliers.

In the stock photo business, you can state the concept this way: "A small percentage of clients are paying high prices to have access to a small percentage of photographers' images." It's a self-perpetuating formula. For the agency to make the big bucks, it has to keep its star photographers happy, thereby turning more business their way, which reinforces the 80/20 breakdown. This is why the pattern is so common in commodity-based businesses.

We can test this in the real world by citing actual data. By doing a search for "stock photography survey" on the net, we will eventually find data that points to a 2001 press release from Getty Images, one of the largest stock photo agencies. Here, the report divulges income data for the photographers in their Tony Stone Images group, a subsidiary that represents some of their top-tier photographers. In the report, the top 20 percent of photographers (280–300) earned just over $40,000 a year (although other survey data suggests that $55,000 is a more accurate number). However, the bottom 80 percent of photographers (1,120–1,200) earned an income that "exceeded $400 a year." (It's hard to nail down precisely what this means, since lots of numbers exceed $400 a year. Yet, one can assume that number was chosen because it was closer to the "real number" than, say, $500 a year.) For more survey data, go to: *www.pickphoto.com/sso/Survey2003results.htm*.

The 80/20 split isn't "soft"—that is, open to interpretation—it firmly establishes a huge disparity between the top-tier photographers and those on the bottom. So, when you said that you weren't that serious about photography, and you wanted to let whatever money the agency made trickle in, that's exactly what you're going to get: a trickle.

This prompts the question, "If the revenue is so low for 80 percent of the photographers, why does the agency represent these masses of photographers at all?" One would think that the overhead of dealing

with so many people would justify dumping the majority of the non-performers and putting more investment into the sales and promotion of the top performers. Turns out, there are several reasons for keeping the underperforming masses around:

1. **Efficiency of Scale.**
 A business has to have a certain degree of infrastructure to operate, and in the stock photo business, this includes salespeople, software, hardware, and, above all, "expertise" in the industry. Having this type of operation means that you have to keep the "assembly line" full, or you will lose money by the simple virtue of dormant resources. So, the agency can (no, *must*) take advantage of the *efficiency of scale* by keeping the infrastructure operating. It doesn't cost any more to put more product into the supply chain than to leave it empty. In fact, by *not* filling the market's capacity with something, profitability can be compromised. The infrastructure necessary to support the top brass (20 percent) just happens to have the capacity to also support the remaining 80 percent at no extra cost of administration or overhead. So, they keep them.

2. **Playing the Lottery.**
 Because images are subjective by nature, one never knows if an unknown photographer will supply a "sleeper hit" (an image that surprisingly seems to have selling power) or, better yet, *staying power*. So, it's always good to bring in images from the 80 percent "masses" on an ongoing basis as a way to inexpensively "play the lottery."

3. **Incentive Sales and Fostering Relationships.**
 Since the real objective of the agency is to lure the lucrative clientele that contributes to 80 percent of the agency's revenue, the firm needs "bait" to attract them. While there are many ways to do this, one method that the agency has at its disposal is the use of "incentive sales." Here, an agency may supply an image (or a few) for free, or at a very discounted rate in hopes of winning a new client. It will still make the contracted royalty payment to the supplying photographer, but this is likely to be at a very low rate, a price easily absorbed due to the low royalties paid to lower-tiered photographers. Obviously, the agency isn't going to give away an image that

173

would generate a lot of money, nor would it license an image for a lucrative *use*, as that would defeat the very purpose of the end objective. No, the "give-away" images are for small-time uses that can help establish the rapport with the client.

4. Completeness.

Last, but not least, it's good to have a large enough supply of images from a broad set of photographers, so as to meet the needs of any given client. If you're a stock photo supplier and a client requests a particular image that you can't provide, this looks really bad. Quality, of course, is important, but there's a perception value associated with the mere appearance of having multitudes of images and a cadre of photographers. The 80 percent lower-tiered photographers are a great source for these images.

Keep in mind that stock agencies like Corbis and Getty don't *just* sell stock images acquired from independent photographers. They also hire a *staff of photographers* who shoot (mostly assignment work) for the agency's clients. These photographers are typically paid a flat rate (salary). In fact, much of an agency's profitability comes from these assignments. The images they shoot usually end up in the stock image supply, much like what was done years ago by the first agencies. Here, the stock agency doesn't really look for long-time photo celebrities, they look for young, recent photo-school grads who know the techniques and basic photography skills to get good commercial work done. In return, these shooters get a handsome "salary," but then are paid a very low royalty from the sales of the stock images they produce. (Note that these photographers are not part of the income survey referenced above.)

Many old-school photographers today complain about this, claiming that the new-school photographers are being taken advantage of. But, the cost-benefit analysis usually shows that the flat salary paid to assignment photographers often compares nicely against the potential for royalties in the short term. Granted, the longer-term prospects are less advantageous, but the job is not designed to be a long-term career; an assignment photographer should only do so long enough to get experience in the industry and then move on. (Unless, of course, he can demand a higher salary for his work, which is not uncommon.) All this relates to career strategies, which is discussed in chapter 3, "Photography and Business Sense."

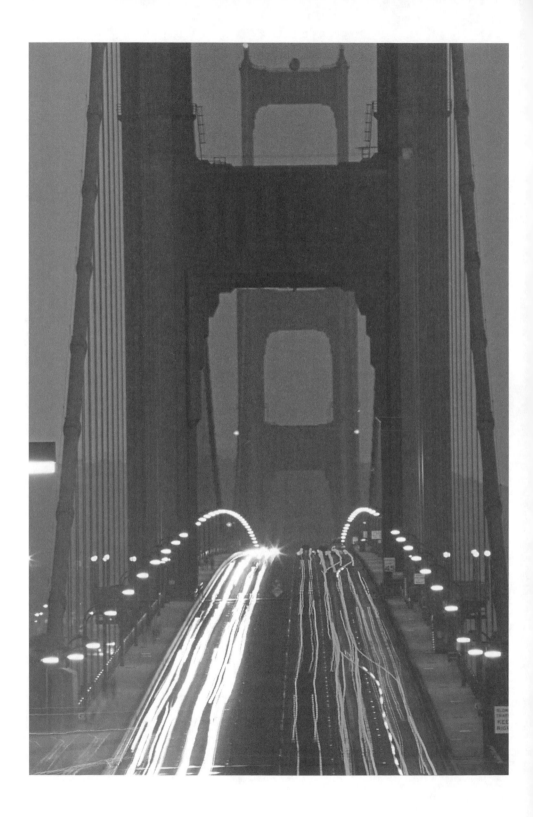

WORKING WITH STOCK PHOTOGRAPHY AGENCIES 9

As discussed in the previous chapter, the stock photo business involves your selling pictures you've already taken to new clients. There are three ways to do this: you can sell direct to the buyer; you can work with an agency that handles your images for you; or you can choose a hybrid of these two options. If you've determined you want to try working with an agency, this chapter explores pragmatic ways for finding the right one and working out a "mutually beneficial relationship" (which is a euphemism for saying that you must set realistic expectations for yourself of what you're going to end up with).

Before we begin, the one thing that almost all agencies share today (and the laggards are moving increasingly faster in this direction) is the obsolescence of *film*. The industry is moving toward digital imaging at such an increasing speed that most larger agencies won't even accept film submissions anymore. You are certainly free to submit *scans* of your film (which is better anyway, since you keep your originals), but it's not even worth approaching anyone with film unless you are dealing with a specialized niche market that still deals with film on specialized subjects, formats, or other conditions (assignments on behalf of the agency, for example). Since the role of film is diminishing quickly, I'm not going to bother with the subject here.

As for image *style*, you usually pick the agency (or it picks you) based on whether your image styles and subjects match. Needless to say, you need to have marketable images for your area of focus, but your creative interpretations may not be shared by others. Thus, half the battle of finding the right agency is finding one that shares your tastes.

Differences in Agencies

Agencies differ considerably in how they do their business, and one can't say definitively whether one model is better or worse than another. That depends on *your* strengths as well as your long-term objectives. We'll address all these things in the course of this chapter, and then glue it all together to help you in choosing the right agency. For now, let's

177

review the most fundamental ways agencies differ from one another. Note that these are not mutually exclusive; some agencies can share in many of these different attributes.

LONG-TERM VERSUS SHORT-TERM RELATIONSHIPS

Some agencies may present opportunities for short-term immediate income at the expense of long-term growth. (These agencies may pass lucrative assignments your way, where you get a fee for doing the shoot, but they retain the bulk of the royalties associated with any ongoing stock sales.) Such a model may be good for photographers who only need quick cash infusions as they grow other parts of their businesses, whereas many photographers take these kinds of agreements because that's all the work they can get—another by-product of a highly competitive and saturated market.

Suffice it to say, however, that most seasoned pros who have established their stock bases years (or decades) ago are doing quite well with the residual royalties from the net sum of their images. These people are working with traditional stock agencies that are more structured to provide little short-term return but a more reliable income stream down the road. This may be what you're looking for if you plan on building up a large library of images where the accumulated collection has intrinsic value all its own and can provide an "annuity" type return.

MANY VERSUS FEW PHOTOGRAPHERS

Another structural difference between agencies is how many photographers they take, which can have reciprocal effects on the "return versus competition" equation. That is, an agency may be set up to favor a few high-profile photographers, making it difficult to get in, but those chosen few will have good returns by not having to compete with one another for sales in their respective specialties. This type of agency only has one or two shooters in each area—nature, sports, landscapes, portraits, fine art, etc. You may already be thinking that if you're a general shooter with no defined "specialty," then this may not be the right agency for you.

The other end of the spectrum finds those agencies that accept photographers quite readily because they are looking to capitalize on

selling images in large quantities. (One form of "bulk licensing" that some agencies use is royalty-free image disks, where the buyer of the CD gets several hundred images for a low, fixed fee.) An agency might warehouse thousands of images for every different market segment they can find within dozens of different industries. Here, the payout is distributed widely among a large population of photographers (hence, the ease of getting accepted). In this scenario, substantial returns are unlikely but are still achievable if your images compete strongly against others at the agency. (See "The 80/20 Rule" in chapter 8, "The Stock Photography Business.")

MARKETING STRATEGIES

Some agencies have marketing strengths that can make your images more visible to a target market segment. But don't get "marketing images" and "photographer promotion" confused. Agencies sell images; they don't make celebrities. Marketing yourself is your responsibility. (Go back to chapter 5, "Photography Marketing" for more on this.) Agencies can't make you a star or even "better known." That's not their purpose or their goal (although it might be part of their pitch for those they try to attract). They may *appear* to promote certain photographers, but you need to look closely at what they're really doing and why. Their goal is to sell images, and the images that sell are those from big-name talent. Hence, agencies look for and aggressively market photographers who already have a name. Their promotion of those names isn't to promote the photographer, it's to promote *themselves* for carrying that photographer's work.

Accordingly, be careful of agencies that claim to market *you* instead of your images. It's often a way (not quite a "scam") to get you to pay cash out of pocket for "marketing and promotion." Agencies that ask for upfront fees are less likely to have enough capital to cover their marketing expenses, plus many others things. Paying your agency's marketing bills for them won't generate more business. Those same dollars should be used for *self-promotion* instead. The caveat to this is discussed next:

E-COMMERCE STOCK HOUSES

Don't get "charging for fees" confused with agencies that aren't really stock photo agencies but just another Web presence where you can house your images for a fee. Such companies do nothing but provide an

e-commerce infrastructure (Web site, disk storage, payment, fulfillment) where you can put your images. They take anyone who wants to pay money to get their images into the mix. This is fine as a business model, as long as you understand that you're paying for a glamorized Web presence and someone to move your images on your behalf. In fact, it may be just what you need if you don't have a Web site at all and don't want to get into that. (See chapter 7, "Running a Photography Business on the Web.") Yet, because this is a relatively new business model, there isn't enough evidence to suggest whether it will last beyond a few years. The few companies that do this have tried to expand beyond their means in attempts to compete with larger agencies, so it may take some time for good ones to emerge as mature players in the field.

ASSIGNMENTS

As the stock photography market has become more saturated, agencies have had to diversify their business models. One of these methods is to offer other services, including custom or assignment photography. In fact, some stock agencies are turning into just that: *assignment agencies*. This type of agency might call upon you to shoot an assignment based on the client's specs. This has many different pay structures associated with it, so it's even more critical that you know what your longer term plan is for your photography (and stock in particular) before you readily accept (or reject) any given business proposal. Many agencies will hire photographers on the classic per diem basis, plus expenses, whereas others may ask the photographers to pay everything themselves and get paid a lump sum after the client has accepted the work. Also in question is the royalty structure for the images, as well as copyright ownership.

Before determining whether the assignment (or the relationship) is worthwhile, you must look at the total package, not just one part of it. Consider what your out-of-pocket expenses might be, what your royalty fee is, copyright ownership (so you can add these images to your existing stock library), what the shooting fee is (or isn't), etc. In all, your worst-case scenario should be the low-water mark for whether the deal is worthwhile. For some who are new to the industry, or who have a hard time getting work or gaining any level of professional experience, such a relationship may have intangible benefits, if not direct financial returns. That is, simply being asked to shoot may be a great way to get

experience. If your images are good, you'll eventually get the income you want and deserve, and you can reevaluate whether this form of relationship is still worthwhile. If your images aren't so good, you will be spending a lot of time and money shooting, getting nothing in return. Yes, that's bad for you, but it doesn't represent a "bad deal." Indeed, it suggests maybe you're not in the right business.

For the slightly more experienced photographer looking to get quick cash, an assignment that pays $5,000 for a two-day shoot but no ongoing royalties and no copyright ownership may be worthwhile. For someone looking to get into the stock industry for the longer term, however, it may not be. As we can see, these relationships are not inherently good or bad—you just have to choose wisely what's appropriate for you.

Your Responsibilities

Many people over-glamorize the relationship photographers have with agencies. The typical perception is that people would give their hundreds or thousands of vacation slides to a stock agency and wait for the money to come in. Very few agencies work like a savings bond, where you make an initial investment (by giving them your images) and you then receive interest payments every quarter. The only ones that work that way are those that have had multidecade track records with star photographers, who can rely on a select portfolio of photos that seem to produce a reliable income stream over time. (This kind of portfolio is rare, but it can happen if it has had the benefit of time to mature.)

For everyone else, you should expect to work so closely with your agency that you feel they are like your photo lab: you deliver photos to them constantly. For shooters who are persistent, and who have no time to manage the sales part of their businesses, they will probably do best with agencies. Your objective is to "flood the pipeline with product, and hope that lightning strikes often." Most will make a small amount of money relative to the number of images they submit, so the numbers game dictates that the more you throw into the pot, the more likely your income will rise from the aggregate total. (Don't forget: you have to maintain image *quality* too.)

The natural timeline for working with an agency usually starts after you've already developed a pretty significant and important arsenal of

images that an agency can pick up right away. This will virtually enforce itself for no other reason than most good agencies won't take you *unless* they see a large enough supply of salable images that they can start with. Even then, it's considerably challenging. Your best bet is when you have a proven and demonstrable *sales stream* (substantiated by high-profile references and tear sheets) that you can present to an agency.

Yes, this throws you back again to the prospect of working alone. But look at it from their perspective: imagine if you were a bank. You wouldn't want to risk loaning money to someone that won't pay you back. Of course, there's a *degree* of risk, but the goal is to loan money to those who are most likely to pay you back. The income you get is on the interest they pay on that money. Agencies work the same way—they seek out photographers who've got a track record and avoid riskier candidates. The money they make is on the revenue generated from photographers who demonstrate sales.

As it turns out, that process of "doing your own sales" first, before even approaching an agency, is probably the most effective and risk-free approach you can take, even if it may not be the most expedient. Put another way, you can take the shortcut through the woods to grandma's house, as long as you're ready to face the wolves you'll meet. There are several pitfalls to approaching agencies too soon. First, you need to have a good, solid understanding of the stock business. Doing it alone first gives you empirical experience, but it also exposes you to those agencies that you may eventually end up working with. You'll learn who's who, who's good, and who's not. You'll also know what your own clients think of specific agencies, since most people get their images from multiple sources. Through them, you can learn what their reputations are, their advantages, pitfalls, etc. When you're finally ready to work with an agency, it'll either be from their calling you, or you finally taking advantage of the contacts you've developed inside (or close to it) over the course of time. And lo and behold, you won't need any "tough questions list" to ask them to determine if they're right for you. You'll already know.

Another risk in attempting to join agencies too soon is the investment of *time*. As discussed in chapter 3, time is your most valuable and precious resource. Attempting to join an agency is exceedingly time consuming, from the gathering and submitting of materials in your application to the incredibly long wait in getting a response.

Worse, many agencies have a habit of stringing applicants along with requests for submittal of more material, especially if they have specific needs for an immediate client. (Even if they license an image, it doesn't mean there are long-term prospects with that agency.) So, it's extremely important not to dive into this model too soon when you have other, more basic infrastructure to build first. If you've already got an existing business, this kind of effort is more easily and efficiently managed, because you can leverage the existing infrastructure you've already built. Thus, the time investment is almost negligible. Wherever you lie along that spectrum between "beginner" and "professional" makes the decision on when the time is right more difficult.

Where it can get even more confusing is through some of the emerging agency models that make it seemingly easier to dip your toes into the water without a big commitment of time or resources. Examples include agencies that are structured so that you don't even join them—they simply have "needs lists" for images their clients are seeking. These lists are posted to their Web sites, which photographers can browse and submit images for consideration. Whichever images the client selects, the photographer gets the sale and/or a commission. (These have sprung up to capitlize on the large number of amateur photographers looking to get in.)

Sounds easy enough. But, you can imagine that the client will be overwhelmed by images, many of which are likely to be amateurish. When I was first testing the viability of one such agency, I'd submitted a few images for an ad requested by a phone company, but never got a response. A few weeks later, I was contacted by that very phone company through my Web site, requesting an image for the same ad. (The image they requested was not one of those that I'd submitted.) When I asked about the company's experience with the agency, they said that the huge influx of poor quality images halted their search for *any* images from that source. (And no, they never saw my submission either because of the volume.)

Many such agency models are going in and out of existence as companies experiment with new models for success. The above example is but one, and it will certainly go through various permutations to improve how images are submitted and edited to optimize the benefits for both the client and the photographer alike. How that evolves is unclear, and it's beyond the scope of this book to foretell what may

come of those agencies, or to suggest that any one may be better than another. Once again, it's dependent on your personal skills and objectives as to whether any given agency may be right for you. However, the basic rules of business management still apply and are echoed here:

Be conscientious of the time investment required for any given activity.

If you put a lot of time into repeatedly submitting images to agencies or clients, yet yielding little success, you've wasted a lot of time that could have otherwise been spent on building a Web site or an image database infrastructure or other business-building activities.

Basics

When any given photographer should consider joining an agency is not measured in time. It is dependent on how far along he is in his career, what his goals are, his skills and business acumen, and of course, experience. All these may vary among individuals. To that end, here are some checklist items to round out the discussion:

❑ **Learn How Stock Agencies Work.**

There is *no* stronger piece of advice for any photographer hoping to work with an agency than to learn the ins and outs of the business itself (see chapter 8, "The Stock Photography Business"). Whatever it is an agency says about its strengths, you need to put that to the test to see *how* they go about doing what they purport to be so good at. If they say they're great at image fulfillment, you should see evidence of it on their Web site. If it's marketing, you should already know the agency by name recognition, and it should have high visibility in advertisements and other promotional materials.

❑ **Your Mileage *Will* Vary.**

You are guaranteed to have different experiences with different agencies. You may also be surprised to learn that even within the *same* agency you may start out very differently than how you end up. While everyone expects to start on the low rung of the ladder and move up, it is *also* possible for you to drop back down the ladder. Worse, there are usually *no good reasons* for your movement within the "ladder" in either direction. It happens to just about everyone.

❑ **Don't Put All Your Eggs in One Basket.**

It's often better to avoid full and total commitment to a single agency unless and until you've gained a certain degree of confidence in their ability to generate a revenue stream, and, perhaps more importantly, by the personal rapport you build with individuals within the agency (sales rep, marketing, upper management). Until that point, you should continue (or try) your own direct sales efforts or work with other agencies simultaneously, or both. Remember Truism #4 of the photography business: *Diversify your income.*

❑ **Know Yourself and Your Market.**

Before you consider having someone else sell your photos, understand the market that's most apropos for your work. If you don't know, or you feel that's the job for the agency, you aren't ready to work with one. *You* have to know your market: the magazines, the trade journals, the ad agencies, the photographers, and anyone else who may be a source of information within your market segment. Buyers who go to stock agencies for images are filling a business need, and if you're going to be a supplier (even if indirectly via an agency), then you have to understand what the buyers' needs are and create images that meet those needs. If you specialize in cars, know the automobile market; if you specialize in fashion, know the latest trends; if you specialize in travel, know what kind of imagery appeals to that market. If you're a general all-around photographer, that's fine, too, but you have to understand your own pictures and something about who would buy them.

If you don't know your own work, you can't gauge whether an agency is good. Photographers mistakenly assume that a stock photo agency is full of experts, with inside contacts at ad agencies and magazines, with expert photo editors who'll sift through your material and pick out the unseen winners from your glorious work, and push them onto buyers, where everyone gets rich. Needless to say, this isn't going to happen. If you know yourself, you'll be better equipped at judging and monitoring the effectiveness of the agency you choose.

❑ **Do Homework.**

Contact the photo editors of the magazines you know, or the ad agencies that produce the product ads, or any other potential user

of photos, and ask them where they get their images. Assuming that *any* of their photos are obtained from stock photo agencies (something that shouldn't be assumed), you will get a list of such companies, contacts, and so on. (Who knows? You may learn that the stock business for your target market isn't big enough to justify working with an agency, and selling direct may be more apropos.) If you are considering a particular agency, but none of your contacts have heard of them, this should tell you something.

Approaching an Agency

There are usually one of two reasons you're talking to an agency. The least effective (but most popular) method is *the fishing expedition.* You're on a calling binge, sending portfolios and postcards, push-marketing yourself onto one agency after another, hoping to find one that will accept you. Accordingly, they are in "defense mode" to this approach (because everyone does it), so their primary goal is to keep out of the fray. More often than not, you won't get very far this way, since the presumption is that you're "spamming" (even if you're not using e-mail to do it). It's not that this doesn't work. You will hear countless stories of photographers who claim that they were picked because they were always in the art director's face, never letting her forget about their presence. Of course, buying lottery tickets also yields a millionaire now and then. Ask yourself whether it's worth your time to play these kinds of odds, and compare those odds with those of other methods.

Alternatively (or, perhaps, concurrently), you are called by an agency that wants to represent you. You've been filled with overly complimentary feedback about the quality of your work and your Web site, and they want to carry your photos. Now you're in their position, playing goalie, protecting your turf. Let's face it, anyone that sends spam to attract business is not the type of company you want to be with (and there are those who do it, as you'll learn sooner or later).

The best way to approach an agency is through some sort of inside contact. One of the best ways to get an inside contact is by going to conferences or other venues where agencies recruit. Photo schools also get recruiters to visit; you might contact a school (if you're not already in school) to see if they can help or offer local advice. You can also gain

access through other photographers who work for an agency. (Note: You have to *know* the photographer, and he has to know *you*. It won't do anyone any good if you ask someone you don't know if they can help you "get in.") Lastly, many people who work at agencies are active on certain photographer discussion boards on the Internet. By participating in those lists, you may establish a good rapport with someone.

THE CATCH-22 RULE

Now for the reality check. The *catch-22 rule* states that the agencies you want to work with don't want you, and the agencies that you've ruled out are eager to represent you. Before you know it, you're sounding like Groucho Marx (made famous by Woody Allen in *Allie Hall*).

"I wouldn't want to belong to a club that would have someone like me as a member."

Photographers often think more highly of their own work than agencies do, and the constant rejection from art directors causes one to doubt the credibility of those agencies that may actually accept them. As pointed out earlier, it's *profitable* to work with known, desirable properties, regardless of how "good" their work is (or used to be). This is why it's often hard to accept it when an agency *does* want to work with you. Psychologically, you've gone a complete circle: you started with the hope that this very thing would happen, but in the process, you learned the ugly side of the industry, so that when it actually *does* happen, you're skeptical. This is understandable, but if you followed the strategies outlined in this book, you'll be able to judge whether working with an agency is worthwhile.

Interviewing an Agency

Once you find an agency you feel is worth considering, now what? Discussing terms, conditions, royalty rates, and other sorts of details is more important than anything else, but because of the diversity of how agencies are structured these days, it would be disingenuous to give specific guidelines as to what you should ask for, or other terms of your contract, since that would presume that I (or anyone) know your business model better than you. (You can read between the lines on this to realize that you need to know this industry well enough to know what your goals are; if you're looking to others to answer this for you, you *will*

fail.) Despite what some might say, there are no "industry standards" for working with agencies, nor are there generalizations, other than signs that illustrate when an agency may not be in good financial shape (when they ask you for fees).

When considering working with an agency, try to avoid questions that get nowhere fast. For example, don't ask this question:

"Do you promise to answer my phone calls?"

This question arises because experienced pros have found that it's hard to get their contacts to return their phone calls or e-mails. There are stories by the bucketful about communication channels breaking down between the photographer and the agency. Believe me, before I ever worked with an agency, I was shocked to hear this—after all, you're supposed to be on the same team. Sure enough, it happens. But, I can't run through the entire list of "what happens" because the nature of business is that the list never ends.

What's more, this is not a business-substance question. These are what I call rhetorical *gotcha!* questions. These questions are not asked because you want an answer, but to put the person on notice that you understand the business, and that you're not a beginner. This doesn't really accomplish that, though, and you don't learn anything about the agency at all (nor do you leave a good impression of yourself). Raising the issue ahead of time is not going to guarantee that the person will do what you want. With that in mind, let's run through some checklist items on what are substantive issues to bring up.

❑ **Know Where You Are in the Ranking.**
All agencies are more than willing to accept top-notch photographers, and few agencies ever want to work with inexperienced wannabes who have no stock base. Somewhere in the middle is you, so the question isn't whether they are taking "new" photographers; it's whether they'd consider *you*. If they are, you need to get a good sense of where you rank in that ladder. The lower you are, the lower your income potential is. Again, this will probably be commensurate with your experience and preexisting track record with sales of your own. Knowing yourself is critical, but in this case you also need to examine the people and portfolios that you'll be up against.

You should do this analysis *before* talking to them so you can be prepared to discuss the subject. You can have differing opinions on the analysis of it, but if they can't discuss their findings coherently, the agency may not be right for you.

❑ **Timelines for Integration, Sales, and Marketing.**
Many photographers think that once their material is accepted by the agency and they've sent their images, their work is ready to sell. Unfortunately, it's not that simple. More often than not, images sit, untouched, for an indefinite period of time because they have to be integrated into a database, placed online, printed in sales books and other promotional materials, etc. What you'll find is that it all comes down to efficiency—the more efficient the agency, the quicker your images will be ready to be sold. Learning what their processes are is critical. If you can help expedite that process—by providing key-worded images in a database format, for example—then that process will go faster.

Assessing the efficiency of an agency involves finding out: How many editors do they have? How many people are dedicated to keywording images and entering them into the global-search database? Who educates the sales staff about the new collections, and what form do those collections take? How often are such introductions done? What software do they use to do that? (Are they on the cheap, or do they use high-end software?) The point is: *know* how their business is run from the inside out. Do not just ask about timeframes.

As for sales, it's senseless to ask when you can expect to receive revenue. (Well, you can ask . . .) More important are the terms associated with payment. When do you get paid? After the agency sends the image to the buyer? Or after the agency gets paid? If a buyer licenses an image for an ad, and they never pay the agency, you don't get paid either. But, it's still important to know *who* licensed images, when, for what, etc. You should still receive this information, *and* on a timely basis.

❑ **Audits.**
Your contract should stipulate the right to audit. Chances are, an agency will "permit" it, but under terms that are favorable to them because audits are extremely difficult to manage, take up people's

time, and are often only done when there is suspicion of fraud. *You* have to bear the cost of the audit, which is not inexpensive, so you want terms that indicate that if the audit differs by a certain percent (5–10 percent) from the actual numbers, the agency reimburses for the audit (as well as paying any due monies).

Chances are very small you will ever audit them (and the owners know that), but a noteworthy item from NPR's "All Things Considered" early in 2004 reported a survey of artists that audited their agencies to see if their royalty payments were accurate. Only a small percentage of them performed audits, but of those who did, 100 percent found that agencies failed to report sales and pay commissions on some portion of revenues. The *smallest* amount was $10,000 in unpaid royalties. This may seem like a high number, but it is skewed by the fact that only the extremely high-grossing talent was able to afford (and justify) the expense of performing an audit in the first place.

❏ **Commission Splits.**
Obviously, the relationship with the agency is that they sell your images on your behalf and split the sale with you. (You get the funds, but they take "commissions.") How it is split varies from one agency to the next, but it is typically set based on the type of service the agency provides. Usually—or, at least, historically— the more the agency does, the more overhead is involved in doing it, so it follows that they would require a higher percentage of the sales.

These days, it's hard to negotiate your terms, and you'll find that it is directly related to your "name recognition value." Still, many agencies don't negotiate at all, if for no other reason than administrative overhead. For those that do negotiate, the risk is that there is less incentive to push work that has higher percentages that go back to the photographer. The profitable images to the agency are those whose commissions are lowest. The exception, once again, is if you are already a known quantity with a track record of performing images, or if your name alone sells images, then you clearly have the upper hand and can usually successfully demand a higher percentage.

Because royalty splits vary so much (from 10 to 90 percent), there is no way to know whether any given agency "earns" what they

take from your sales until you've been with them for a while. If you love the agency for all the other analysis you've done, don't worry about leaving money on the table. If, over time, you've done well and think you can do better with another agency or by going at it alone, you're in a better position to negotiate higher rates.

One thing to note: many agencies have "sub-agents" in other countries, which further dilutes your royalty. If this is the case, you might want to factor it into your analysis on what your return potential is. Some agencies will allow you to opt out of using their sub-agents; others may not. All you can do is negotiate what you want. But, keep in mind that if you do choose to find your own international representation, you have to go through the same difficult process of finding an agency and negotiating terms. If you think it's hard to do this in agencies in your home country, consider the time and expense associated with dealing with foreign agents. It just may be worth giving up another 25 percent. (But that's up to you.)

❏ **Frequency and Nature of Image Submissions.**
Some stock agencies *require* photographers to supply a minimum number of images in various time periods. This is good for you too, since you naturally get more revenue when you've got more material for sale. If you have a unique specialty, or the agency doesn't have many other photographers who shoot what you shoot, a constant stream may be required in order to keep you. Remember, when new material comes in, old stuff usually cycles out.

A concern is that the agency is inefficient and tosses images too quickly, leaving potential value behind. They may not tell you when images are cycled out either, so you should keep a record of which images the agency has and their status. I recommend keeping an extra tag in your personal image catalog on which images the agency has and which they don't. If you're working with multiple agencies, this is *absolutely critical*.

❏ **Photo Editors and Other Business Contacts.**
A determining element in calculating your "worth" to the agency is what level of person you are given as a main contact. Once again, different agencies work different ways. Many have a sales staff that

works with image buyers, as well as a staff of *photo editors* who work with photographers. (In some cases, the sales staff is also your assigned rep, in which case, you don't have "formal" or "assigned" access to a photo editor. Knowing this is important.) It's *great* to be assigned a sales rep who deals with buyers, but it's critical to have a good rapport with the photo editors. These people are the bottleneck between photographers and buyers; if the photo editors don't choose your images, the sales reps will never see them. While the sales staff tells the editors their image needs, it's still up to the subjective tastes of the photo editors to determine what images will meet those needs.

❏ **Assignments.**
Does the agency have regularly published "needs lists" that indicate what they're looking for? Can you be given assignments to produce those images? Of course, one can always shoot assignments on the speculation that the agency may sell the resulting work, but this can be costly if you do it several times without having made a sale. This is why having an "assignment" to do it is more cost-effective. If that's the case, what are the terms of the assignment, and how do they differ from the regular stock agreement for images you've already submitted?

Also, you want to know whether needs lists and assignments are ever given to photographers outside the agency. It is usually the case that agencies that publish such lists work with a large collection of photographers, including freelancers *not* represented by the agency. There's nothing necessarily wrong with this, but it does illustrate who your competition is and that your images will be diluted by a plethora of commodity products coming through a very fat pipeline. If this is the case, find out what advantages there are in working with the agency versus as an outsider alongside the others. (If the response is *verbal only*, this is a sign that you may be better off as one of the outsiders. Otherwise, you should have verbiage in the contract that states the agency won't go to outsiders before giving you the right of first refusal.)

If they do have outside lists, consider getting that list first and just watching it for a few months. Submit images as you feel comfortable, and if you find the agency never chooses your work, you now know you saved yourself from signing up prematurely.

❏ Does the Agency Have Rights Protected ("RP") and Royalty-Free ("RF") Work?

The only way to gain any revenue from dead capital is to dump it on the market. What happens is that the most generic or lowest selling images of general interest are sold as "royalty-free images." This has provided some benefit to stock photo agencies and photographers alike, because everyone has a chance to reap *some* financial return for inventory that would otherwise have no value. The risk, of course, is undermining the value of other, more traditionally valuable images either by diminishing the value of photographs as a whole to the entire stock industry and/or of particular images or classes of photos. But this is still a relatively new phenomenon, and the few years it's been around hasn't shown consistency in its use or acceptance. This is true among buyers, agencies, and photographers alike. So far, it has only been quantitatively identified by the low end of the market, where small firms and individuals who never were the type to license images in the first place have embraced RF images. Still, there are stories where larger companies have used them in ways that caused major gaffs, such as when both Dell and Gateway licensed the same image from an RF disc, which showed up at the same time in various magazines.

This sort of "cannibalization" of low-end products into its higher end counterparts is typical, common, and expected within any commodity-based industry. Examples include computer hardware, software, and long-distance telephone charges, just to name a few. In each of these cases, production grows, demand is high, new products replace obsolete products, and prices drop.

Where the question becomes relevant is whether you can opt out of having images in the RF category. Some agencies require that photographers allow them to make this business decision on their behalf, so you should determine ahead of time whether you think an image (or series of them) is still capable of better returns if you sold them directly. In this case, don't submit images to programs that could subject them to RF.

❏ Exclusivity.

This is a biggie. If an agency requests exclusivity to your images, it means that you cannot sell any of them through any other agency,

and in some cases, *even on your own*. If you decline exclusivity, they'll probably not try to argue with you, because the request is unreasonable and few photographers accept those terms.

If you're a highly sought-after photographer, then an agency may argue that exclusivity will maximize the price they can charge for your images. Of course, you want this too, so provided that the agency does well for you, it may be a good thing if the lack of competition keeps your price point higher to buyers, and the agency is well-placed enough to service all the buyers that may need your images. Additionally, it's easier to work with one agency than many, so another advantage to exclusivity is that it is simpler and easier to manage your business relationships. Also, this may enable you to negotiate more favorable terms, such as prepayments or other terms in your favor.

Exclusivity is best negotiated as a *quid pro quo*: require something in return—don't just give it away; for example, minimum quarterly fees paid in advance annually. Depending on the number of images you provide, the frequency of delivering new images, and/or the term of the contract, you may request a higher or lower dollar amount. Such payments act as incentives for an agency to perform so those payments they give you aren't money they're throwing out. They need to sell at least a minimum number of images to offset those payments. If the agency is serious about exclusivity, this won't be a problem. But chances are they'll back off pretty quickly because they weren't that serious about exclusivity in the first place.

❑ **Rights of First Refusal.**
This comes up when you do not have an "exclusivity agreement," discussed above. Here, the agency requests to review all your images before you make them available to other agencies; only those images that they "refuse" are given back to you so you can shop them to other agencies. Unlike "exclusivity," which does have some potential benefit to you in very rare circumstances, there is *no* advantage at all for providing first-refusal rights. Well, no advantages except one: another opportunity for a *quid pro quo* in your favor.

No one expects an experienced photographer to give right of refusal, and inexperienced/unproven shooters probably don't

generate the type of product that the agency is going to lose sleep over if you don't present it to them. So, be mindful of what you choose to barter; it may not be that important to them either.

❑ **Length of Contract.**
Many agencies will claim that it takes a lot of time to get images into the sales pipeline, and, once in, the sales cycle is very long. Also, they will claim that years of marketing your images is a costly and time-telling process fraught with trial and error, and such an investment cannot be made unless they can be protected from your terminating the contract. Lastly, time is required to create a more consistent demand for your work, not to mention a larger, well-established base of successful images to draw upon. For these and other reasons, agencies try to write contracts that allow them to represent you for *ten years* or more.

This is a very valid concern, but not a valid timeframe. The issue on your side is that lengthy agreements can keep you tied to a partner that may not necessarily be performing well. If you can't go to other agencies in this case, your career is over, or it will stagnate. So, applying quid pro quo again, it would be entirely reasonable to negotiate for *performance metrics* to be tied to timeframes. That is, if they don't do a certain minimum dollar amount of sales by year X, then you have the right to terminate. What those specific numbers are varies, and you (again) need to be informed and realistic about your business model and the cost of lost opportunities. No, this isn't easy, but then it isn't for any-one else either.

The most important question you need to ask before signing up with any given stock photo agency is: "Do I trust these people, and do I feel comfortable working with them?" That's not an easy question to answer unless you go through the discussions and negotiations described above. There's no way I or anyone else can prepare you for the real-time dialog that will transpire at any given time, and I can only imagine the plethora of questions that you will have as someone presents circumstances to you that aren't addressed here. But, if you find yourself stumped, the *best* thing to do is think for yourself with the big picture in mind; don't just start asking others for answers. It's good

to seek advice, input, opinions of various sorts, but take them for what they are: one person's opinion. No one is expert enough at this field to speak authoritatively on *every* situation. All they can do is relate their own opinions and experiences and speculate based on what they'd do. No matter what you are told, you *will* find someone with an opposite experience or opinion to counterbalance it. If you learn to think for yourself, that will be the best decision-making tool you will ever have.

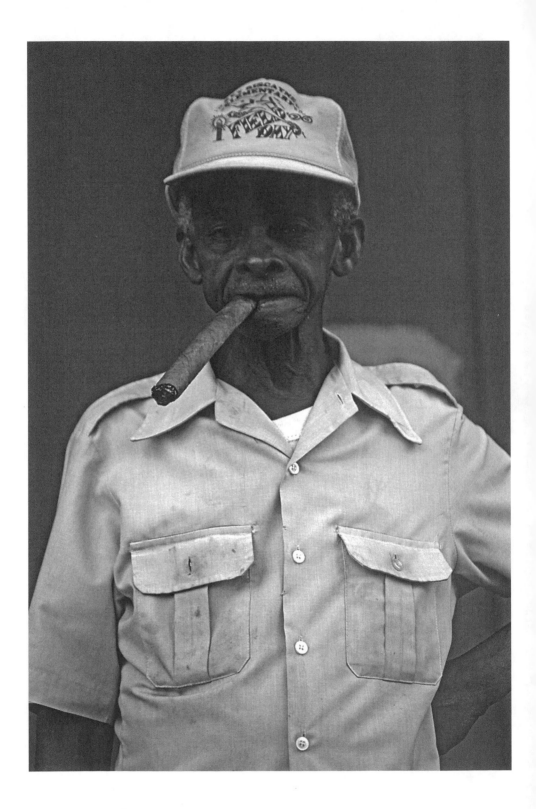

MODEL RELEASES 10

Sample Model Release

> *For valuable consideration received, I hereby grant to*
> *_____, and his legal representatives and assigns, the*
> *irrevocable and unrestricted right to use and publish photo-*
> *graphs of me, or in which I may be included, for editorial trade,*
> *advertising and any other purpose and in any manner and*
> *medium; and to alter the same without restriction. I hereby*
> *release photographer and his legal representatives and assigns*
> *from all claims and liability relating to said photographs.*
>
> *Name:_____*
>
> *Address:_____*
>
> *Phone: (__)_____*
>
> *E-mail:_____*
>
> *Signature:_____*

You're at your kid's soccer match at school and you're taking pictures. Being the photo buff that you are, you get everything—kids scoring goals, parents screaming from the sidelines, the popcorn vendor, and fans in the stands. Later, you show the pictures to some of the people and find that some want to buy a print for themselves. This becomes a popular event and, over time, your reputation grows. The local newspaper gets wind of your talent and wants to license a few photos so it can put some in the paper for an article on the school's sports curriculum. Perhaps some shots are so good that the local gift

199

shop wants to sell enlargements of the shot you took of the winning goal at the state championships.

All's going well, until someone tells you that you can't do any of these things unless the people in the photos sign a "release" allowing you to use their pictures.

This and other virtually identical scenarios illustrate a most common situation, in which a photographer has to decide whether he or she needs a release from the people he or she is photographing. Whether it's a school game, a music concert, an amusement park, or a professional-league game—the circumstances may vary—it's about the same thing: What are people's rights concerning their own likenesses, and what are your rights and obligations as a photographer to use those photos?

Definitions

In brief, a model release is a document that stipulates the terms under which one party may use pictures taken of another party (or of the property owned by that other party). Most of the time, it's a brief (one paragraph) statement, although it can also be a lengthy contract full of stipulations on payment schedules, lists of permitted and nonpermitted uses, legal rights, and sometimes even limitations on the amount of money you can sue the other party for in the event of a contract violation. As such, a model release can say whatever you want it to say— long or short—as long as both parties agree to it. It can also be retroactive. That is, you can shoot first and get the release later. (In fact, many photographers don't bother getting a release unless they have an opportunity to use the picture in a way that would require one.)

There is no government mandate about when a release is required. That is, it is not subject to the federal court system, in which the government tracks down violators. It is strictly a matter of *civil law* that stipulates rights that people have, both as subjects of photographs *and* as users of photographs. People have rights to privacy and other protections, but the First Amendment of the U.S. Constitution also grants rights for people to express themselves, to report news, and so on. It is this mixture of rights that often run counter to one another, so a model release, as its name implies, is designed to "release" one party from liability for having violated the other party's rights. Only the subject of a photograph (or his assigns, heirs, or agents) can file a complaint against someone else for using a photo in a way that violates his rights. One cannot sue on behalf

of someone else without the legal authority to represent that person. This is why a model release is usually signed between the photographer and the subject himself. No one else is involved in this process.

One doesn't have to be a professional "model" to be eligible for a model release—anyone or anything that is the subject of a photograph is considered the "model" in this context. Similarly, you do not have to be a professional photographer to need or use one—anyone who uses a photo of someone else under certain conditions may need a release to protect himself from being sued by the subject of the photo.

Herein lies the controversy. What are those conditions? When do they apply? What do you do when the rights of free speech conflict with someone's right to privacy? Because of these complexities, this is probably the *most* misunderstood topic in the world of photography, which makes it ripe for misinformation running rampant. Whether it's verbal hearsay or rumors that spread in Internet chat rooms, the mistake people make is trying to simplify into a few words a topic that cannot be simplified. Most legal cases that you hear about are too specific for one to draw broad conclusions about generalized behaviors. For instance, if you were to hear about a case in which someone was sued for taking a picture at a soccer game, don't simply assume that one cannot take pictures at soccer games, or any other kind of sporting event. This is how rumors get started and get spread over the Internet. The basic facts of that one case are usually misinterpreted from the outset, and those who spread rumors usually fail to follow these cases, which are often dismissed as "frivolous" anyway.

The reality is that almost every case is different, because the conditions that trigger the need—or lack thereof—for a model release are tightly intertwined and interdependent on multiple factors. It is more the exception than the rule to establish conclusively the necessity of a release for any given image.

The Checklist

To get a handle on this so you can apply it to your business, you have to start by adjusting your impression—and, by consequence, your expectations—on the evaluation process. The most important rule about model releases that you *must* commit to memory is this:

"Most scenarios are *not* clear-cut as to whether or not a model release is required. In fact, most cases fall somewhere in the middle."

It's this wide, grey area of imprecision that most people don't expect, making them extremely uncomfortable. They want precise answers and are reticent to accept vagaries like, "It depends," or, especially, "Well, technically . . . but you probably don't need to worry because . . ." In other words, they don't want to think. (The quest for simple, easy answers is what feeds the rumor mill.)

Evaluating when you need (and don't need) to use a release is a two-step process, which is the basis for this chapter:

1. **Review the four checklist items about the photo and the people in it.**
2. **Consider the *risk/reward analysis*.**

Both of these steps are not just important, they're interdependent; you don't just evaluate one without considering its affects on the other. For the purposes of establishing an understanding of the principles, I will begin the discussion with the checklist items that you should commit to memory. (Each of these will be discussed in full later.)

❑ **Can you *identify* the subject as a unique person or property?**
If you can't, you probably don't need a release. This is not quite as easy as you think, because there are always grey areas. It may *also* be the case that even if the person or thing *is* clear, you still don't need a release. Why? This depends on the next question.

❑ **How is the photo to be used?**
There are some uses of images that don't need a release, even if you can clearly identify the person or thing. News, editorial comments, and satire are but three of numerous examples. These lines often blur, so don't just assume you're safe until you needle out those details. Also, commercial uses often require a release, but again, many people dispute what is actually considered "commercial use." This will be important during the risk/reward analysis, discussed later.

❑ **How did you take the picture?**
Was it a public setting? Did the person know you were taking a photo? Were laws violated to get the photo, such as "breaking

and entering," invasion of privacy, or placing a hidden camera in a workplace? These seem like rare and obvious examples, but the less obvious include taking pictures of someone or something in a private home, or a venue where you have to pay to get in, like a bar or concert. What about a paid event in a public place, like a fair or park? Some of these situations apply differently under different conditions, which we will also review.

❑ **Was there proper compensation?**
This is less of a concern for the everyday use, but it is a technicality that you should be aware of. For the moment, set a bookmark in your mind that, if certain other conditions apply, there may be a requirement for compensation in order for a model release to be "valid."

Most of the time, you should be able to go back to this checklist to figure out where the grey areas are that need more thorough consideration. But knowing the answers is not enough—you need to understand how they all tie together, which is not so straightforward. Even then, a final decision is incomplete until you go through the risk/reward analysis and apply some pragmatism.

How to Read this Chapter
My final words of advice:

- *Do not* **assume that you can look up a fact and move on with business**
 You can often get yourself into as much trouble trying to get a release when you *don't* need one as you can if you use an unreleased picture. Most of the people who get into trouble do so because they oversimplify rules and make sweeping assumptions that don't apply. Similarly, people make mistakes by thinking they can be safe by being overly conservative, but this is just another form of oversimplification.

- **Don't just know the facts. *Understand them***
 It's not enough that *you* know the information, you have to *explain it to someone else*. Getting into trouble is never something that happens out of the blue. It happens because someone objects (or will

203

object) to something you are doing with a photo. How you deal with that person usually determines the outcome, and you don't do it "just by being right." Most people are far less informed than they think they are, and you don't appease them by simply informing them of the facts. You have to appease their *concern*. Otherwise, it'll cost you a lot of money to go to court and win. (It's costly and counterproductive to spend money just on proving people wrong.)

- **Opinions vary**

 The use of images (and the need for a model release for those uses) boils down to the First Amendment of the U.S. Constitution (as well as legal statutes in many other countries). This means that you're going to get many different opinions on the matter. Lawyers disagree with one another (often citing contradictory examples) on many cases, just as there are court cases in which one judge rules with one opinion and an appellate judge reverses that very decision. Again, there are often no "true answers" in some situations—it depends on the judge, the jury, and the nerves of the litigants. You will soon find out that there are as many varying opinions on the subject as there are people. This is why it is so critical that you understand the section on risk/reward analysis, later in this chapter, to know whether a given scenario presents a legitimate cause for concern, or "much ado about nothing."

Analyzing the Checklist

First, let me put you at ease: *most disputes never go to court.* People sue either because there is a perception of easy money (usually, a false one) or because they are upset about how an image was (or will be) used. If it's not about money, the solution is relatively easy: *Talk to them.* Allaying people's fears about how their images may be used eliminates 90 percent of the problem right away. You may still need to pay people for a release—and you should—but that typically isn't a lot of money. (A dollar or two is typical for a street grab-shot, although conditions, and luck, may vary.) As for those who are just seeking money, that's another issue, which I will discuss later.

The remaining 10 percent of people who object to their photo being used are worried about potential misrepresentation, such as an unflattering photo in a catalog, or that their pictures will be used in an ad

promoting a product or idea that they don't want to be affiliated with. A reasonable concern, to be sure, but one that is rarely realized. Again, the problem is easily solved through knowledgeable discussion, but some people are simply adamant: no photos. It happens, so prepare for it.

The risk of legal entanglement is not something that should scare you out of the photo business, or even cause you to limit your subjects to birds, bees, snow, and trees. Yet, I don't want to put you too much at ease: these are important issues, and guidelines should be followed to the best of your abilities.

So, let's review the checklist in more detail.

IDENTIFIABILITY

In my introductory example involving the soccer game for your kid's school, one thing we can assume is that the people in the photos are identifiable. This doesn't mean that you *do* need a release; it just means that we haven't ruled it out yet. Other factors now have to be considered. Namely, that of *use*, which is discussed next. However, even when people can be identified, there are other ways to handle the situation.

One way is to digitally alter the image to make the person unrecognizable. "Rubbing out" an otherwise identifiable face is perfectly legal. In fact, you see this all the time in video broadcasts, such as those commercials that advertise weight-loss programs. (Faces are usually "pixilated" or "smudged," leaving the rest of them clear and visible.) Obviously, altering an image changes the business opportunities available to it, but that's why we're talking. You have such opportunities, and this method may be applicable in some situations.

Whether an image has been digitally edited, or if you can't even tell who the person is in the first place, the use of such a photo almost never requires a release. Simply put, if the judge can't unambiguously identify the subject of the photo, he's not going to rule against you. If he did, all sorts of frivolous claims could easily be made. There *will* be grey areas, not just in terms of identification, but in terms of context and intent.

For these, let's add a twist: What if you just shot a general picture of the entire field because there was a great sunset? Although you can still identify some people individually, do you still need a release? It's been successfully argued that if the point of the photo is not a specific person, but a broader scene, then a release is not necessary. These cases usually involve innocuous items like postcards and other simple

consumable products that are not tied to the promotion of an idea. As a counter-example, a litigant once sued a postcard company for the use of a photo of him, not because of anything to do with the photo, but because the company used the proceeds to support the Mormon Church, thereby implying that the person was an advocate of the church. The judge ruled in favor of the man in this case, but it was noted that if it were *not* advocating something, there was no basis for a claim. The point is, once again, the *use* has a great influence on whether a release is needed, bringing us to the next item on the list.

IMAGE USE

When it comes to image use, the two that most people are familiar with are "advertising" and "news stories." (We'll get to the stickier issues later.) In the case of advertising, let's say you wanted to license your photo to a soccer ball company for a magazine advertisement depicting the kid you photographed scoring the winning goal. If you *did not* have a model release, all the parties involved could sue you, including the company that used your photo. The reason is because people are entitled to be compensated for using their "likeness" for purposes of promoting a product, idea, or political or religious view (or for implying support for any of those things). The law regarding this subject can be found at *http://caselaw.lp.findlaw.com/cacodes/civ/3344-3346.html*. While the *law* may be clear on this, the definition of commercial use isn't always as clear. Magazine ads are easy. What isn't so easy are certain forms of artwork, the context in which they are presented, or other uses that dance along the line between "commerce" and "freedom of expression." We'll tackle that after we finish covering the basics.

As for "news," here's the basic premise. In the United States and other parts of the world where "free speech" is generally protected by law or by the Constitution, the government cannot interfere with journalism and other forms of expression (opinion, art, etc., with many exceptions and limitations, of course). This sometimes trumps people's individual rights because news is deemed to be in the greater public interest, and people cannot stop pictures of themselves from being used in this context. So, to be clear: *Newspapers, magazines, or other sources of news and editorial can use images for editorial (news) usage without a model release*, as long as the story itself is considered newsworthy. As you can imagine, what is considered "newsworthy" is often disputed.

An important distinction needs to be made here: "editorial" implies expressing an opinion. As such, *making statements* is free speech, so you may make all the statements you like, provided they are yours. Associating *someone else* with your views (without his permission) is *not* (necessarily) free speech. (Hence, using an image of him that suggests he supports your view.) Nor is making false statements about someone (libel). Therefore, it is advisable that you understand how a proposed image is to be used, even in an editorial context, before you license an unreleased photo. Pragmatically, you might expect a well-known school textbook company to be using an image in an educational context, which does not require a release. However, if a religious organization wanted to use an image, you're almost assuredly going to need a release.

Note that how much money you make on a deal has nothing to do with this. You can sell an unreleased photo for millions of dollars to a news organization, provided the image was used solely for news reporting in a news context. But you couldn't give it away for free to a nonprofit organization making a public service announcement promoting the use of condoms and safe sex in public schools. Like the issue of religious use, people have a right to associate (or not) with such messages.

As the commercialization of journalism has evolved in our society, many Americans have a hard time distinguishing between news and non-news media, a trend that many TV shows have capitalized on in order to sell to broader audiences. A "reality TV show" is not editorial use, thankfully, because they are not considered newsworthy, despite how some portray themselves. This is often why you see people's faces blotched out of police videos.

For example, a photo studio in the shopping mall that takes people's protraits for a fee doesn't need to get a release because there is no "use"—the customer is just getting his pictures back. However, if the studio wanted to use one of those portraits to hang in the studio itself to illustrate the kind of work it does, a release would be required from the subject of that photo. This is a form of advertising. Since public versus private settings are so interdependent on other factors, it's best to continue the discussion in broader examples, which follow.

HOW WAS THE PHOTO TAKEN?

One thing about the soccer photo that's easy to understand is that it was taken on school property. For this example, we're assuming a public

school, which makes it public property. But, what about a picture that was taken of kids playing soccer at a private school, or more to the point, in their own backyard? In the case of private property, the question is then, "How did you get the picture?" If you broke into their property and planted a camera, that would be illegal, and you cannot sell the photo to anyone, even a news organization. If you used a long lens from outside their property—even on your own property—you may still be in violation of the law, if you are found to be a "Peeping Tom." OK, those examples are easy because it's "against the law," but most of the time when people take pictures on private property, they may not know it, or be aware of it. So how you got the picture takes on a whole different set of issues.

Public versus private settings is an important distinction, but, again, it depends on end use, which can trump the issue. Usually, rulings are based on whether there is "general public access." We'll get into this later with "fair use."

AN EXERCISE

Let's go through an example by looking at the following photo of the "face in the crowd." Did I need to get a model release from this person (or her parents)? Let's go through the checklist:

- **Are the people identifiable?**
- **What's the use of the photo?**
- **How was the photo taken?**
- **Was there compensation?**

What's your analysis? Can you argue *both* for and against the need for a model release here?

Let's start the discussion by looking at the first two questions: *Are the people identifiable?* And, *What is the use?* If the people weren't identifiable, we could rule out the need for a release. But since they are, it depends on other factors. So, let's look at those.

We know the "use" because you're reading this text: It's *editorial*. That is, I'm teaching a subject. Note that not all "teaching" is necessarily considered editorial; religious and political opinions are often not considered editorial when it comes to released photos of people. Also, I'm not teaching a subject about how to use a commercial product, such

Face in the Crowd

as a camera. Books that teach general photography are different than those that teach how to use a specific camera. That's considered a commercial use. In this case, I am not promoting a product or espousing views that a judge would reclassify as commercial or political or religious. This almost makes the issue a slam-dunk. But there's one more question to ask: Am I misrepresenting the people in some way or making statements about them that might not be true?

Alluding to the religious or political uses described earlier, there is an issue of misrepresentation to consider, although, again, it doesn't apply here, as I am making no such statements at all. This makes the question of identifiability irrelevant because I am not making claims that these people subscribe to my opinions.

The next question is whether the picture was taken in a private setting. It doesn't matter here because *there are no identifying elements here that prove it.* This is key because many people worry that shooting a picture in a private place, like a hotel room, or an amusement park, automatically requires approval or a release from the property owner. This is not necessarily the case, especially if there are no identifying elements. If the "face in the crowd" photo were inside an amusement park, one wouldn't know it from just looking at it, so a litigant wouldn't be able to convince a judge of the claim. If there were a sign or caricature (which is copyrighted or trademarked), then the situation might be different.

The final question, whether there was compensation, doesn't apply because a release is not required. Only if a release was required—and signed—does the question apply. Let's address that next.

COMPENSATION

In the United States, a model release is a contractual agreement that is not enforceable unless there was some form of compensation. A photo release is a *mutually reciprocal* feature of this form of agreement. That is, compensation without a release does not imply permission; and a signed release without compensation is incomplete. What is interpreted as compensation, or what form it takes, is not set in stone.

A popular form of compensation that some photographers like to use is a physical "print" of the photograph in return for permission to use it (via the signed release). This is fine, but be aware of the time, cost, and effort it takes to do this. It's more common to do this for emerging models who are trying to build their portfolio. They often exchange a photo-shoot session for a print and a release giving you (perhaps limited) rights to the images you take. For the common person on the street, however, it just might be easier (and quicker) to pay them money. A dollar is typical.

Professional photo shoots usually involve a modeling agency, which will produce a release for *you* to sign, binding you to limitations for what you can do with the photos. Usually, the client and use are known ahead of time, which is written into the contract.

Where the "compensation" is not involved is when the release is part of a broader agreement between the parties. A typical example is when one goes on tour with an adventure-travel company. Here, the *liability release* waiver, which usually states that you won't sue the company if you slip and hurt yourself, usually has additional language that allows the company to use pictures of you for use in its catalogs. In fact, this is part of my business. I shoot photographs for travel outfitters that sell trips to clients who pay to go hiking, biking, or to take cultural tours around the world. The clients are always informed of what's going on, and people can opt out if they want to, simply because that's good business etiquette. However, the advantage here is that the release has been obtained *ahead of time*, thereby relieving everyone from the hassle of taking care of it after the fact (or during the trip), should the need arise.

"Compensation" is deemed to be part of the package of activities that the client receives for going on the trip. The enforceability of any release is going to depend on whether an objective judge perceives the relationship between the parties to be that of full disclosure and mutual agreement, including compensation.

The Risk/Reward Analysis

There are upsides and downsides to the prospect of getting a subject to sign a model release. As with anything in business, there are always risks, ranging from errors *you* make to the "Murphy's Law" syndrome, where bad things happen no matter how hard you try to avoid them. Because there are fuzzy scenarios, and people don't always take well to being asked for a model release (timing is important!), you can actually cause yourself more of a headache by trying to get a release than if you just took the picture and dealt with the release later (or not at all). By having a better understanding of certain realities, you can find a happy medium between the upsides and the downsides of asking for a release. This is what I call the *risk/reward analysis*.

* **Risks**

 Obviously, the biggest risk of all is financial. People or companies with lots of money always have to be careful about what they do when it comes to the public because of their susceptibility to lawsuits. Even baseless claims are costly to defend, and unscrupulous people are known to go after large media companies for photo usages, even though 99 percent of these claims are without merit. The best defense against this is only to use released images, even if a given use does not require one. In a sense, *your* own risk is somewhat guided by this fact. If you are wealthy, you should be proportionally concerned. (Again, another reason why it's important to incorporate, to optimize your protection using the "corporate veil.")

 Conversely, if you are not wealthy, it's ironic but true that your risk of liability is next to nil. Outside of the obvious ethical problems you face if you knowingly sell unreleased images to clients that expect them to be released, you'd also be killing your photo career off pretty quickly if a problem came back to roost. But, realistically speaking, it's highly unlikely that anyone will put up with the cost and effort to sue you if you have too little to bother with.

A great example of this is a story my friend Bob told me about when he was shooting in Jamaica for a tourism magazine. He took a picture of a family lounging on hammocks next to the beach, and by coincidence, the family happened to see the magazine months later. They contacted their lawyer, who immediately started writing threatening letters to the magazine and to Bob. The magazine was indemnified because of its contractual agreement with Bob, so he had to deal with the family on his own. The family's lawyer informed Bob that the image did not have a model release, and that "remedies would be sought." While the lawyer gave no specific numbers, Bob responded with an offer: 50 percent of what the magazine paid him for the image. A month or so passed before he heard from them again, at which point, the family accepted. Bob sent them a check for $150 and never heard from them again.

What happened is clear: the family accepted the offer once they had done their homework and realized there was no real money to be had. Their lawyer made the same erroneous assumption, failing to do his homework as well. This goes to show just how uninformed anyone can be on these topics, even lawyers.

One could say that Bob should have gotten a release in the first place, nipping the problem in the bud. The nature of his usage didn't need one anyway, but paying off the litigants made the whole problem go away more quickly. This photo was one of thousands, and it's not feasible to get a release from everyone you shoot, so it's more practical and realistic to be more casual about it in these cases.

Strangely, market forces seem to impose a sort of equilibrium on this matter. If you never get releases for your photos, chances are you're not going to have many high-priced sales because those licensees won't assume the risk of using unreleased images (even though their use may not require one). Therefore, the market that will actually buy unreleased photos will be limited (to editorial clients), thereby reducing your risk more. Not that there's anything wrong with this—there's plenty of good money in selling to editorial clients, so don't assume that your collection of unreleased people pictures is worthless.

PRAGMATISM

Here's another quote that applies to this problem:

"Sometimes it's easier to apologize than to ask permission."

In reality, there is a pragmatic middle ground that should be taken into consideration for most any problem. This is where reasonable, practical judgment comes into play and brings a balanced perspective to the fore. We are all afraid of being sued, and many photographers are extremely worried that simply photographing someone potentially violates his privacy or other statutes. But, the reality is that most situations are not liabilities. This is a pivotal part of the risk/reward analysis. But pragmatism is not a guarantee—it's just an educated guess about what is most likely to happen under the given circumstances. This means that you have to have had practical experience in the world to develop that sensibility.

Here's where the business dilemma arises: if you have an opportunity to license an image in some way that *should* have a model release, but you don't have one (and can't get one), what do you do? Here, you have a judgment call to make. Since this scenario is likely to happen more often than you anticipate, be prepared to deal with the worst-case scenario. (For example, I consider Bob's experience with the family in Jamaica as being a realistic "worst-case" scenario.) The sections that follow will enumerate more scenarios for consideration, but they are not complete by any means. The possibilities are infinite, but the pages I can dedicate to the subject are finite. All I can do is to try to establish a pattern that you can extrapolate from your own experiences.

To that end, let's start with something you will undoubtedly run into with a client.

THE INDEMNIFICATION CLAUSE

While the discussion of contracts is beyond the scope of this book, what you'll find in the license agreements that some larger media companies require you to sign is an *indemnification clause*. That is, you will have to "hold the company harmless against any claims" that the subject of a photo may later make in connection with the image you've licensed. (This is why the family's lawyer sued Bob: they couldn't get the magazine, which is where the "money" is at.)

Obviously, you don't want to assume the risks on behalf of the client, but the reality is that most companies won't license the image unless you sign the agreement. "It's our policy," is what you'll no doubt hear. Pragmatically speaking, this is easier than it appears. First, if you have already notified the client of the status of the release (including the potential lack of one), if its end use violates the terms of the release (if one existed), then the indemnification is a moot point. The company would have already violated its license agreement, alleviating you from holding them harmless in a claim. Moreover, since these types of suits are usually about money anyway, the lawyers are going to go where the money is. Chances are, the company has more than you do, so, again, you are likely to be left alone (again, see Bob).

There are no guarantees, which is part of the reality of the business world. But you have to make real-time decisions, and when you're getting started in this business, you have less "weight" to push around to get your way. You're going to sign their agreement because you don't have a choice; I'm just trying to help you see why it doesn't really matter in the end.

Completing the Picture

So far, we established the foundations: the checklist of four tests help establish the basis for whether a release is required, you are more unlikely to come to a *definitive* conclusion (though your compass may be leaning towards one direction or another). The risk/reward analysis must be applied to find a pragmatic clear perspective that tips your decision one way or another.

At this point, I will raise a number of extremely common issues that contribute to the question of whether or how a release may or may not be required. As you read through them, you may gain a better appreciation for just how complex circumstances can become, especially if you envision mixing any of these scenarios together. All the more reason why it's important to get the big picture—the spirit of the *intent* of the law—which can help you with your pragmatic view.

FAIR USE

Remember the photo of the soccer game at your kid's school that I started with? Now, consider the "face in the crowd" picture shown and discussed earlier in this chapter. In both cases, the subjects are identifiable, but there's another common element: they are either *on* public

land, or are freely visible *from* public land. When such a condition exists, another variable comes into play: *fair use*. This is actually a legal term that refers to a subject that happens to be in full view from anywhere at any time by the general public.

The presumption of the fair use exception is that a person should be aware that he could be photographed at any time by anyone. One cannot stop the photography *process* from taking place, even though he or she may still have rights for how those photos are *used*. This is in contrast to private settings, such as going into someone's home, or into a bar or a concert. Under those conditions, a person has the right to stop you from taking his picture. This almost always is expressed on an admission ticket in fine print that says, "No cameras." Obviously, you see people there shooting anyway, and if you "snuck one in" as well, you may have gotten a picture, but your right to use it is still zero. You can't even sell it for news stories, even though those uses require no release. Why? You violated the contract that was part of your admission, obviating all other issues.

In open, public space, however, fair use can work for you in more ways than you think. The problem is that fair use can be ambiguous in many cases as well, and many photographers often try (erroneously) to protect themselves where it doesn't apply. Therefore, let's examine it carefully, and in context with the issues that follow. (Again, remember pragmatism!)

Using the soccer game example, if you got a great shot of a kid kicking the ball into a goal and wanted to license it to a soccer ball manufacturer, a release would be required. On the other hand, the "sunset shot" described earlier, where the group of people is sufficiently large and proportionally minimal in comparison to the whole picture, a "reasonable person" may not assume that the photo is about any *one individual*. If this were the case, this "unreleased image" may be eligible even for uses that would necessarily require one. Again, context and specifics are important, but cases have shown that fair use can apply here.

PROPERTY RELEASES

A "model release" applies to people, but a "property release" applies to buildings or real estate. (Technically, the wording is similar, but references are made to reflect the specific property.) Such releases are

necessary for using photos of a private home or even a public business, and the restrictions apply here just as they do with people. The issue of identifiability is still in play as well. In general, people's homes, buildings, or other structures tend to be unique enough that it's easy to identify a particular property among others. However, more often the fair use clause applies because structures tend to be visible from public land. So, again, *use* has to be taken into account.

For example, you can take a photo of Ross Valley Winery and sell it to the city, which is making a publication titled, "Directory of Ross Valley Businesses." The winery has no claim here, since the photo was shot (presumably) from the road, on public land, and the photo is being used in a noncommercial context. This is a classic example of the fair use exception. However, the same photo cannot be used for a book called, "History of Mondavi Winery," since the photo is not of that particular winery. Using the photo of Ross Valley Winery would be a misrepresentation of both companies.

Pop Quiz: What if you had an unreleased photo from *inside* the winery? Could you use it in the directory example? No, because the photo was taken *in a private setting*, which may contain business secrets or other aspects about the company that it wishes not to be known. One way to establish whether you're on private property, aside from it being someone's home or a business, is whether you had to pay money to get in. Amusement parks, for example, are private property, so you would need a release from the company that operates the park if you wanted to use an image of the park *in a way that would require a release*. (Remember, not all photo uses require a release. There's the question of "fair use" that's open, which can possibly lift restrictions on use. There's also the question of identifiability. You need to be reminding yourself constantly of the four checklist items.)

Exceptions to "private property" include state or national parks or other venues owned by the government, even though you often have to pay to get in. These places are considered *public domain* and generally do not need a release. Again, fair use. Similarly, paying to enter an event that's held on public land, like a concert in Central Park, falls under fair use in most cases. Note the exception of the performers, however, who may be trademarked or copyrighted, which puts up a completely different set of blocks (and fair use notwithstanding). Remember those uses that may misrepresent people or suggest that they advocate an idea or product.

216

PETS

As with humans, pets are also subject to identifiability. People are easier to identify because we're the same species, and we're wired to see the uniqueness of one another. The same cannot be said of animals, though. More specifically, animals we don't know. Owners may vigorously claim they can always identify *their* golden retriever among a group, but that owner is not the entity that determines identifiability, the question is whether an impartial person could (usually, a judge).

Specific and well-known animals with unique markings are generally protected, not necessarily because they are so unique, but because their likenesses are usually trademarked. If you are looking to make an ad campaign very much like Taco Bell's, using a dog that's visually similar to its Chihuahua "spokes-dog," then Pepsi (who owns Taco Bell) might sue you for trademark infringement, even though the dog itself is not in dispute. Can you think of an exception? How about:

SATIRE

Yes, when it comes to humor, just about anyone and anything is free from requiring a release. You see this all the time on television and in printed form. *Saturday Night Live* has made such satire a household name. But, tread carefully in this area; people hate to be made fun of. Also, people might make veiled attempts to capitalize on a celebrity, and use the "satire" excuse to justify it. For example, a company that makes the "bobbing head doll" made one of Arnold Schwarzenegger after he became governor of California. The governor sued, and the defense claimed that he was a public figure and the doll was satirical of his persona. The company lost the case after a long court deliberation. The fact that it was a close call is a reminder that you fly very close to the mountains when hiding behind the First Amendment: it's not always clear, and you may clear the peaks, or you may crash. Even in the best cases, where you may be within your rights, it won't stop an angry person from making your life difficult and expensive. (This should be part of your risk/reward analysis.)

ART, BOOKS, EXHIBITIONS, PRESENTATIONS, ETC.

Speaking of the First Amendment, we now get into the stickier subject of art. For the most part (in the United States), artistic exhibitions (and publications) are considered editorial and are usually protected

by the First Amendment. This means that your photo of a person can hang in an art gallery or in a restaurant and does not need to be "released." Furthermore, you could publish your pictures of the soccer players at school in a book, but that's not to say you wouldn't get a knock on the door late at night from a big ugly dude named Bubba. (Or worse, a big ugly *woman* named Bubba.) Here's a great example of when a legal use of an image is better handled by having obtained a release.

The exception is a book cover, which is often considered commercial in nature because it's considered the part that "sells the book." This is similar to posters and postcards. If it looks like advertising or a salable product, it crosses even more over that line. But keep in mind that these products are generally considered mass produced consumables, not necessarily unique works of art, which are characterized differently, as discussed earlier. Rights of publicity are generally created by state statute, and it depends on exactly what the statute says and how the courts interpret it before a judgment can be made.

The exception to when art isn't really *art* brings us back to the example of when you have a portrait studio in a shopping mall. Remember my point about posting a photo of someone in the store to demonstrate your work? That's a commercial use because you are promoting your business. Here, the photo—or "art" in one of its forms—is being used in a commercial context because it is specific to the nature of the business. This is quite different from a restaurant, where artwork is not so clearly a part of the establishment's "business model." Here, it's more widely accepted as being part of the decor. (One can argue that decisions to eat at a place aren't based on its artwork.) What's more, it is generally accepted that eating establishments have *always* been venues for art. This *de facto standard* has been established long ago, and courts usually uphold such traditions.

While art exhibits are exempt from requiring a release from subjects who happen to be portrayed, an exception may apply if the exhibit were displayed in, or underwritten by, an organization, which *may* trigger the need for a release. For example, if your photo of the kid scoring the winning goal was in an exhibit that was underwritten by an organization that helps children with AIDS, the parents of that child may take issue with it, since there could be a point of misrepresentation. Again, the picture is very fuzzy here, because corporations underwrite museums

all the time, and other major sponsors are known to support the arts while maintaining First Amendment protections. The lesson again is, *don't oversimplify.* You need to look at the broader context and think objectively.

Overhead presentations are subject to similar constraints. If they are for commercial use, the images might have to be released. But here's a case where pragmatism comes into play: presentations are to be screened in front of such a small audience, and usually on a one-time basis, that acquiring a release may be overkill. Of course, this equation changes if the presentation occurs more often, to wider audiences, or is underwritten by a high-profile entity.

TO SHOOT OR NOT TO SHOOT?

Should your concern for whether a given image requires a model release govern your decision on whether to shoot it? The clear answer is an unambiguous *no.* There are those who believe that if you may need a release for a photo, then you better not even shoot it. *Nothing could be further from the truth,* which is easily proven by the simple fact that photography is a common activity that everyone does, from the three-year-old toddler to the vacationer in Hawaii. Even blind people have been known to take extraordinary photos. It's a hobby to most people, and laws don't change simply because you may be a professional (or want to be). If you have a camera, and you are in a public setting (in most free countries, including the United States—for the time being at least), you are perfectly within your rights to snap those pictures.

What you choose to *do* with a photo is another thing entirely. So, even if you're unsure about how you can use an image, keep this in mind: if you don't shoot the picture, you've lost a potentially great image. If nothing else, you could have put it in your scrapbook. If you can somehow manage to get a release later, or if you want to use the image in an editorial context, you always have that option. The rule of thumb is, *shoot first, and ask questions later.*

PHYSICAL OWNERSHIP AND RIGHTS

Physical ownership of images (prints, film, and digital) has *nothing* to do with rights to use them. Obviously, the point of this chapter is to obtain those rights via a model release. How to apply this to different scenarios is what's important to understand. Even if you don't have a model

release, you still *own* the picture. You are not required to forfeit your media (prints, film, digital copies) just because someone did not authorize you to take his picture, let alone sign a release. (Note, the only time someone can prohibit your taking a photo is on a private property, as discussed earlier.)

All this time, we've been talking about photos *you* took, but what if you are in possession of photos you didn't take? One person e-mailed me saying that he had purchased raw negatives of the Beatles on eBay and thought it gave him the right to make new prints and sell them. This is not the case because this would involve reproduction and distribution of copyrighted material. Hence, buying a photo does not implicitly transfer the rights to use that photo. You would have to either obtain a license to the photo (if it were required for your intended use) from the original subject, or you would need to obtain it from the current license holder (assuming one exists, such as a record label, or the deceased person's estate). Again, here's where pragmatism comes into play. Obviously, if there is an existing (or emerging) commercial interest in the subject (person, animal, or place), then using the image implies increased risk. However, if it's not someone or something that's easily recognized and there is no commercial interest in it, then your risk is lower. (If an objection miraculously surfaced later, your position would be easily defendable, and you would most likely be able to "settle" the dispute amicably.)

Furthermore, *rights* to an image do not have anything to do with the physical prints or media. For example, if you licensed the use of an image, it doesn't mean that you are allowed to obtain the original media of the image. Licensing a "right" is not the same as purchasing physical property.

On a similar note, if someone hires you to photograph him for a portrait, *you* own the pictures (unless you sell them to him), but he still owns the rights to his likeness. The whole point of a model release is to grant you rights of usage that you didn't otherwise have. Same applies here. Here's a piece of advice for portrait shooters: include a clause in your contractual agreement that gives you certain commercial rights to the images that you shoot of the client. This obviates all potential disputes.

Adding a twist, let's assume you gave a digital copy of your photo to a client. Can he use it commercially? No, because you're the photographer, so you own the copyright. Images can only be sold or

licensed if you own the copyright, or if you were given permission through a contractual agreement or as part of a purchase. Just because a client may have a physical copy of a picture of himself doesn't implicitly give him rights to use it.

By the same token, some believe that if they are the subjects of a photo, they are entitled to the physical prints or negatives, which is not the case. This usually comes up, not in a portrait studio situation, but in event photography or in general street shooting. If you shoot someone against his wishes, even though you may be allowed to, the subject may demand the film or the media, claiming that he owns it because it is of him. While he doesn't have the right to demand the actual media, he obviously has the right to withhold permission for you to use the photographs. (The only thing he needs to do here is nothing. That is, by not signing a model release, you have no right to use the picture of him.)

PRIVATE USAGE

Private *use* of images is legal and never requires a release, regardless of whom it is of, or how the picture was shot. You can take a picture of anyone and put it up in your house, show it to your friends, and put it in your scrapbook. However, the line between private use and "public distribution" is difficult to put into words. Decisions have to be made on a case-by-case basis. For example, if you were to make a CD of your favorite photos and send it to your family and friends, would you need a release from the people in those pictures?

Assuming this is a straightforward question and that it doesn't involve complexities, like you're trying to promote a product or service, are a nonprofit cause, or are expressing religious or political ideologies (each of which would increase the likelihood of requiring a release), then the question on private use is a matter for consideration. A judge would probably ask, "How big is your family?" And from there, he'd look at intent, content, and circumstances that may or may not mitigate your case. If it's a typical family unit, it's not going to be a problem. If it's a mailing list of 5,000 people, many of whom are *not* related, but merely clients of your photo business, there may be an issue. For the middle ground, there's just no telling.

One can look to the music industry for precedents of separating private use from music distribution, in the cases involving online file

sharing sites. These are Web sites where people are distributing *copyrighted* material, which is entirely different from a photograph involving a model release. The point of looking at file sharing, however, is to try to establish precedent of what is or isn't "private sharing between individuals" and "distribution." The translation to photography is slightly different.

PHOTOS ON THE WEB

Just as with music, photos are also protected by copyright, and because you own your photos, there's no question you can put them on your Web site without violating copyright. But, when it comes to model releases, the question of "private use versus distribution" requires looking at other factors. As usual, we return to *use*. Because the ability to sell photos in editorial contexts without a release permits unreleased photos, you are allowed to display them as such. Where it can get sticky for pro photographers is whether the photos can be construed as being a form of advertisement or advocating a political or religious position. This can be a problem for photographers who specialize in certain kinds of industries, like religious photos or political stock photography. The more specific you are, the more risk you assume. The more general you are, the safer you tend to be.

It has been questioned whether photos on a Web site constitute a form of self-promotion (i.e., advertising) because your site is something like a portfolio. Yet, this has never been tested in court so, at this point, it's merely conjecture. That said, it's another question of where along the spectrum a Web site may lie if it portrays images: is it a portfolio, or are you presenting material in an editorial context, or are you making photos available for use by editorial clients that do not need releases to license? Until a true precedent is established, I would assume that eventually a judge is going to look at cases individually and decide independently based on the context.

VERBAL AGREEMENTS

Quote time:

> "A verbal agreement is as good as the paper it's written on."
> —Samuel Goldwyn

As a pioneer in the early motion picture industry, when and where many of today's laws on the subject were established, Sam Goldwyn had to deal with such issues all the time. His mantra was to have *everything* written down. Whatever you agree to, even with the best intentions, can be withdrawn unless it's in writing. Just because someone says it's okay isn't enough for those truly critical situations where you *know* you need a release.

OTHER COUNTRIES

If you are not from the United States, or are on vacation in countries outside the United States, there are different issues involved. U.S. law isn't necessarily identical to other countries', although many are based on the same ideas. Licensing images to foreign publishers tends to be pretty safe because of pragmatism: the audience tends to be pretty separate, and laws are often restricted to U.S. companies anyway. Similarly, U.S.-based publication of photos of people *from* other countries isn't straightforward either, for the same reasons.

Summary

When you began this chapter, it may have been unclear to what extent you can use your pictures. Returning one final time to the photos you took at the school soccer game, maybe you can now answer some of these questions yourself. If you wanted to license some of the photos to the local paper for a news story, now you know that you could—without a release. If you wanted to sell prints of the kids back to the parents, again, you know that you can do this—without a release. If the school wanted to put your pictures on its Web site, you know that it can do this—without a release. However, if you wanted to use the pictures for some sort of ad, promotion, or statement, that's another story. For these, you need a release.

Then we examined the risk/reward analysis, which teaches that you can't just look at things at face value; the context always needs to be taken into consideration. If one of the parents has a problem with your showing his kid's face in print, your biggest problem is probably going to be social concerns, not legal ones. No doubt, such an event will cause a stir in the community, and if you're going to have a business selling pictures, this won't bode well for you. Even though you're legally

allowed to publish these pictures in many contexts, chances are you won't want to pursue this line of action.

The examples I just gave are simple, but as I mentioned at the beginning of the chapter, most situations aren't as cut and dry. And while most consumers don't run into them often, pro photographers do, and, as such, you must get used to encountering ambiguously grey lines between whether or not a release is required for a given subject or use. That said, just about every situation has a pragmatic side that will help you determine the best course of action. In some cases, that may mean that you *don't* use an image that you are entitled to, or it may mean that there is no harm in using an image for which you "technically" need a release. So, while the technical details are critically important to learn, it's impossible to put them into use without a pragmatic voice that interprets the circumstances for what they really are.

There's no way to teach pragmatism. It's an offshoot of common sense that comes from empirical experience in life. You either get it or you don't. One way to determine if you're *not* being pragmatic is, as described above, you find yourself constantly worrying about whether you need a release for one photo without thinking about the checklist items at the beginning of this chapter. If you find yourself looking for literal interpretations, you're not being pragmatic. If you're trying to pinpoint specific arguments for or against something, you're not being pragmatic. There's certainly nothing wrong with contemplating the subtler nuances of the law and having thoughtful discussion about it, but if it affects your decision-making on how to move forward in your business, then you're not being pragmatic.

Lastly, don't assume that I am suggesting that you be carefree about the issue of releases. I'm not: you can make as many bad decisions by being too lax on the matter as well. Pragmatism is finding that reasonable middle ground where the costs and the benefits are in balance.

INDEX

Books from Allworth Press

Allworth Press is an imprint of Allworth Communications, Inc. Selected titles are listed below.

The Photographer's Guide to Negotiating
by Richard Weisgrau (paperback, 6 × 9, 256 pages, $19.95)

The Real Business of Photography
by Richard Weisgrau (paperback, 6 × 9, 256 pages, $19.95)

Photography Your Way: A Career Guide to Satisfaction and Success, Second Edition
by Chuck DeLaney (paperback, 6 × 9, 336 pages, $22.95)

ASMP Professional Business Practices in Photography, Sixth Edition
by the American Society of Media Photographers (paperback, 6 3/4 × 9 7/8, 432 pages, $29.95)

Photography: Focus on Profit
by Tom Zimberoff (paperback, with CD-ROM, 8 × 10, 432 pages, $35.00)

Business and Legal Forms for Photographers, Third Edition
by Tad Crawford (paperback, with CD-ROM, 8 1/2 × 11, 192 pages, $29.95)

The Photographer's Guide to Marketing and Self-Promotion, Third Edition
by Maria Piscopo (paperback, 6 3/4 × 9 7/8, 208 pages. $19.95)

How to Shoot Stock Photos That Sell, Third Edition
by Michal Heron (paperback, 8 × 10, 224 pages, $19.95)

Pricing Photography: The Complete Guide to Assessment and Stock Prices, Third Edition
by Michal Heron and David MacTavish (paperback, 11 × 8 1/2, 160 pages, $24.95)

The Business of Studio Photography, Revised Edition
by Edward R. Lilley (paperback, 6 3/4 × 9 7/8, 336 pages, $21.95)

Starting Your Career as a Freelance Photographer
by Tad Crawford (paperback, 6 × 9, 256 pages, $24.95)

Please write to request our free catalog. To order by credit card, call 1-800-491-2808 or send a check or money order to Allworth Press, 10 East 23rd Street, Suite 510, New York, NY 10010. Include $5 for shipping and handling for the first book ordered and $1 for each additional book. Ten dollars plus $1 for each additional book if ordering from Canada. New York State residents must add sales tax.

To see our complete catalog on the World Wide Web, or to order online, you can find us at **www.allworth.com**.